# STRANGE
# BEDFELLOWS

# GEORGE WOODCOCK

# STRANGE BEDFELLOWS

## THE STATE AND THE ARTS IN CANADA

Douglas & McIntyre
Vancouver/Toronto

Douglas & McIntyre Ltd., 1615 Venables Street,
Vancouver, British Columbia V5L 2H1

**Canadian Cataloguing in Publication Data**

Woodcock, George, 1912–
  Strange bedfellows

  Bibliography: p.
  ISBN 0-88894-456-X

  1. Arts – Canada – Management. 2. Art and
state – Canada. 3. Art and society – Canada.
4. Federal aid to the arts – Canada. I. Title.
NX750.C2W65      700′.971      C85-091039-0

Design by Barbara Hodgson
Typeset by Evergreen Press
Printed and bound in Canada by D. W. Friesen & Sons

# CONTENTS

The Lord gave,
and the Lord hath taken away.

*Job 1:21*

# INTRODUCTION

A s I point out in the first chapter, I have felt for a number of years the need for a new study of the relationship between the state and the arts in Canada. What propelled me into writing this book was the situation that arose in the autumn of 1983, when the state, in its negative tax-collecting aspect, mounted a major attack on all sections of the artistic community, visual artists, writers and performing companies being equally victimized. This attack was carried to an absurd extreme when Revenue Canada, the left hand of government, actually confiscated grants that had been given by the right hand through funding agencies like the Canada Council and the Ontario Arts Council. This series of alarming incidents, which affected several hundred artists and which I discuss later on in more detail, led me to consider their background: what was in fact the situation of the Canadian artist in 1985, thirty-four years after the Massey Commission made its report on the state of the arts in this country at midcentury, and twenty-eight years after the Canada Council was founded.

At this point we could look back over a quarter of a century in which the government at various levels — federal, provincial and municipal — had made unprecedented efforts to assist both creative and performing artists. In this era the arts underwent an upsurge unparalleled in Canadian history, so that the number of

artists who could be regarded as professionals has increased many times since those grey days of 1949 when the Massey Commission first began its investigations. More than that, the audience for the arts has grown vastly. In spite of Marshall McLuhan's dismal prophesies in *The Gutenberg Galaxy*, more books were being not only written but also published and sold. Many more artists were exhibiting their works in a host of public and private galleries that had not existed a quarter of a century ago. The upsurge in the performing arts, most strikingly exemplified in the revival of a live theatre tradition that had once seemed moribund in Canada, was attracting hundreds of thousands of people to plays, dance performances, concerts and showings of the feature films that Canadian producers were beginning to make with Canadian actors, using the scripts of Canadian writers.

But I found that, in spite of this increase in both creative activity and public interest, the artists of Canada, with a few fortunate exceptions, were hardly better off as individuals than their less numerous predecessors had been when the Canada Council was established. It did not matter greatly what branch of the arts one chose — writers or visual artists, actors or musicians — their average income was round about the accepted Canadian poverty line, and their mean income was generally below it, which meant that when one had counted out the tiny minority of big earners, artists as a class were the poorest people in the country except for old age pensioners and native people living on reservations.

As the following chapters will show, poverty is not the only threat to artists in Canada and, by implication, to a continuing tradition of vital art. There are at least two other perils.

One is the danger of the arts increasingly becoming the servants of the state. In recent years governments have tended to retreat from the arm's length principle on which the Canada Council was established as an autonomous agency, and to attach political strings to their grants, so that if the cultural bureaucrats have their will, artists may well be more frequently expected to pay for what aid they receive by producing approved works useful to governments, as happens already in totalitarian countries.

The other peril, manifest in the increasing tendency to see the arts as "cultural industries," is that of artists becoming the

8

victims of the profit motive. The threat in this direction does not come merely from free enterprise. It comes even more from government departments that seek economic evidence of the benefits of government aid. These bureaucrats fail to understand that the benefits the arts confer on the community are not material and therefore cannot be assessed in this way.

In dealing with these problems, I begin with the historical background to state aid to the arts in Canada. How was its necessity recognized, and how did it develop? How has it grown, and changed with growth? How has it affected the condition of the arts and the acceptance of artists by the community? And I end with the question: How can the artists be extricated from their present predicament, and their professions be recognized and rewarded like any others, without submitting either to the unpredictable demands of the state or to the ever-present pressures of the profit motive and its advocates?

## Chapter 1

# ART
# AND
# CULTURE

My sense of the need for this book goes back to a day in the autumn of 1976 when, as the snows swept in early over northern Ontario, I arrived in Ottawa to take part in a colloquium called by Gov. Gen. Jules Léger. It was the twenty-fifth anniversary of the submission of the Massey Report, and Léger wished not only to celebrate the work of his predecessor, the first Canadian-born Governor General, but also to gather together a few people in the arts whom he and his advisers thought might be able to make fruitful suggestions about what could still be done to foster the nation's arts and sciences.

As my taxi stopped under the portico of Rideau Hall and the security guards closed in, another drew up beside it, and the poet Dennis Lee stepped out. Inside we joined the other guests for that long and loquacious weekend: the critic Malcolm Ross and the painter Alex Colville, the writer-actor Gratien Gélinas, the poet Pierre Trottier and the musician R. Murray Schafer. The next day, as we sat down to our discussions, we were absorbed into the milieu of Ottawa volubility as politicians — Jeanne Sauvé, Hugh Faulkner, Gordon Fairweather — and cultural bureaucrats — Naïm Kattan of the Canada Council and Al Johnson of the CBC — joined us in the Long Gallery, where royal and gubernatorial portraits by Winterhalter and Millais gazed down benignly on our deliberations.

Our task was a curious and perhaps anomalous one, since any group called together by the Governor General on a personal whim clearly lacked the constitutional right to interfere in the government's handling of cultural affairs or in any other public activity; we did not even have the right that is accorded a royal commission to make ourselves publicly heard. All we could do was assess Canadian policy towards the arts over the past quarter of a century, and formulate recommendations — regarding whose destination we were even then in considerable doubt — on what might still be done in the spirit of the Massey Report. The recommendations we did formulate in the intervals between lavish luncheons, dinners and receptions, all conducted in full viceregal style, were never made public. I have not heard that they were even circulated to those who make cultural policy in Canada. In fact I have not heard anything of them since the day at the end of the colloquium, when I stepped out of those august premises with Dennis Lee at my side into the first of the winter's blizzards. They seem to have dropped into one of those deep oubliettes that await so many good intents voiced in Ottawa.

The whole occasion has taken on in memory the aura of a dreamlike and gratuitous interlude. As I remember our conversing — often at manifest cross-purposes, in those surroundings of high-Victorian gemütlichkeit — and contemplate the lack of evident results, I am reminded of Peacock's novels of incompatible people coming together for garrulous country-house weekends; I have often, indeed, thought of turning the memory into a play.

Yet at the core of this gathering there was a good idea, even if it was not the kind of idea that is best developed by a group of mingled artists, bureaucrats and politicians coming together for three days in the rarefied atmosphere of Canada's surrogate Buckingham Palace. Perhaps our strivings were in themselves merely symbolic, a recognition of the noble efforts of our predecessors a quarter of a century ago. Yet in ways that were far more than symbolic, the appointment of the Massey Commission in 1949, followed by its report in 1951 and the creation of the Canada Council six years later in 1957, does represent a kind of watershed in Canadian attitudes to the arts. In what it elicited from people of all kinds in its two years of hearings and travels,

in the spirit and substance of its recommendations, and in the actions they finally provoked from Canadian political leaders, the commission revealed for the first time a widespread recognition among Canadians of the truth from which this book sets off: that in its arts a community finds the most profound and faithful expression of its true nature, and that for this reason — first among others — the community is under an obligation to see that the arts do not die, but flourish.

At this point I choose my terms deliberately. I talk of the community, since I believe it is from natural relations between men and women in their daily lives that the arts emerge. If I use the word *state* in my title, and talk often of the state in relation to the arts in the pages that follow, it will be because in practice, whether one likes it or not, the state in the modern world usually serves as the agent for the community in its relation to the arts and thus, for better and more often for worse, tends to shape the community-artist relationship. But always I shall have in mind that the relationship does not necessarily have to be shaped in this way, and much of what I say will be directed towards considering a more direct and less structured intercourse between creator and community than that which becomes inevitable when the state enters into the role of patronage. For there is, as history demonstrates, the danger that the state may change from patron into director, and then the delicate relationship between community and artist is endangered because the artist is called upon to express the political imperatives of the state rather than the spontaneous insights of the community as represented by its most imaginative and perceptive representatives, those whom Shelley called "the unacknowledged legislators of the world."

I talk of the arts rather than of culture, since the term *culture* has become vague and generalized, and in such matters one has to be specific. In 1976, at the height of the populist attack on elitism in the arts, Susan Crean published a widely read book, *Who's Afraid of Canadian Culture?*, which represented a particularly strident form of Canadian cultural nationalism. Seeking to prove that Canada has such a vital cultural life of its own that we can in fact do without great art from the past or, for that matter, the vital art that is today created outside Canadian borders, she devalued the idea of culture until it became almost meaning-

less. After dissociating herself from the elites who cultivate the fine arts and patronize symphonies, ballets, operas and Shakespearean festivals, Crean remarks:

> For the rest of us, sports, domestic crafts, and the host of activities of the masses that are usually identified as leisure pursuits or hobbies are also culture. Bowling is culture, and so is watching TV. Culture includes art: art is only a part of culture. . . . Going beyond language or shared understanding, culture provides a *modus operandi* for all aspects of social activity, from manners and mores to the practical side of everyday life.

Crean is not in fact an unintelligent writer: her book shows a shrewd grasp of the way culture is organized in the modern world and of the quasi-political infrastructure that emerges as soon as governments on whatever level become involved in artistic activities. Here at times she is very acute, particularly when she shows how the people who most benefit from official programs to help the arts are invariably not artists, but the new breed of cultural bureaucrats. Yet she sustains her arguments with the curious idea, which shows an ignorance of the creative function, that we can only appreciate art which has an obvious and direct relevance to our experience; as a result, she condemns out of hand "Shakespearian fantasylands, Beethoven and all his works, . . . and Henry Moore's pavilion in the Art Gallery of Ontario."

There is of course a sense in which Susan Crean was right in her definition of culture, for what we mean by the word has changed since the emergence of the quasi science of anthropology in the late nineteenth century. Originally, culture meant the understanding and appreciation of literature and the other arts, and that connotation survives when we speak of a cultured person. But in the view of an anthropologist, a culture is the sum of the customs of a group of people gathered in a community, the manifestation in action of its special civilization — and of this the arts are only a part. At the same time, the earlier definition of culture has undergone a subtle shift of meaning, so that it comes to connote less the creation of art and literature than the dilettantish enjoyment of them. As we shall later see

13

more fully, politicians and bureaucrats often make use of this confusion in the meaning of the word *culture* to bring the arts under the same administrative aegis as the more technical aspects of communications, on the ground that both are embraced within the concept of culture. They even talk of a cultural industry, so that the arts become judged by the criteria of consumerism. The critic Herbert Read, in his anxiety to save the arts from the false values of the marketplace, once wrote a famous pamphlet which he called *To Hell with Culture!*, and in this book I shall adopt his title as my only slogan: To Hell with Talk of Culture, since in the modern age it submerges the arts in other activities that are in no way artistic, and so obscures the special role and the special claims of artists.

Among them I am including interpretive as well as creative artists, and this brings one, by way of Ms. Crean's "Shakespearian fantasylands," to what is perhaps the main distinction between the arts and culture as defined by the anthropologists and, presumably, by critics who wish to impose their political nationalism on the creative or the performing act. A culture, seen in this narrow way, is limited to the community that has developed it, though it embraces all its activities; it is, in several senses, a *national* culture, as much attached to a particular people and place as to their spoken and written language.

Art defies these limitations of a culture; it traverses boundaries of time and space, so that a modern Western man or woman can appreciate equally an archaic violin-shaped statue from the Cycladic Islands made three thousand years ago, or a recent wood carving from New Ireland with its marvellous capturing of space in a filigree of wood, or a painting done last week by Jack Shadbolt on Hornby Island. Even in literature the great elements of structure and theme, of image and metaphor, appeal across the barriers of language as well as time and space, and the trials of Job, the fated wanderings of Odysseus and the memories that were opened to Marcel by the taste of a madeleine soaked in lime-flower tisane are part of the accumulated experience of every person for whom literature is a living thing.

The arts indeed have their origins within a culture, and, as Northrop Frye has said, "cultural movements tend to decentralize and regionalize." No art can in fact spring from other than personal and local experience, and it is art's paradoxical

14

achievement to work through the particular and discover the universal. Blake's oft-quoted quatrain makes sense above all for art:

> To see a World in a grain of sand,
> And a Heaven in a wild flower,
> Hold Infinity in the palm of your hand,
> And Eternity in an hour.

In the same way, art begins with the individual insight and proceeds to the universally understood truth, but it can only do so through the community to which the artist belongs. Art indeed may be the only human activity that works on all three levels — personal, local and universal — for even religions remain strangely bound in their actual manifestations to regional cultural complexes, so that while a Christian receptive to visual art has no difficulty understanding the aesthetic qualities — the visual language — of a Gandhara bodhisattva or an antelope cult mask from the Upper Volta, he would have much more difficulty absorbing the esoteric doctrines of Mahayanist Buddhism or the concepts that underlie animist fetishism.

The corollary of this unique function, of course, is that if we hope to foster the universal appeals of art, and to benefit from them, we cannot afford to cut our links either with our own traditions or with those of the rest of the world. To claim, as nationalistically inclined critics like Susan Crean do, that we should neglect Shakespeare and Beethoven because they are not Canadian is to assume that art originates at a point in time and place hermetically sealed from history. No such point of course exists, and as any student of comparative literature knows, we enhance our own arts by seeing them in the context of the pasts that both the artists and their audiences have brought with them into the present and of the parallel arts that exist in other times and places. We miss a great deal in recent home-grown Canadian drama if we do not see it in relation to the Shakespeare and Shaw festivals that have kept the great dramatic traditions fresh; we miss even more of west coast painting if we ignore the Chinese and Japanese traditions whose influence has percolated through the arrival of so many emigrants from East Asia; we cannot understand Earle Birney com-

15

pletely without some awareness of the great Old English poems like *The Wanderer* and *The Seafarer,* or even the Group of Seven without an acquaintance with European art nouveau.

In making these arguments, I am offering what in this context of the state and the arts is a necessary protest against those who, whether they intend it or not, diminish the arts in the public eye by raising the artificial division between elitist art and popular art. Art can begin in an aristocratic setting and become popular, as Mozart's operas have done. Art can begin among the people and permeate the whole of society, as jazz did. Art can begin on a popular level and remain there, as the whole nine-teenth-century Italian opera tradition from Rossini to Puccini did. And the artists, particularly performing artists, can, if they are good enough, move with integrity from point to point within this great continuum, refuting the artificial distinction between the elitist and the popular as Benny Goodman so splendidly did when he moved with his clarinet from the mastery of jazz to the mastery of Mozart.

It is necessary to make such clarifications at the start of this book because so many of the people who are likely to become involved when the state takes an interest in the arts are those without either academic training in the field or, more important, without the intuitive sense — even when it is untrained — that enables one to distinguish what is truly art from what is not. The concept of culture as understood by the anthropologists and sociologists contributes, as we have seen, to their confusion. Art and mere entertainment can easily become one in the minds of politicians and bureaucrats who have no artistic interests or commitments. So long as one continues to talk only or primarily of culture, these misunderstandings are inevitable. If live the-atre, thinks the average philistine, why not movies, and if mov-ies, why not soap opera, why not advertisement jingles, why not violent pornography? They are all in the broadest sense part of our culture. And for this reason it is necessary to state clearly that what we are concerned with is solely that element in our general culture which belongs to it and yet overleaps it: the arts in their dual aspect of creation and interpretation.

A generation ago, speaking of the very question of assisting the arts which is the subject of this book, T. S. Eliot, in *Christian-ity and Culture,* put the case admirably:

16

Some safeguard may be provided, against increasing central-
ization of control and politicization of the arts and sciences,
by encouraging local initiative and responsibility, and as far as
possible, separating the central source of funds from control
over their use. We shall do well also to refer to the subsidized
and artificially stimulated activities each by its name; let us do
what is necessary for painting and sculpture, or architecture,
or theatre, or music, or one or another science or department
of intellectual exercise, speaking of each by its name and
restraining ourselves from using the word "culture" as a com-
prehensive term. For thus we slip into the assumption that
culture can be planned. Culture can never be wholly con-
scious — there is always more to it than we are conscious of;
and it cannot be planned because it is also the unconscious
background of all our planning.

# ART, SOCIETY AND THE STATE

A rt originates in the individual vision, yet it is fed by the collective experience and perhaps, if we are to accept the theories of Carl Jung, by the collective unconscious as well, with its access to primeval sources. And, however isolated the processes of creation may be, it is a social activity, conditioned in form as well as in content by the time, the place and the circumstances in which it is made. It could hardly be otherwise, since art — no matter how idiosyncratic it may be and how often at times obscure in appearance — is always in the last resort an attempt at communication. The plays of Aeschylus could not have been written anywhere but in Athens after Marathon or the novels of Hugh MacLennan anywhere but in a Canada where the first urges of nationalist consciousness were beginning to emerge. Artist-and-audience is one of the symbiotic relationships that form part of the natural network of any community.

That relationship is necessary to the artist, for if the arts are languages, oral and visual, they are silent without minds to listen and perceive. It is also necessary to the community, which finds its true definition and projects its real nature through the works of its artists, so that those rare societies that have been totally lacking in the arts have also been intellectually and emotionally barren and liable to mass psychosis; Khomeini's Iran,

where the arts are suppressed in the interests of Islamic ortho-
doxy, is a typical example. The spirit of the community finds its
expression as much through the creations of those who retreat
into solitude to write their poems or paint their pictures as
through the achievements of those whose interpretive activities,
as singers and actors, as dancers and musicians, demand the
participation of a collectivity, first as the performing group and
then as the witnessing participants. Indeed a community often
survives only through the works of its creative artists which act
as Malraux's voices of silence, communicating its vision of exis-
tence to later generations. We know something of the individual
and family life of Cro-Magnon men from their skeletal remains
and their stone tools, but their life as a community, manifested
through collective rituals, we know only through the magnificent
paintings in the caves of Altamira and Lascaux.

But if artists of all kinds give expression to the identity of a
community as well as satisfy those individual aesthetic needs
which journalists are inclined to neutralize by discussing the
arts under the general heading of entertainment, then the com-
munity owes the artist its support. The artist's work has to be
recognized as being of equal social value to occupations that
are obviously necessary in material terms; just as society cannot
afford to do other than sustain farmers, even at times by giving
them special advantages, so it cannot afford to do other than
ensure the artist's survival.

In premodern societies, where the political strand was weak
and where community arrangements came into being without
the emergence of an organized state structure, the role of the
artist as image maker and remembrancer, custodian and inter-
preter of myth and history, was accepted, and so was the need
for the artist to be supported by the society that depended on
him to define through icons and symbols its relationship with
the natural and supernatural worlds.

One need not go beyond Canada to find an example; it is
there in the past of the Kwakiutl Indians of what is now British
Columbia, whose summers before the white men destroyed
their civilization were spent gathering and preserving food and
trading, and whose winters were devoted to the lavish commu-
nity ceremonials of a society that had hierarchy without govern-
ment. The Kwakiutl dance fraternities and the individual chiefs

provided their artists — carvers and painters and constructors of ingenious theatrical machines — with an abundant living in return for their indispensable contributions to the great dramatic choreographies of the winter dances and the potlatches, or giving feasts, through which the peoples of the coast lived out their myths and defined their collective as well as their individual personae. Men and women in such a community danced their own dances, which confirmed their positions in the social order; but the masks they wore, the rattles they flourished, the poles they might dedicate, would be the work of professional artists whose skills and whose knowledge of the myths were revered, and whom the community sustained without question.

During the Middle Ages, in the earlier stages of the European civilization from which our own is descended, urban communities were held together partly by their Christian faith and partly by the particular variant of mutual aid which, as Peter Kropotkin and later writers like Patrick Geddes and Lewis Mumford have so convincingly shown, was manifested in the guilds of the great free cities that provided a counterbalance to the strength of feudalism in the rural hinterland. The Gothic cathedrals that still tower over the towns of France and Britain and the Rhineland were the great testimonies to communal art in this period, in which religious fraternities and guilds of artisans and artists collaborated and competed to exhibit, in architecture and sculpture and painting, in stained glass and textiles of unprecedented richness, the glory of God and the creativity of His people. There was as yet little distinction between artist and artisan, and the painter or sculptor, like any other craftsman, worked and was sustained within a guild structure, completely outside the rudimentary structure of the feudal state. It took him through the grades of apprenticeship, journeying and mastery, and gave him not merely a recognized status within the community but also the assurance of an adequate living so long as he maintained the standards of the art. The support of the arts by the fraternities and guilds, which were the most characteristic social organizations of the period, declined after the Reformation; however, it survived in an attenuated form in Canada right up to the present century. It was in church construction and decoration commissioned by religious orders, fraternities and sororities that the visual arts

first appeared in Quebec. Some of the greatest Canadian artists were sustained in this way by the people of French-speaking parishes, including Ozias Leduc — arguably the first truly modern painter in Canada — who made his living by church decoration, and Paul-Émile Borduas, who was his assistant and pupil before he set out on the course of artistic nihilism that led to the famous black canvases of his final phase.

Parallel to the church-cum-guild strain of religious art that developed in the cities and monasteries of the Middle Ages ran a strain of aristocratic art sustained by the nobility and manifested largely in the epics of mediaeval chivalry like the *Chanson de Roland* and in the songs of the troubadours which expressed the stylized eroticism of the late mediaeval feudal courts, notably in Provence. As the arts became more individualized from the Italian quattrocento onward, with the concept of the artist as personality beginning to emerge and the master detaching himself from his guild context, the patronage of artists by individual noblemen and great ecclesiastical magnates became the custom. Merchant princes like Lorenzo de' Medici and condottieri like Sigismondo Malatesta (the patron of Piero della Francesca), monarchs like Henry VIII (the patron of Holbein) and Charles I (the patron of Van Dyck) are now remembered largely because of the artists they subsidized and protected.

This shift from the community support of the Middle Ages, when the artist was actually one of the guild or fraternity that sustained him and hence tended towards the anonymity of the mediaeval craftsman, to the patronage of the Renaissance and Baroque periods, led to the emergence of the artist as an individual — and in the persons of men like Michelangelo and Rubens almost as a hero — whose personal vision was recognized in contrast to the collective vision of the past; it was at this time that the idea of the artist as creator, which would have seemed blasphemous in the Middle Ages, first appeared.

But individualism and independence became combined with an insecurity bred of dependence on the caprices of a single — however enlightened — patron rather than on the support of a reliable if somewhat conservative community. There exists a harrowing letter from the great sixteenth-century humanist Erasmus to one of his friends, which shows the uncertainties that came to be endured by men whose independence drove

them out of the security of monastic establishments into reliance on the support of unreliable individuals in a situation where the infrastructure of the modern world of literature and the arts did not yet exist, even in rudimentary form.

So I entreat and implore you, dear Batt, if you have a single spark of your former affection for me, to give your most earnest consideration of saving me. With your agreeable, easy-going disposition, you can possibly believe that you have left me well off; however, I seem to be in a worse state of ruin than ever before, since X offers no bounty, my lady merely extends promises from day to day, and the bishop goes so far as to turn his back upon me, while the abbot bids me be of good hope. In the meantime, not a soul comes forward to give, save only X, whom I have already squeezed so dry, poor fellow, that he has not a penny more to give me. . . . At the same time, I have many thoughts to ponder: Where shall I flee, without a rag to my back? What if I fall ill? Granted that nothing of this kind happens, what will I be able to achieve in the literary field without access to books? What can I hope to do if I leave Paris? And, finally, what will be the use of literary productions if I have no recognized position to back them? Will monsters like the person I encountered at Saint-Omer be able to laugh at me, calling me a prater?

Erasmus stands at an important historical turning point, and we can read his letter two ways. He lived in an era when the corporate patronage of church and guild was coming to an end and a modern milieu of literature and the arts, with its publishing houses and art galleries and periodicals and, eventually, its arts councils spending money provided by governments, was still far in the future. Unless he had independent means like Sir Philip Sidney or a sinecure like Chaucer or the support of some magnate, the writer was in danger of starvation. Yet Erasmus's letter is by no means archaic in the anxieties it projects. One can imagine a Canadian counterpart being written in 1985 by some woebegone writer turned down for a grant, with individuals replaced by institutions, with an impoverished independent publishing house taking the place of squeezed-dry X, and the CBC, the Canada Council and one or two provincial arts councils

assuming the roles of "my lady," the bishop and the abbot. Perhaps nowhere do contemporary artists any longer endure the acute humiliations that Erasmus suffered in grovelling to private patrons, but there are still some who have unwisely become so dependent on public grants that they are vulnerable to any shift in the economic or political wind that makes the government decide to trim its cultural programs.

During the eighteenth century the spread of the middle class and the broader distribution of wealth gradually replaced patrons with customers. Through publishing, either by subscription like Alexander Pope or with the help of glorified booksellers like Jacob Tonson who began to take risks on printing books at their cost, writers began to gain an independence from individual benefactors. The artist's studio emerged as not merely a place for work but also a place for viewing and buying, and the first art dealers appeared. We gain a good idea of the shift in relations by comparing the panic-stricken anxiety of Erasmus's letter with the reproachful independence of the more famous missive that Samuel Johnson wrote in 1755 to Lord Chesterfield, who came too late to offer assistance with the work on the great *Dictionary of the English Language*. It still merits quotation for the benefit of those who ponder the advantages and disadvantages of patronage of any kind.

Seven years, My Lord, have now passed since I waited in your outward rooms or was repulsed from your door, during which time I have been pushing on my work through difficulties of which it is useless to complain and have brought it at last to the verge of publication without one act of assistance, one word of encouragement or one smile of favour. Such treatment I did not expect, for I never had a patron before.

The shepherd in Virgil grew at last acquainted with Love, and found him a native of the rocks. Is not a patron, My Lord, one who looks with unconcern on a man struggling for life in the water and, when he has reached ground, encumbers him with help? The notice which you have been pleased to take of my labours, had it been early, had been kind; but it has been delayed till I am indifferent and cannot enjoy it, till I am solitary and cannot impart it, till I am known and do not want it.

Johnson's letter, it has been said, marked the end of the age of patronage, which is not quite true. But it does show that a time had come when there were means other than patronage that enabled an artist to survive, and that a writer who had become well enough known and who was engaged on a work that seemed of public usefulness or appealed to public taste could live without the support of magnates and — in the individualist world of emerging capitalism — could raise a support within the community that was far less structured than that offered to his predecessors in the various arts by the mediaeval guilds and fraternities.

The difference between Erasmus's day and Sam Johnson's day and our own is of course that the state — which in its modern form did not even exist when they lived — is now deeply involved in the arts, in democratic just as much as in totalitarian regimes. The shift began a mere five years after Johnson's death, as a result of the French Revolution. The Bourbon kings, and especially Louis XIV, had patronized artists in the old feudal way for their own personal or dynastic glorification. Otherwise their interference in the arts had been negative, censoring content rather than form, though not doing that very successfully: Beaumarchais managed to get his radically oriented play, *Le Mariage de Figaro*, produced in 1784, the year of Johnson's death, largely because he had the personal backing of the Queen, Marie Antoinette. But during the period of Jacobin ascendancy between 1792 and 1794 the Robespierrian Committee of Public Safety turned its ominous attention to the artists. It not only encouraged them to produce works that would glorify the Revolution, of which the most celebrated surviving examples are the vast sycophantic canvases of Jacques-Louis David, but also deliberately promoted a neoclassical style which became official and from which artists would deviate at their peril. David survived the downfall of Robespierre to put his grandiose talents at the service of the dictator Napoleon, and art was now used for the glorification of the Empire; but the idea of fostering an official style dissolved in the general atmosphere of imperial eclecticism that was evident in the gathering into the Louvre of artistic masterpieces from all ages and places, in all manners and styles. Art at this stage was used mainly as an ornament rather than as an instrument of the state. The dictator,

in the person of Napoleon, was still a manifestation of heroic individuality, as Alexander had been two millennia before, rather than a personification of the totalitarian will embodied in the ruling party, as Hitler and Stalin, in anticipation of Big Brother, both became.

The defeat of Napoleon and the end of the revolutionary-imperialist phase of French political life resulted not only in a retreat from Robespierre's proto-totalitarian concept of the state as a projection of the popular will but also in a temporary abandonment of the preoccupation with art as both a manifestation and an instrument of power. In general, during the nineteenth century, the prevalent economic doctrines of laissez-faire "liberalism" led to the state avoiding involvement in the arts, whose value bourgeois philistinism in any cases tended to depreciate. Lord Melbourne expressed the common attitude of political leaders when he remarked, on the occasion of the painter Benjamin Robert Haydon's suggestion that he set up a fund to assist painters, "God help the Minister who meddles in art." Art, like industry, was allowed to drift with the market, with the result that some writers and artists, like Trollope and Arnold Bennett, like Lord Leighton and Picasso, became rich on their earnings, as did their publishers and dealers, and others, like Vincent Van Gogh and the novelist George Gissing and the poet Francis Thompson, lived in poverty and died in despair.

By the later nineteenth century patronage was replaced by accumulation; the noblesse oblige that might lead eighteenth-century princelings to insultingly patronize living artists like Mozart was replaced by the many-sided avarice of the industrial tycoons who collected as commodities the works of recognized artists, sometimes living but usually dead; such a tycoon — a Pierpont Morgan or an Andrew Mellon — used them to enhance his credit while alive and to preserve his memory through suitable bequests when he was dead. Receiving such legacies of art from the past was one of the few positive ways in which, during this period, the state remained active in the arts. It participated negatively through censorship of various kinds, indirectly in the democracies by means of obscenity and libel laws, and in autocratic countries like Tsarist Russia by an open supervision of all writings. Considering that, unlike the Russians, the democracies developed no specialized bureaucracy for carrying out censor-

ship, they showed themselves remarkably active in making life difficult for writers whose works are now regarded as literary classics, but were then prosecuted for being in one way or another too explicit in their discussion of sex: Flaubert's *Madame Bovary*, Baudelaire's *Fleurs du mal*, D. H. Lawrence's *Rainbow* and *Lady Chatterley's Lover*, James Joyce's *Ulysses*, Henry Miller's *Tropic of Cancer*. Shifts in social mores would eventually make all these books acceptable, at least outside fundamentalist circles, just as the erosion of religious certainties turned into innocuous pamphlets books that had formerly been condemned as heretical, as Voltaire's writings were in Quebec under the rule of the French kings.

It was the Russian censorship, developed under the Romanov autocrats from Ivan the Terrible onward, that had the most lasting and ironic consequences. It was a thoroughgoing censorship, embracing moral, religious and political criteria, and it offered lessons from which the totalitarian regimes that emerged after the collapse of the Tsarist regime in 1917 did not fail to profit.

The great Russian writers of the nineteenth and early twentieth centuries were mainly dissident in their political attitudes, and circumventing the censor was a preoccupation that largely shaped their works. Even conservative writers like Dostoevsky and Gogol in their own ways found much to criticize in the corruption of the regime, as *The Inspector General* and *The Devils* both show. In recognizing that if they criticized explicitly they would not even get their work into print, all writers learnt to do so obliquely, by allusions and inferences their readers would pick up, and often by the very forms they gave to their works. The strange discontinuities of Chekhov's plays were themselves a revolutionary device used by a writer who seemed politically uncommitted to show the feelings of alienation in Russian society. Turgenev's *Sportsman's Sketches* was a prime early example of principled evasiveness: an apparently innocuous book of tales about shooting trips in which the narrator describes the people he encounters in the countryside, demonstrating that Russian peasants are, in temper and intelligence, much like other men, and so undermining the main justifications for retaining the institution of serfdom.

Thus, by translating their convictions of the wrongness of the Tsarist system into the imaginative forms of fiction, poetry and

drama, the Russian writers offered a powerful body of implied criticism of the regime, a criticism that helped weaken public acceptance among educated people and thus prepared a situation in which change became possible. However much they might have rejected the consequences in terms of a new tyranny — which Dostoevsky for one foresaw with a great deal of accuracy — leading Russian writers like Tolstoy and Turgenev, Belinsky and Nekrasov, quite apart from declared revolutionaries like Maxim Gorky, must be regarded among the precursors of the revolution of 1917, even if not of the Bolshevik coup, the so-called October Revolution.

There is no doubt that the authoritarians who seized power in that coup had already learnt much from the role played by the arts during the Tsarist period. They recognized that artistic subversion is as much a matter of form as of content, and that it can often gain rather than lose effectiveness by obliquity. Early on they decided to control the arts with a double aim: to prevent oblique subversion of the kind we have just described, and to use the arts for their own propaganda purposes. In this respect, as in others, the new totalitarians showed themselves more efficient than the old autocrats. There was a surge of formal experimentation in the years immediately after 1917, by artists for whom revolution meant liberation on all levels, but by the mid-twenties the persecution of avant-garde trends was already underway, and party discipline was increasingly imposed on writers' and artists' organizations, while officially inspired trends like Proletcult and Socialist Realism put an end to experiment and imposed formal standards — the beginning of totalitarian art. Any kind of free association between artists was virtually brought to an end with the adoption by the Communist Party's Central Committee of a resolution "concerning the Reconstruction of Literary and Artistic Organizations." Poets like Yesenin and Mayakovsky had by this time been driven to suicide by the destruction of their hopes for a freely revolutionary art. From this time until the end of the Stalinist regime writers who did not conform were often done to death in the prisons of the secret police, as happened during the 1930s to the novelist Isaac Babel and the poet Osip Mandelstam, who were among the first real victims of the spirit of 1984. In more recent years, after the brief flurry of qualified artistic freedom under Khrushchev, it has

become more customary to subject dissenting writers to psychiatric treatment.

The other totalitarian realms of the interwar years, in Italy and Germany, followed the same course as Russia in their treatment of the arts. Formal experimentation became anathema, and modernist art of all kinds was persecuted in Germany as "degenerate" just as it was persecuted in Russia as "individualist." Public art in buildings and monuments celebrated the imperial ambitions of the regimes, and writers were ominously encouraged to project the prevalent ideologies; like Socialist Realism in Russia, the grandiosely patriotic styles favoured in Germany and Italy reverted to the worst kinds of nineteenth-century academicism, whose formal conservatism made it, for those whose aims were primarily propagandist, more neutral — and therefore more adaptable — than any kind of experimental art could be.

Political interest in the arts began to appear in democratic countries a little while after it had developed in the totalitarian nations. It was partly the result of crisis and partly of revolutions in communications. The Great Depression of the 1930s affected artists as deeply as people in other fields of life, and the first extensive effort in a modern democratic state to assist them occurred when the Roosevelt Administration in the United States established the Works Progress (later Work Projects) Administration. Mainly concerned with providing work and a basic income for people who had fallen out of regular employment, the WPA also took into its scope artists of various kinds who found it difficult to earn a living in the dislocated economy of the time, which had killed off the vestiges of private patronage. The tendency in the United States since the depression has been more in accordance with classic free-enterprise doctrine, for patronage of the arts has tended there to be concentrated in the private hands of philanthropic foundations established by industrial dynasties, of which the John Simon Guggenheim Memorial Foundation and the Rockefeller Foundation have perhaps been the most directly concerned with the support of artists.

Such programs as the WPA were the first practical signs of a new attitude to the role of the state as a factor in social as well as political life and as a substitute for the voluntary fraternities through which the community had operated in the past. Capitalist individualism — Adam Smith's laissez-faire — seemed to

have failed, and in place of the fraternities and guilds of pre-capitalist days the state began to take on the role of provider of aid for the needy. Its new role was most clearly expressed in the phrase *welfare state*, which became current in Britain during World War II and spread out from there. The welfare state is not itself totalitarian, but the structure it has created — through the registration of the population and, later, the computerization of personal records — has made it even more possible than in George Orwell's day to detect a tendency even within overtly free societies towards the totalitarian destination reached by the society he described in his novel *Nineteen Eighty-Four*. It is a tendency all the more alarming because up to now it has seemed to be irreversible. Recent public involvement in the arts is an aspect of this development that we must bear in mind as we go on to consider the contemporary relationship in Canada between the state and the arts.

The depression was not the only or indeed the first crisis that brought the state into the arts in Western countries. During World War I military authorities in both Britain and Canada employed "war artists" — some of them very distinguished painters — to make a record of the war fronts, and in World War II the same kind of program was devised, while writers were drawn into propaganda agencies like the British Ministry of Information and performing artists were engaged to entertain the armed forces on various fronts in the first large-scale program of state employment of artists in British and Canadian history.

In Britain between the wars the major move in the direction of involvement in the arts was in the area of communications. When radio came into being the governments of many countries decided that such a valuable medium of information and opinion, with its virtually unlimited facilities for propaganda, could not be allowed out of the hands of the state. Accordingly, the British Broadcasting Corporation was founded in 1927, with monopoly control over radio and later television, and even though independent television was allowed in 1952 and independent local radio stations in 1970, the major broadcasting channels remained in the control of a Crown corporation. Theoretically, the BBC had an arm's length relationship with the government and was free of direct ministerial control, but in practice, during World War II, it became a propaganda service

hardly distinguishable from the Ministry of Information; working in its studios, Orwell learnt a great deal about the systematic distortion of facts and events, and used this knowledge in his portrayal of the Ministry of Truth in *Nineteen Eighty-Four*.

As we shall see when I come to discuss Canadian state interventions in the arts, the CBC was originally largely modelled on the BBC, and, as we shall also see, the relation between the state and the artists in such situations is one of employment rather than patronage. More direct patronage first appeared in Britain during World War II, in endeavours quite distinct from the official use of artists for propaganda work or for entertainment of the troops. It grew out of the notion which began to emerge in this period, that a nation's arts are the most reliable signs of its real nature and that they can therefore be used as political tokens both internally and in relations with foreign countries. To support them, with an eye to the possibility of manipulating them, may well serve the wider interests of the state.

In a small way, and in terms of foreign relations, this was recognized in Britain by the founding in 1936 of the British Council to introduce British achievements abroad through exhibitions and lecture tours by writers and other artists. The British Council's patronage role was minimal, consisting of little more than paying artists' expenses on tours they might later turn to use in their work. Direct patronage began in 1945. Then the Committee for the Encouragement of Music and the Arts, which had been set up in 1940 to organize concerts, exhibitions and dramatic performances during the war (I remember its excellent lunch-time concerts at which one sat on the floor among the masterworks of the National Gallery and listened to the country's best musicians for a few pence), was transformed into the Arts Council of Great Britain and endowed with government funds to continue supporting the performing arts and eventually to make grants to individual artists. As the BBC was the model for the CBC, so the Arts Council of Great Britain would be the model for the Canada Council. Whether that fact is an example of lingering colonialism or merely of following a good and convenient precedent, I must leave those involved in the politics of artistic nationalism to settle among themselves.

Canadian culture was D'Arcy McGee, who recognized how a literature speaks for a nation, and in 1865 said: "Patriotism will increase in Canada as its history is read." But McGee's view was disregarded by early Canadian political leaders, whose inclination was to regard the arts as an aristocratic luxury and to leave their encouragement in the somewhat symbolic hands of the viceregal presence; kings, not parliament, had after all been the traditional patrons of artists. And so it was Queen Victoria's son-in-law, the Marquis of Lorne, who as Governor General founded the Royal Canadian Academy of Arts in 1880 (two years later he would found also the Royal Society of Canada) and made the paintings from its first exhibition the nucleus of a National Gallery for which the government of the day, obsessed with the more material national goal of building a railway from sea to sea, accepted unenthusiastic responsibility; for decades afterward the charge of the gallery was handed from department to department in Ottawa, until finally, in 1968, it found its place with other similar institutions under the aegis of a National Museums Commission. Although it is now more than a century old, the National Gallery, Canada's first venture in the arts, still does not have a permanent building to house its collections.

For many years the National Gallery, with its tiny acquisitions budget (as late as 1957 its *total* budget was only about $500,000), represented public patronage of the arts in Canada, buying paintings and sculptures parsimoniously for the nation. Otherwise, for many decades, it was left to voluntary organizations to provide encouragement for the arts in Canada, and they did so in symphony societies and little-theatre associations, in professional societies like the Ontario Society of Artists, founded in 1872, which supported an art school that in 1911 became the Ontario College of Art, and in local art galleries which might later gain municipal or even provincial or federal support, but owed their beginnings to groups of dedicated volunteers. Two of these voluntary organizations, the Contemporary Art Society founded in Montreal in 1939 largely through the efforts of the painter John Lyman, and the Federation of Canadian Artists, organized in 1941 on the initiative of André Bieler and Lawren Harris, played important roles in the development of a Canadian modernist movement in painting. Such voluntary efforts received, at least until the 1950s, very little encourage-

32

ment from the Canadian government. In its report, the Massey Commission laconically recorded:

> Voluntary societies do indeed receive federal aid — at present $791,504 is granted to some twenty-four different groups including $356,876 to Fairs and Exhibitions and $115,200 to Military Associations and Institutes. *Only five of these organizations, however, are concerned with cultural matters, and these five together receive $21,000.* [My italics.] If national interest in voluntary efforts in the arts, letters and sciences were expressed by existing grants of money from the Federal Government, Canada could scarcely be called a civilized nation.

This, let it be noted, was written as recently as 1951.

And if the Canadian government's contribution to voluntary organizations in the arts up to the middle of the present century amounted to a paltry $21,000 a year, its support of public institutions in the cultural field, considered in the broadest sense, was little more inspiring. Bernard Ostry, in *The Cultural Connection,* notes:

> In 1932 the Miers Markham Report of the Museums Association of Great Britain noted that, while the Canadian federal treasury did support the Public Archives, the Historic Sites and Monuments Board, the National Parks Board and the War Museum and other Canadian institutions of the kind, "less is spent on the whole group of 125 institutions than is spent upon one of the great museums of Great Britain, Germany or the United States."

Even less was devoted to the support of individual artists, though by purchases and by holding exhibitions that attracted attention to their works a few painters were given encouragement, notably — during Eric Brown's incumbency as director of the National Gallery — the Group of Seven and Emily Carr. It was also in the visual arts that the Canadian state first appeared as the employer rather than the patron of artists and, ironically, this was not through any culturally oriented agency, since none existed, but through the Department of National

Defence, on whose behalf during World War I Lord Beaver-brook commissioned painters, on a scale unrivalled in any other country, to document the conflict. F. H. Varley, A. Y. Jackson, David Milne and Wyndham Lewis were among the painters involved; their often very fine works are preserved, not in the National Gallery, but in the Canadian War Museum. In World War II the Department of National Defence again showed itself more astute and imaginative than other departments in recognizing the role of art as an influence on the national consciousness. Alex Colville, Jack Shadbolt, Bruno Bobak and Molly Lamb were among the artists drawn out of the ranks and encouraged to do what they could do best; in most cases the experience contributed to their artistic development. But these programs disappeared during peacetime, and the artists were left to make their way in a society where the demand for their work was still little developed.

There was one other direction in which, during World War I, the desire to develop effective propaganda media led the Canadian state to become involved in the arts. Film had not even been recognized as an art form in 1914, when the Department of Trade and Commerce established an Exhibits and Publicity Bureau which began to make publicity films. Eventually, in 1917, this became the Government Motion Picture Bureau. But only in 1939 was the artistic potential of film officially recognized with the establishment of the National Film Board (which shortly afterward took over the Motion Picture Bureau); in choosing John Grierson, one of the great pioneers of British documentary film, to direct the new board, the Canadian government recognized — without any explicit statement — the usefulness of artistic creativity in the political process.

A similar evolution of attitudes manifested itself in broadcasting. Like the film, and for that matter like the book, radio and television are not in themselves art forms. On the basic level all they offer is a means of transmitting information. It is the artist's intent that can transform these basically neutral means of communication into art, just as the intent of the politician or the publicist can turn them into propaganda.

The first approaches of the Canadian government to radio broadcasting were tentative. In 1924 Canadian National Railways, which was the publicly owned half of the Canadian rail-

way system, began broadcasting experimentally. It was the beginning of public broadcasting in Canada, and by 1927, in time for the Diamond Jubilee of Confederation, a coast-to-coast hookup was established. Meanwhile, in the absence of any kind of regulation, private stations were appearing and becoming affiliated to the American networks that were emerging during the mid-1920s, and already the enduring addiction of Canadian listeners to programs from south of the border was becoming evident. It was only in 1927 that the Radio Telegraph Act began the first tentative regulation of broadcasting in Canada through the establishment of the Federal Radio Commission. Many questions still remained to be settled. Was a public service other than that provided on a somewhat rudimentary scale by the Canadian National Railway needed? If so, who should pay for it? And how far should radio — whether publicly or privately operated — be directed to education and what might roughly be called the arts, and how far to entertainment?

To consider, if not to solve, these problems, a royal commission was established under Sir John Aird, the first of many such commissions that over the years have considered communications and the arts in Canada, and the nebulous areas that lie between them. In Canada, as in Britain where they originated, royal commissions and their reports occupy a special position in the relationship between the state and society. Political considerations will persuade an incumbent government that a situation is urgent and needs solution, yet is beyond the competence of administrative action, and will not be solved by hastily conceived legislation. The royal commission is set up to gather information of use to the government, and to this extent it is a political instrument of the ruling administration, which can gain from it not only information but precious time as well, since while the commission is in session action can be deferred. But once established, a royal commission exerts an independence of action and investigation resembling that of the judiciary, and its enquiries, if they are well conducted, not only discover relevant facts but also ascertain the views of various sections of the community and, if the commissioners are astute, dedicated and patient, encourage those who speak from among the people to think over the issues involved and to form independent opinions.

Thus, by the very nature of its genesis, no royal commission can be without its political aspects. The Aird Commission took the view that broadcasting should become a public service aimed at encouraging the sense of a separate Canadian identity: "Canadian listeners want Canadian broadcasting," it asserted with somewhat excessive confidence. A public broadcasting service should be created with the aim of bringing together Canadians from all regions and local cultures. The great anxiety over national unity was already upon us.

But how the recommendations of the Aird Commission were to be implemented was in doubt for a considerable period, and the courts debated on whether, under the British North America Act, the federal government really did have exclusive jurisdiction over broadcasting. The Aird Commission, while recommending that broadcasting should become a public service, had also included the suggestion that each province should have control over the programs to be heard within its boundaries. The Radio Telegraph Act of 1927 had made no provision for provincial control, and on the strength of the recommendations of the Aird Commission, a number of provinces, led by Quebec, opposed the legislation; Quebec, in view of its special linguistic and cultural identity, rightly believed that programs suited to its people could only be effectively organized within Quebec.

The debate went as far as the Judicial Committee of the Privy Council, which in 1932, rather surprisingly in view of its record as a defender of provincial rights, found by a majority of three to two in favour of the federal government's right to legislate in this area. The provinces have never been wholly reconciled to this decision, and have used their constitutionally guaranteed rights in the educational field to justify the establishment of local informational and cultural networks. But by and large the Canadian Radio Broadcasting Commission, which emerged from the new Broadcasting Act of 1932, was given responsibilities for adequate regional broadcasting which its centralized form never allowed it to fulfil. The commission, which had been dedicated to "the diffusion of national thought and ideals" (then as now largely undefined), was replaced in 1936 by the Canadian Broadcasting Corporation, which survives to this day in the same form of a Crown corporation theoretically free from direct political control and instructed to "develop a national broadcasting ser-

vice for all Canadians in both official languages which would be primarily Canadian in content and character."

Unlike the BBC, the CBC in its earlier days did not enjoy a monopoly of broadcasting; a typically Canadian compromise was reached, similar to those achieved in rail and air transport, by which a public agency operated side by side with a collection of privately owned stations and networks, all supervised by a series of federal regulatory bodies that culminated in the Canadian Radio-Television Commission, which was established in 1968. How far such an arrangement served the real interests of the Canadian community is hard to determine, since the private stations and networks have always done their best to evade — in order to use American programs — the regulations of bodies like the CRTC, which aimed at restricting the amount of foreign shows available through Canadian channels, while the CBC, which up to the mid-1960s made a serious effort to nurture local broadcasting that would draw on regional sources of material and inspiration, has during the past two decades carried out a growing centralization that has run counter to its mandate to represent all parts of the country. Only Quebec, whose separate language forced even the CBC to establish a distinct French-language service, has been able to evade this deliberately homogenizing tendency.

In none of the early documents relating to establishing a national broadcasting system was there much reference to radio as an instrument for cultural development or, what is nearer to the subject of this book, as an agency that in some way might foster the arts. The first aims under consideration seemed to be patriotism — how to build up and sustain the image of a nation — and power — how to apportion control over a medium of unparalleled efficacy in the dissemination of information or — if the needs of propaganda required it — misinformation.

Yet almost immediately the Canadian Broadcasting Corporation began to influence actively the situation of artists in Canada at a time — the 1930s and 1940s — when for any of the arts this was otherwise a barren land. It helped writers and actors and musicians (with visual artists to find a place when television arrived) to survive while in some way or another carrying on their arts, though it employed them to produce programs that fitted into its own plans rather than patronizing them to work in

37

their own ways. Original works were indeed commissioned in music (including opera), drama, fiction, criticism and that form so peculiarly associated with radio, the sound documentary. Out of such endeavours emerged a number of works that truly merited the label of art. This was especially the case with short stories, which seemed to face extinction as magazines and publishers ceased for a long period to print them, but were largely saved through the efforts of a single CBC producer, Robert Weaver, who systematically encouraged writers to give him stories that could be read over radio and which he then published in volume form. Weaver also devised programs devoted to reviewing the arts and helped to keep intelligent criticism alive at a time when it had no encouragement from the newspapers and when literary periodicals hardly existed. (That Weaver, outside his role as a CBC man, played the major role in founding one of Canada's leading literary journals, *Tamarack Review,* belongs to another part of this book.)

There are other ways in which the CBC came opportunely on the Canadian scene and carried out a vitally important holding operation so far as the performing arts were concerned. As well as giving commissions to composers (almost the only ones they got for a considerable period) and employing individual musicians, it established or kept alive orchestras of notable standard. The radio drama, on the other hand, was a more ambivalent form so far as the encouragement of the arts was concerned. It is true that it kept alive a kind of dramatic tradition when professional live theatre in Canada had almost died away. It gave employment to actors and producers, among whom, when a stage tradition did re-emerge in Canada, a corps of people trained in at least some of the dramatic techniques could be found. The amateur theatre movement, which even during the dead years of the 1930s and 1940s showed at times a considerable level of accomplishment in the Dominion Drama Festivals of that period, was stiffened by the presence of men and women who kept their crafts professionally alive thanks to the CBC's guarantee of at least modest employment, and who played their parts as producers and instructors as well as actors. It has been said with a great deal of justice that if it had not been for the CBC's having sustained dramatic traditions during the generation after it was founded, the most important Canadian theatri-

cal enterprise, the Stratford Shakespearean Festival, could hardly have got off to such an excellent start in 1952; for though the first director, Tyrone Guthrie, and the stars for many years came from Britain, the main casts consisted of actors trained in radio drama who for the first time in their lives were getting the chance to appear in stage plays where the standards of direction were international.

For writers — the creative artists so far as drama was involved — the benefits of radio plays were a good deal less evident than they were for performing artists. At a time when the possibilities of literary earnings were scanty, the kinds of fees — minute by present standards but generous in 1949 — which the CBC paid for dramatic scripts could contribute substantially to a freelance writer's income, and there were many Canadian men and women of letters, not primarily inclined towards drama as a form, who turned to it both as a relatively well paid literary occupation and as a means of reaching a wide audience when publishing in Canada was still rudimentary and the public reading circuit was not nearly so well developed as it was in later years.

In some ways resembling operatic libretti, which are rarely accepted as literary works of any significance, the texts of radio plays are so closely directed towards a special kind of evocation where even the words, though spoken, are never seen by the listener, that they are hardly transmissible into the literary form of a printed text, perhaps because the writer, the producer and the actor between them are creating nuances that depend on a special combination of words, voice and ear, and belong to a realm of heard images intractable to the reading eye. These limitations of the medium combine with bureaucratically controlled programming, which tends to see individual works fitting into planned formulae and series, to make radio drama an almost unpublishable genre.

About ten years ago it was estimated that there were four thousand radio plays in the archives of the CBC, which are in fact incomplete, so that probably in the period up to 1970 at least five thousand plays were put on the air, a formidable amount of writing. Yet roughly one hundred radio plays have actually achieved publication. The majority of radio plays are produced twice at most, surviving as scripts but unprinted and unplayed.

For the writer, whose ultimate success tends to be judged by publication, such a situation is frustrating.

In other words, the CBC has customarily paid writers to produce what suited its corporate needs; except in very limited areas like the short story, or in the case of producers who went against the system, it did not set out to encourage them to write according to their inclinations. The views of cultural bureaucrats in the Toronto headquarters of the organization on what the public might want became increasingly the criteria by which writers' tasks were shaped and their works judged. This situation gave a foretaste of what the writers' situation would be if they became in any real way pensioners of the state, and it resembled, on a more limited scale, the relationship between the writers and the state in totalitarian countries, where the writers survive in their occupation by following the party line and where the kind of disobedience that springs from original ways of thinking and feeling may well lead either to persecution or to starvation. In such circumstances writers who appear to be successful are indeed assured a living, but their talents are steadily suffocated.

Any writer who toes any line too long loses those sparks of inspiration and individuality which, in the realm of art, are the only justification for their efforts. In this respect there is little difference between the radio and television writer regularly employed by the CBC and the writer who joins the staff of a magazine and turns out articles on set subjects according to the house style, or the painter who finds a way into the art department of an advertising agency. To employ artists on narrowly directed tasks dictated by either political or commercial interests is one way of suffocating art. There are, of course, others, as we shall see often in the course of this book.

Employing writers and painters, musicians and actors, rather than finding means to offer them time to follow their own inspirations, was virtually the only way, until the 1940s, that the Canadian government — through the Ministry of National Defence or the National Film Board or the Canadian Broadcasting Corporation — became involved in the arts. The results were not wholly negative. On their temporary wartime assignments, a few painters produced memorable works. The best of the NFB films have been justly celebrated, though over the years the

board has been responsible for a vast and dense mass of pedestrian work that largely served political ends. A few good short stories, a handful of plays eventually worthy of publication, an occasional brilliant radio talk from the days when the CBC still seriously sought them, still survive as literary artifacts from the extraordinary efforts that were put out by writers on the corporation's behalf: for those five thousand mainly forgotten plays I have mentioned were paralleled by an equal number of unremembered documentaries, and even greater numbers of talks that were mostly lost upon the desert air, unless those who wrote them were eventually able to incorporate their leading ideas into what is still, pace McLuhan, the survival medium of print. But in general, the phase during which the state, following the good commercial tradition of getting value for money, employed artists who did the tasks it needed done, was also the phase that failed to give the artists the undirected leisure that is essential, in the most important phases of their lives, to keep their creative urges flowing.

*Chapter 4*

# THE ROLE OF THE MASSEY COMMISSION

T he characteristic Canadian symbiosis between private endeavour and public action came into evidence in the arts as well as in other fields, and the urgings of influential interest groups had, at the beginning, a considerable effect on government policy. The Canadian Broadcasting Corporation was eventually created largely in response to the promptings of the Canadian Radio League, which was founded in 1930 by Graham Spry and Alan Plaunt with the idea that only public control of broadcasting would ensure that this powerful agency was used to foster the sense of a Canadian identity with its own characteristic culture. Among the leading activists of the league was Brooke Claxton, who was later to play a major role in bringing the Canadian government more broadly into the field of support for the arts.

In a similar way, the crucial transition in government aid to artists from employment through bodies like the NFB and the CBC to real patronage, which would enable them to carry on their arts according to their own inclinations, was preluded by considerable activity on the part of organizations of artists or of friends of the arts. In 1941, largely under the inspiration of wartime activities in Britain and the work of the Council for the Encouragement of Music and the Arts in London, a conference called in Kingston by the Royal Canadian Academy led to the

foundation of the Federation of Canadian Artists, dedicated to the cause of gaining public support for artists and their activities. Three years afterward, foreseeing the impending end of the war and the problems of adaptation that would follow, the government set up the Special Committee on Reconstruction and Re-Establishment, known after its chairman as the Turgeon Committee. The Federation of Canadian Artists and other interest groups saw here their opportunity to get a public hearing and perhaps even the ear of a government about to undertake a major reassessment of public objectives.

As Bernard Ostry records in *The Cultural Connection,*

the result was the famous "March on Ottawa" (in fact most of the marchers came by bus from Toronto) by three different groups acting together. The first represented the Canadian Federation of Artists and the Royal Canadian Academy. The second was a consortium of four painting societies (Water Colour, Canadian Group, Graphic Arts, and Painter-Etchers and Engravers), the Royal Architectural Institute, the Canadian Society of Landscape Artists and Town Planners, the Sculptors' Society, the Canadian Authors' Association, the Dominion Drama Festival, the Canadian Guild of Potters, and a music committee headed by Sir Ernest MacMillan. The third group was a deputation of three reluctantly nominated members of the Toronto Arts and Letters Club. The brief was endorsed by the Société des écrivains canadiens.

The joint brief which this impressive group of organizations presented points to the facts not only that Canadian artists were starved of the opportunity and the time to fulfil their vocations but also that, because of the lack of facilities, there were enormous numbers of Canadians who had no chance to see original works of art, or to attend concerts or dramatic performances given by professional artists. A way had to be found for both needs to be met. The brief recommended a nonpolitical body, supported by the government, which would evolve and administer a comprehensive program of aid for both the performing and the creative arts. It also made subsidiary recommendations regarding copyright, community arts centres and the establishment of a national library. The Turgeon Committee was favour-

ably inclined towards the petitioning artists, and one of its rec-
ommendations was that either a department of cultural affairs or
some kind of nonpolitical board be established to organize pub-
lic aid to the arts.

The government did nothing in immediate response to the
Turgeon Committee's recommendation; in fact four years later
Mackenzie King would tell Jack Pickersgill that the idea of estab-
lishing a royal commission to look into support for the arts was
"ridiculous." But the artists' organizations were not willing to let
the matter sink into the mire of political inertia, and when a
group of them came together in 1949 to form the Canadian Arts
Council, one of its immediate actions was to send an appeal to
King proposing that the government set aside funds for the
encouragement of the arts, and that a national arts board be
established to administer them and to introduce the arts of Can-
ada abroad. Clearly what the group envisaged was a nonpoliti-
cal organization that would combine functions similar to those
of the Arts Council and the British Council in London.

If King was indifferent rather than hostile to the idea of gov-
ernment patronage for the arts, a number of his associates were
intent on action. These included Brooke Claxton, then minister
of national defence, Lester Pearson, who became minister of
external affairs in 1948, Vincent Massey, Canadian High Com-
missioner in the United Kingdom, and Jack Pickersgill, that nim-
ble Figaro of politics who at that time was serving in the Prime
Minister's Office, and who was to find Louis St. Laurent, after
King retired from politics in 1948, more receptive to the idea of a
royal commission on the arts.

The motives of the men involved are not, at this distance in
time, entirely clear. Perhaps Claxton, Pearson and Pickersgill
were mainly concerned with the role of the arts in national
image-making, an essentially political attitude that to this day
has given a perilous ambivalence to state programs in support
of the arts in Canada. It is certainly significant that when the
Royal Commission on National Development in the Arts, Let-
ters and Sciences was created in 1949, much of its time was
actually devoted to suggesting ways in which, without appear-
ing to encroach on the constitutional rights of the provinces in
the field of education, the federal government might mitigate
the funding crisis that was likely to develop after grants to

veteran students came to an end just when the costs of higher education were rising and its scope was broadening. It is likely that this was the preponderant factor so far as St. Laurent was concerned.

Indeed, only Vincent Massey among the group active in initiating moves that finally led to the appointment of a royal commission seems to have been concerned primarily with fostering the arts; he had already been actively engaged in promoting them in Toronto through the foundation of Hart House, and he had given a notable collection of pictures to the National Gallery in Ottawa. It seemed appropriate, therefore, that when the commission was appointed by order-in-council on 8 May 1949, Massey, who had recently given up his position as high commissioner in London, should be chosen as chairman. The other four members were Fr. Georges-Henri Lévesque, dean of Social Sciences at Laval University, Norman MacKenzie, president of the University of British Columbia, the historian Hilda Neatby, and Arthur Surveyer, a civil engineer. No creative or performing artist was appointed, nor were any persons whose occupations brought them into daily contact with the arts or letters, such as a librarian, an art gallery director or even a critic. The three academicians were not in disciplines that brought them directly into contact with the arts, and this appearance of disinterest was to give their final recommendations an added emphasis.

The commission's mandate gave little hint of the breadth its enquiries would eventually assume, or of its most important recommendations. The Privy Council noted it to be "desirable that the Canadian people should know as much as possible about their country, its history and traditions; and about their national life and common achievements," and remarked that it was "in the national interest to give encouragement to institutions which express national feeling, promote common understanding and add to the variety and richness of Canadian life, rural as well as urban." The commission was specifically requested to examine and make recommendations on policy in broadcasting; on a mixed group of agencies under the federal aegis, ranging from the National Film Board and the National Gallery to the Public Archives and the Library of Parliament; on Canadian relations with UNESCO, and — in the end its most important function — on the relations between Canadian gov-

45

ernmental agencies and various voluntary bodies operating in the cultural field, considered according to its narrower definition as the sum of artistic activities. Significantly — as the commissioners themselves pointed out — the word *culture* did not appear in the terms of reference, nor, outside the commission's title, were the arts mentioned. There was indeed little to indicate the proportions that the commission's task would eventually assume.

When the Massey Commission began its enquiries in the spring of 1949, there was no world of Canadian arts and letters of the kind that existed in European countries and the United States, or, for that matter, of the kind that has since developed in Canada. In the same spring, three weeks before the commission was appointed, I had arrived in Canada from England, and while its members were travelling and enquiring from one end of the country to the other, I was experiencing the situation from below, as it were: as a writer who had come from the busy and relatively thriving literary world of postwar London into what by comparison seemed the Barren Ground inhabited by Canadian writers.

The commission itself would talk in its report of the Canadian writer's loneliness, of his suffering from the fact "that he is not sufficiently recognized in our national life, that his work is not considered necessary to the life of the country, and it is this isolation which prevents his making his full contribution." But this was by no means the whole story. Any thriving world of the arts and of literature depends on the presence of a considerable core of professional artists, people who can dedicate their lives wholly to their vocations as writers, painters, musicians and so on, and this possibility, as I quickly found, existed at that time in Canada for a minority too slight to be noticeable. The Canadian Arts Council began the brief which it submitted to the commission in April 1950 with a stark statement of fact which every artist's experience at the time confirmed.

No novelist, poet, short story writer, historian, biographer, or other writer of non-technical books can make even a modestly comfortable living by selling his work in Canada.

No composer of music can live at all on what Canada pays him for his composition.

Apart from radio drama, no playwright, and only a few actors and producers, can live by working in the theatre in Canada.

Few painters or sculptors, outside the field of commercial art and teaching, can live by sale of their work in Canada.

My own experience reflected the situation evoked by that statement. In London I had — with royalties and advances on books and with a certain amount of literary journalism — been able to survive on the modest scale, somewhat better than the traditional garret, of a young writer who had just published his fourth book. In Canada I fell immediately into the well of poverty; for my first three years in the country my annual income from writing, most of it earned through my surviving contacts in London and New York, never reached more than $1,200 a year, and I was forced to supplement it by various kinds of ill-paid manual work, until in 1954 I finally found a temporary refuge in university teaching.

My situation was in no way exceptional. Many of the writers I encountered then earned their main income as professors, if they had the necessary degrees. The few who attempted to live on what they earned from practising their arts found it difficult to survive as full-time writers or painters. Unfortunately no statistics are available from that time on the average incomes of Canadian writers and painters from practising their arts, but their earnings must have been minute.

This situation was partly due to the lack of interest on the part of most Canadians, still barely out of the pioneer age, in art. But even more it was due to the lack of the kind of infrastructure which transforms a scattering of people working in virtual isolation into a really functioning artistic and literary world that reaches out to audiences both urban and rural and in all regions. In 1949 even the basic facilities for bringing the work of artists and writers to the attention of the public and providing them with modestly adequate incomes had hardly begun to appear. For instance, when I arrived that year there were three struggling literary magazines in the whole country — *Contemporary Verse,* which Alan Crawley edited in Victoria, John Sutherland's *Northern Review* in Montreal and *Fiddlehead* in Fredericton; none of these journals could afford to pay their writers. In

47

publishing the period is perhaps best represented by the Ryerson Chapbooks, those tiny paperbound volumes in which Lorne Pierce would occasionally encourage poets by publishing a maximum of sixteen pages of their verse. Most publishers kept going as agencies, distributing in Canada books issued by American and British houses. In 1969 Hugh MacLennan looked back to that period when he wrote an article entitled "Reflections on Two Decades" for the tenth anniversary issue of *Canadian Literature*. Of the writer-publisher situation in the 1940s, just before the Massey Commission began its hearings, MacLennan said:

> My novels had earned me a certain reputation, but the most successful ones had been published in the days when the Canadian book trade was almost entirely controlled in England and the Canadian mentality was so colonial that if a book were published only in Canada it was automatically regarded by our own reading public as insignificant.
>
> For the writer in those days such a state of affairs was almost fatal. If you signed with a Canadian publisher, you lost your essential rights abroad. If you signed with an American or English publisher, and your work was successful in the home market, the kind of contract you drew meant that your royalties in Canadian sales were minuscule.
>
> Any Canadian writer of my age knows all this by heart, and I believe Morley Callaghan has told the story more than once. I'll make my story as succinct as possible. My *Barometer Rising* sold 110,000 copies in all editions in the first two years in Canada and earned me barely $600. My *Two Solitudes* sold 68,000 in hard covers in Canada in approximately the same time and this Canadian sale netted me slightly less than $5,000. This was ruinous economics in a time when there was no Canada Council, when even the Governor General's Award was only a medal with no cheque attached.

And Hugh MacLennan was a best seller in Canadian terms. What other writers, whose novels might sell two or three thousand copies, earned in those days can easily be imagined.

In the performing arts the situation was illustrated by the fact that in 1950 there were just four symphony orchestras in Canada,

none providing full-time employment for their musicians; ballet companies and seasons of opera did not exist. As for professional drama, the Massey Commission found that "Canada is not deficient in theatrical talent, whether in writing for the stage, in producing or in acting; but this talent at present finds little encouragement and no outlet apart from the Canadian Broadcasting Corporation which provides at the moment the greatest and the almost unique stimulus to Canadian drama. The CBC drama, however, is an inadequate substitute for a living theatre." The revival of living drama in Canada did not begin until three years after the commission started its work, when, with a great deal of faith and courage in those days before the advent of the Canada Council, the burgesses of Stratford embarked in 1952 on their Shakespearean Festival.

Even the employment provided by the CBC to actors, musicians and writers assured in most cases only part of the money they needed to survive. When I reached the west coast in 1949, I was paid at the rate of $25 each for thirteen-minute talks over the regional radio network, and for the occasional talks I gave on the national network, $45 each. For the script of my first play to be accepted by the corporation, a half-hour comedy, I received $75. Other fees were in keeping. Only after the freelance actors and writers formed the union which eventually became ACTRA were reasonable fee scales eventually established, though even these did not guarantee regular employment; writers and actors were still left with the consciousness that they were spending the precious time they should be devoting to their real art on earning a partial living by working according to the demands of an impersonal corporation whose primary aim was not the fostering of true art.

As for the visual arts, their situation was hardly better. In 1949 the average budget which the National Gallery could devote to purchases of all kinds, of which the work of living Canadian artists was only a part, was a mere $32,000, and other public galleries were faced by similar limitations of scope. At the same time there existed only a rudimentary network of private galleries, and by no means did all of these attempt to sell the works of living painters. In Vancouver, for example, the first establishment devoted entirely to contemporary arts appeared in the mid-1950s, when Alvin Balkind and Abe Rogatnick founded the New

49

Design Gallery. I came to know many west coast artists shortly after I reached British Columbia in 1949. Except for Lawren Harris, who had abundant private means and in any case had already ceased to paint, all of them either taught or carried on work totally unrelated to their art.

What I saw in British Columbia was typical of the situation of the arts in Canada in 1949. It was a country still emerging from an age of practically minded pioneers; the arts were considered unnecessary luxuries in a life devoted to the conquest of a hostile land. At best, the current wisdom held, they might have a role in the city, which was remote from the primary industries by which Canada was sustained. But in the life of the great rural hinterland and the small towns and the mining and industrial centres, the arts had no real place. Those who set out to dedicate their lives to writing or painting, to music or any other of the arts, unless they bent their talents to commercial ends and earned enough money to buy acceptance, were considered oddities, to be tolerated perhaps, but hardly to be admired.

Yet a shift in attitude was beginning, as the Massey Commission discovered when it zigzagged ten thousand miles over the country, holding series of hearings in major towns and cities, eliciting almost five hundred briefs, hearing twelve hundred witnesses, and commissioning Canadians eminent in their fields to write critical studies of the conditions of the various arts and sciences.

The report that eventually emerged in 1951 was not only a document of great historic importance in the life of the arts in Canada but also, as I was reminded when I recently read that long out-of-print best seller, a considerable work in its own right. Time seemed to have given it a positively classic character; written with a literary flair one does not usually associate with royal commission reports, it showed genuine wisdom in its assessment of the great cultural lacks of Canada in the late 1940s, and the scanty resources that then existed to meet them. What impressed me perhaps more than anything else was the way the commission created its own bow wave of interest, not only looking into needs, but making people think of them, so that by the time of the report's publication the idea that the community had a responsibility towards its arts and artists was accepted without serious opposition.

50

I have often heard it said that Vincent Massey was an elitist, and that the report was an elitist document. And so, if you think in such barren terms, it probably was. But in the cultural desert of Canada at that time a group of men and women was needed who could act the elitist role and decide what seemed to be good for the arts and suggest that what was good for the arts was good for the country. One has, even, to admire the grudging courage that St. Laurent showed as a politician in first setting up a commission to enquire into what must then have seemed very much a minority area of interest and, having set it up, to implement so many of its recommendations.

The report included recommendations on broadcasting (which were quickly rendered out of date by the development of television) and some specific and practical suggestions that helped improve the efficiency of museums and archival institutions and led to the foundation of the National Library. It entered more deeply than the commission's terms of reference had anticipated into the problems of the humanities in an academic setting, and took advantage of its mandate of enquiring into voluntary associations to survey in depth the situation of the arts, that most voluntary of all worlds. It was the dual recognition of the plight of the humanities in an academic setting heavily oriented towards the sciences, and of the critical situation of the arts in Canada, that generated what in the eye of history has been the Massey Commission's most important recommendation — that which led to the foundation of the Canada Council.

What the Massey Commission did, if we give it credit for the long-term consequences of its recommendations, was create an entirely new situation for the arts in Canada, and to change, in ways not entirely anticipated (and not in every way good), the general attitude of Canadians towards the artist as creator and performer. The arts have since flourished and interest in them has increased in ways that few observers could have envisaged in the 1940s. This observation by no means implies that because of an eventual increase in public patronage there was more and better art, or that a royal commission was the only factor helping to precipitate the extraordinary upsurge of the arts in Canada during the 1950s and 1960s. At the same time it is obvious that there are interconnections flowing from political initiatives and political inhibitions that we cannot ignore if we are concerned

with the future of our cultural life. Official support can nourish the arts; it can also destroy them, depending on the attitude of the givers and, no less, the receivers.

The report of the Royal Commission on National Development in the Arts, Letters and Sciences is thus not only a document of great importance for revealing the state of the arts and the humanities in Canada a third of a century ago but also one of the basic statements on which, since that time, the relationship between the state and the arts in Canada has been established. Before the commission stirred the imagination of Canadians and showed their political leaders what was possible, that relationship had been no more than rudimentary. Afterward it became a growing element of Canadian life that even the financial austerities of economic crisis have not been able to eliminate completely.

*Chapter 5*

# THE SWEET FIRST SPRING OF THE CANADA COUNCIL

T he Massey Report was received with varying degrees of satisfaction and a little philistine dismay. Perhaps most enthusiastic were the emergent cultural nationalists, whose point of view was well represented in the grandiose phraseology of the historian A. R. M. Lower, writing in, of all surprising places, *The Canadian Banker:*

> The Report of the Commission is a classic document. The Canadian state now turns to the highest function of a state, building the spiritual structure (the word is not used in the religious sense) of a civilization, the material foundations of which it has already sturdily laid. If the builders can continue to be men and women of the calibre and vision of those who prepared this Report, the work will go forward to brilliant achivement in future ages.

I doubt if many of the artists who read the report with satisfaction and hope saw the matter in such highfalutin terms, mainly because they distrusted, as artists usually do, any approach that seemed to put them at the service of a political ideal. They hoped that, by revealing the problems of the arts and the difficulties of artists in a society excessively devoted to the pursuit of material security and financial gain, the report might lead

53

to means being found to bring their work to wider audiences and ease their personal economies so that they would have precious time in which to work.

The upsurge in the arts that characterized the later 1950s was already beginning to stir, and it ran parallel to a postwar economic resurgence which made Canadians look more confidently and more adventurously on the future than they had done at any time since the 1880s, when the building of the Canadian Pacific Railway symbolized the emergence of a pan-Canadian economy which, then also, was accompanied by modest but genuine upsurges in poetry and the visual arts, represented by the Confederation poets and by the rapid development of landscape painting under the beneficent eye of William Van Horne, the railway magnate who was the nearest thing, as a private patron of the arts, to a Canadian Medici.

The 1950s was indeed the kind of expansive decade for a generous and somewhat Quixotic report to stir response even outside the narrower circles of the arts, and there is no doubt that the success of the Arts Council in Britain encouraged not only the artists but also the politicians, who saw a lively artistic community as a national ornament, to continue hoping and to match their hopes with action.

There was, of course, an interval of almost six years between the submission of the Massey Commission's report and any substantial action towards implementing its principal recommendation. But a few straws floated in the wind — small initiatives which suggested that St. Laurent's government was looking more benevolently on the arts than previous administrations had done. One of them, which I remember well because I was a beneficiary, was the creation of an Overseas Fellowship program, administered by the Royal Society of Canada and supported by blocked funds — foreign debts which the Canadian government could only collect by spending the money within the debtor country's controlled currency area. These little-known fellowships were given to writers and painters who were willing to receive them in France and, I believe, Italy, and represented the first acknowledgement in Canada of the principle of public patronage applied to individual living artists, as distinct from repositories for works of art like the National Gallery.

54

I was among the last handful to receive an Overseas Fellowship, in 1957 on the eve of the foundation of the Canada Council, and by the time I sailed for France the council had come into being. It had been a slow process. When he became the first Canadian-born Governor General in 1952, Vincent Massey felt it would no longer be proper for him to interfere in Canadian public policies by continuing to advocate the implementation of the commission's recommendations, and so a powerful supporter was lost to the cause. However, the Liberals, like Claxton and Pickersgill, who had originally propelled St. Laurent into accepting the idea of a royal commission, were still intent on developing a cultural policy that would enhance national glory, and they had no intention of letting the Massey Report, like the reports of so many other royal commissions with excellent proposals, slip into oblivion. They recruited some powerful and strategically placed allies.

One of them was John Deutsch, the well-known economist who was then secretary to the Treasury Board. One morning in the summer of 1956 Jack Pickersgill was strolling to work in Ottawa when he ran into Deutsch. As they walked together Deutsch began to talk of the coincidence that two of Canada's wealthiest men, the multimillionaires Sir James Dunn and Isaak Walton Killam, had died within a short period of each other. The combined death duties on their estates would bring the government more than $100 million, and Deutsch remarked that it would be a shame to piddle it all away on day-to-day government expenses; something special should be done with it. Pickersgill listened with mounting excitement and on the spot — or so he claimed — was inspired with the idea that half of this splendid windfall should be used to tide the universities over their present crisis, and the rest should become an endowment to finance the Canada Council, which the Massey Commission had proposed in 1951.

The next recruit was Maurice Lamontagne, who was later to become secretary of state and responsible to Parliament for the Canada Council, but was then St. Laurent's economic adviser. (Lamontagne had been the student of Father Lévesque, the devoted Quebecois representative on the Massey Commission.) Deutsch told him of the conversation with Pickersgill, and one day in July 1956, when St. Laurent was at a loss for a subject on

which to address the National Conference of Canadian Universities in the following November, Lamontagne said to him, "Why don't you announce the Canada Council?" and told him of Deutsch's idea for using the duties from the Killam and Dunn estates. St. Laurent, who had already been approached by Pickersgill, consulted and finally persuaded a reluctant C. D. Howe, then minister of trade and commerce and Canada's virtual economic Tsar, and then told Lamontagne to prepare his November speech with the Canada Council in mind.

The speech was duly made; the cat was safely out of the bag. In the Speech from the Throne on 8 January 1957, the establishment of the Canada Council was first proposed to Parliament, and shortly afterward St. Laurent himself introduced the bill establishing it, and in doing so laid down a principle that, despite the manoeuvres of later Liberal politicians, has mainly guided the council's actions, though lately with dwindling confidence. "Government should, I feel, support the cultural development of the nation, but not attempt to control it."

The council, formalized when royal assent was given to the Canada Council Act on 28 March 1957, was established to "foster and promote the study and enjoyment of, and the production of works in the arts, humanities and social sciences," and a measure of independence was guaranteed. The council was to set its own policies and make its own decisions within the terms of the act, reporting to Parliament through an appropriate minister (at one time the secretary of state and later the minister of communications). Its relation to the government, nobody doubted at the time, was to be an arm's length one, with little political supervision and no political demands. And for the first few years, while the council operated on the income from the endowment of $53 million that remained to it after half the taxes from the Dunn and Killam estates had been given as capital grants to the universities, the means of exerting political pressure did not exist. The council, in its annual report for 1963, was able to point to the difference between the creation of a Ministry of Fine Arts, which would have brought the ascendancy of cultural politics over the world of the arts, and the creation of its own very different organization: "By providing the necessary funds from the public purse, Parliament made every Canadian taxpayer his own de Medici. But, because the Council was

allowed under the act almost complete autonomy, state control of the arts was avoided." The situation would shortly change.

The history of the Canada Council has been one of finding its way through a changing artistic situation, which has involved over the decades a moving away from imperial models, and a need to cope with the kinds of pressures, often indirectly applied but not for that reason any less irksome, that emerge when politicians confuse art with politics and talk of the democratization of culture, or when bureaucrats attempt to impose on the arts the attitudes of the marketplace and to treat the arts as "cultural industries."

Such threats were still in the future when the Canada Council came into being, with the Arts Council of Great Britain as its principal model and the influence of British immigrants and visitors strongly evident. In an article he wrote in *Saturday Night* on the council's quarter-centenary, Robert Fulford elaborated on this phenomenon, which has always been a matter of annoyance to our more extreme cultural nationalists.

The culture of English-speaking Canada from the Second World War until around 1970 fell into a pattern that became clear only in retrospect: domination by a small group of talented British immigrants or visitors. During those years Canadians worried publicly about undue American influence on Canada, and with good reason; but it was the British who built our institutions and shaped the framework within which the English-Canadian culture now operates. Americans weren't interested in coming here (they had their own culture to build) and Canadians lacked both experience and confidence. The British, in the empire-building tradition, arrived on our shores with a sure knowledge of what could and should be done in a young country. They brought with them the British rules, and then improvised as they went along. John Grierson at the National Film Board, Celia Franca and Betty Oliphant at the National Ballet and the National Ballet School, Tyrone Guthrie and Michael Langham and Tanya Moiseiwitsch at the Stratford Festival, Gweneth Lloyd at the Royal Winnipeg Ballet — the list is long and impressive. Even those native Canadians who played central roles in this period — Alan Jarvis, who directed the National Gallery with flair and imagination from 1955 to

1959, George Woodcock, who founded *Canadian Literature* magazine in 1959 and provided the basis for academic study of fiction and poetry in this country; and Massey himself — were educated in England and formed by British models.

One of these British immigrants was the former intelligence agent Peter Dwyer. During World War II, the British secret service absorbed a great many literary intelligentsia, including Graham Greene and Malcolm Muggeridge; Dwyer, whose great intelligence feat was probably the unmasking of the atom bomb spy Klaus Fuchs, was of their kind. If he did not rival the literary successes of his more famous colleagues, he was a reasonably good amateur playwright and was reputed to have a prodigious knowledge of opera. Dwyer's early links with the Canadian government were an extension of his intelligence activity, for he held security-related positions at the National Research Council and in the Privy Council Office. It was only when he joined the Canada Council as supervisor of the arts program that Dwyer moved finally out of his spy master's role and devoted himself entirely to the arts.

The first chairman of the Canada Council was, appropriately, Brooke Claxton, who had done so much to bring it into being; the first director was A. W. Trueman. Claxton set an excellent precedent in assuming that the administration of the council's affairs was best left to its staff, and adopting the role of defender and spokesman rather than supervisor. Trueman, as an academic, was mainly interested in help to the humanities and social sciences, and Dwyer was left to shape the arts side of the council's work as best his excellent taste and organizational tact allowed him.

It was Dwyer who, by setting up juries, brought the artists of the country directly into the operations of the council. The juries consisted of writers and painters and musicians rather than of civil servants. As well, Dwyer made and maintained wide circles of acquaintances in the artistic community, so that he was always well aware of trends and currents in the arts. He travelled throughout the country, inviting artists to meet him, and developed personal contacts that gave one's relations with the council a directness and a warmth that have long vanished in the process of growing bureaucratization. Old Canada Council

hands, meeting and remembering the days when Dwyer extended his control by becoming associate director in 1965 and director in 1969, are likely to go nostalgic and say: "Things were better in Peter's day!" He was a true friend to the arts and to artists, and one remembers him as such with a great deal of regret. The council lost its human face when Dwyer departed.

But Dwyer of course controlled a much less complex organization than the council has since become. In his last effective year, 1970–71 (he retired in November 1971 and died in 1972), the council's budget for the arts was just over $10 million; ten years later it had increased to almost $44 million. And, in retrospect, Dwyer's style of administration was not without its defects, for it was marked by a very European tendency to consider artistic institutions, rather than individual creative artists, more appropriate objects of public patronage. Theatres, orchestras, operas, ballet companies and art galleries were subsidized so generously that in Dwyer's last year of office two ballet companies — the National Ballet and the Royal Winnipeg Ballet — received more between them than the entire writing budget, which included not only grants to individual writers but also to publishers, while three art galleries between them consumed more than a quarter of a visual arts budget that included films and photography.

This tendency — encouraged by the greater public interest and support that institutions can generate, and their greater aggressiveness in lobbying — continued after Dwyer's departure, so that a decade later, in 1980–81, less than 12 per cent of the total Canada Council budget (about $5 million out of $44 million) was spent on grants to individual creators. The writing and publication budget had indeed increased tenfold, to more than $7 million, but most of that was spent on recently instituted subsidies to publishers, and only $878,000 was being used to buy writers time to devote themselves to the works they felt were important.

Not that more grants to individual writers would necessarily be the best way of helping them; in countries where writers become virtual pensioners of the state, lack of economic anxiety does not itself produce better or even more work, and the perils of excessive dependence are obvious; the element of venture should never be lost. Later I shall discuss the practical alternatives, but at this point, in assessing what public aid has been

59

given to the arts in Canada, it is important to notice the tendency to give more generously to the institutions that have a cultural-political as well as an artistic role. National pride is involved in icons like prestigious theatres and orchestras and great art galleries in a way that it is rarely involved in the work of individual creators while they are alive.

Another feature of the Dwyer era that had lasting and not entirely beneficial consequences for the arts in Canada was the council's increasing dependence on Parliament for grants and hence its growing vulnerability to the cultural policies of the government of the day. Just as a new road creates its own increasing flow of traffic, so the council — appearing at a time of growing activity in the arts — stimulated the rapidly escalating demands that were made on its funds. Until 1965 these were restricted to about $1.5 million a year out of the interest on the endowment fund of $53 million, the remainder going to support the humanities and social sciences.

By 1965 it was evident that the Canada Council's endowment alone could no longer adequately support the increasing needs of the artistic community. By this time the Pearson government had taken a considerable step in the direction of a Ministry of Culture by transforming the portfolio of the Secretary of State. This department had originally been set up at the time of Confederation as a kind of bureau for conducting federal-provincial relations. It had found little use in such a role, but had continued as a relatively minor ministry supervising a few government activities that did not fit easily into other departments, such as the office of the Registrar General, the Patent Office, the Companies Branch and a section, directly under the Secretary of State, dealing with matters of protocol. Jack Pickersgill, one of the original champions of the Canada Council, had been secretary of state since 1953, and in 1963 he presided over the beginning of a reconstruction of his department, which was continued after 1964 by his successor Maurice Lamontagne, to embrace a variety of agencies that might broadly be called cultural. Apart from the Canada Council, these included the Canadian Broadcasting Corporation, the National Film Board, the Board of Broadcast Governors (to be transformed in 1968 into the CRTC), the National Gallery, National Museum, National Library and Public Archives, and the Centennial Commission; in 1968 the

National Arts Centre in Ottawa was added, followed two years later by the short-lived Information Canada, incorporating, as long as it survived, the more durable Queen's Printer.

This expansion of the Secretary of State's responsibilities gave the Canada Council a supervising government department whose presence in the shadows threw into doubt the practical validity of the crucial clause of the Canada Council Act — that "the Council is not an Agent of Her Majesty"; it also provided the council with a strong voice in the Cabinet under Lamontagne, who had put the thought of it into St. Laurent's ear, and later under the energetic Judy LaMarsh. With Lamontagne's help, Jean Boucher, who had succeeded Trueman as director of the council, was able to obtain in 1965 a special grant of $10 million, intended to last for three years but in fact spent in two. In 1966 Boucher was back asking for more, and the Secretary of State obtained for the council extra funds for the year 1967–68 of almost $17 million, and at the same time gained agreement in principle to the proposal that the Canada Council should benefit from annual parliamentary grants.

Not all — or indeed most — of this money was to be spent on the arts. The Cabinet and Parliament had been persuaded with relative ease because of the need of the academic rather than the artistic community for funds at a time of uncertain provincial grants. As Frank Milligan, a former associate director of the council, remarks in *Love and Money: The Politics of Culture,* edited by David Helwig, for the next few years "the arts continued to float upwards to a state of relative affluence as an indirect consequence of the popular esteem enjoyed by science throughout this period." In 1967–68, out of a total of more than $20.7 million in grants and awards, just over $7.1 million went to the arts; in 1968–69, $8.8 million out of $26.5 million; in 1969–70, $9.5 million out of $29 million, and in 1970–71, $10.4 million out of $31.3 million. (All these figures are taken from the council's annual reports.) Those were the prosperous years of steady economic growth in Canada, when the parliamentary grant went up almost automatically from year to year. Eventually, in 1978, funding for scholars would be taken away from the Canada Council and moved to the newly created Social Sciences and Humanities Research Council, and the Canada Council would be able to spend on the arts the whole of its much larger income

61

— held at a fairly consistent but inflation-eroded level of between $41 million and $43 million annually during that and ensuing years, and eventually rising to $69 million in 1984–85.

Being brought under the aegis of the Secretary of State's Department (and later under the Department of Communications) and becoming dependent on parliamentary grants tended to limit the Canada Council's freedom in fact if not in theory. The thin edge of government interference in spending patterns was introduced with that first regular parliamentary grant in 1967–68. The money the council received each year from Parliament was termed an "Unconditional annual Government Grant," but in fact it subjected the council to the criticism, in parliamentary committees, of M. P.s who did not quite understand the arm's length relationship and regarded the council as a government agency like any other, while the Treasury Board bureaucrats insisted on apportioning beforehand the amounts the council could spend respectively on the arts and on the humanities and social sciences.

It was not, however, until the Trudeau years, beginning in the early 1970s, that interference in the funding of the arts and of related activities like publishing began to appear in a variety of ways, all reflecting the centralism essential to the philosophy of Trudeau and his Quebecois associates, particularly Gérard Pelletier. At the end of the first era of the Canada Council, the formative Dwyer era, they were no more than a cloud on the horizon.

# THE UPSURGE
# OF THE
# ARTS

D uring the early years of the Canada Council the revival of the arts and the emergence of public support seemed to parallel each other with little sign of trouble ahead. Among its comparatively few sensible utterances, the Federal Cultural Policy Review Committee (less reverently known as the Applebert Committee after its co-chairmen Louis Applebaum and Jacques Hébert) remarked in its 1983 report that some features of the Massey Commission's report "did much to alter the cultural landscape of Canada," but it also cautioned that "the cultural growth of the period since 1951 ... might well have taken place spontaneously, with or without the encouragement of formal policy recommendations."

The relationship between an artistic movement and patronage is always ambiguous. When there are great artistic movements, we tend to notice the circumstances that favour them and the individuals who seem intent on furthering them. But when art seems uninspired, we do not notice the patrons who are probably doing their best to foster the fashionable dullards. We remember Mozart's patrons, even the one who kicked his bottom, while we forget Salieri's. We forgive Sigismondo Malatesta his appalling record as a condottiere because he was astute enough to recognize and lucky enough to patronize that serenely magnificent painting master, Piero della Francesca.

But would Mozart or Piero have been any less if either had been forced to make shift in ways other than those offered by even the best of their patrons? Or were their works any better in quality because of the patronage? We can answer such questions by remembering all those Italian and German princelings who from the fifteenth to the early nineteenth century kept their courts filled with tame artists and, for all their generosity, did not feed a single poet or musician or painter who would be remembered after their lifetimes or his own.

Patronage cannot make a silk purse out of the ear of even the most eloquently grunting sow. Yet there are times, great fortuitous occasions, when the patron, the artist and the circumstances for splendid work come together with striking synchronicity. Fortune took Domenikos Theotocopoulos, whom we call El Greco, to Spain at the very time of the counter-Reformation, when his disturbingly mannerist art would find ecclesiastical patrons in a culture dominated by the revival of ecstatic religion among saints as varied in their expressions of experience as Ignatius Loyola, John of the Cross and Theresa. Which was the more important — the yet unproven talent that El Greco took with him from Rome to Toledo or the favourable atmosphere in which it flourished? The Mexican Revolution coincided with the emergence of a modernist trend in that country's painting; on the walls of the secularized monasteries Rivera and Orozco could develop their great murals. But both these painters were already committed to formal revolutionism of an expressionist kind before events gave them a cause to channel their energies and the right physical circumstances to work on the scale their painterly ambitions demanded. How much can we attribute the glories of the Sistine Chapel to the urgings of that most impatient employer-patron, Pope Julius II, and how much to Michelangelo's spontaneous creativity, then at its grandiose height?

The fact is that patronage in itself never creates an upsurge in the arts or inspires any artists in the sense of stimulating them to achievements beyond their evident powers. In the absence of vitality and originality among the recipients, patronage is no more than a meal ticket for mediocrity. But when the vitality and the originality are in fact there, patronage does indeed have an important facilitating role.

This, I suggest, was to become the role of the Canada Council during its best period, from 1966, when modestly generous funding became available, to 1977, when the growing size of the organization led to bureaucratic ossification and the council's energies began to be sapped, as they have been ever since, by the need to defend its autonomy against political encroachments.

But the myth that the Canada Council in itself inspired the artistic flowering of the past quarter of a century or so is untenable. Indeed, the council itself has rarely attempted or claimed to play an initiatory role. It has held pretty consistently that private effort must get an institution off the ground, whether it is a theatre or an art gallery, a symphony, a literary magazine or a publishing firm. It is true that Robert Fulford in his 1982 *Saturday Night* article on the Canada Council quotes an initiative by Peter Dwyer which suggests the contrary:

> In 1961 he gave $500 in expense money to Leon Major, a young Toronto director, and Tom Patterson, founder of the Stratford Festival, with instructions to go to Halifax and find out whether a theatre could be founded. With Dwyer's persistent encouragement, they sold Halifax on the idea, and in 1963 the Neptune Theatre opened.

But such interventions were rare, and the council's policy has generally been to foster rather than to initiate. The principle is sound: the council was not established to attempt the impossible task of creating art, but to support artistic endeavours when they had taken on an identity and proved their seriousness. It is when that first stage in the natural selection of survivors has taken place that the council usually judges it proper to intervene.

By the time the Canada Council had enough money and practice to intervene decisively, the upsurge in the Canadian arts was already gaining impetus as it moved forward on many parallel paths. Some of the major institutions that have set the tone of the performing arts during the past quarter of a century were in fact started before the Canada Council appeared or in the early years before its assistance could be active; it is possible that their emergence, mainly after the Massey Commission set to

work, was one of the factors that helped persuade politicians to establish the council.

The theatrical movement that liberated drama from its long dependence on the Canadian Broadcasting Corporation began in the early 1950s with the foundation of Jean Gascon's Théâtre du Nouveau Monde in 1951 and the Stratford Shakespearean Festival in 1952; these were followed in 1958 by Gratien Gélinas's Théâtre de la Comédie-Canadienne and by the Manitoba Theatre Centre, the first major English-Canadian regional theatre. Canada's role as a centre of dance began in 1949 when the Royal Winnipeg Ballet went fully professional; the National Ballet of Canada was founded in 1951 by Celia Franca and the National Ballet School followed in 1959. The Opera Festival Company, which had gone fully professional in 1954, became the Canadian Opera Company in 1958 and in 1960 produced its first Canadian opera, Healey Willan's *Deirdre*.

Most of the major orchestras and public art galleries which the Canada Council would fund so generously in later years were already in existence in 1957. During the 1950s the orchestras had also moved into professionalism, and the exhibitions of the National Gallery under Alan Jarvis between 1954 and 1959 and of regional institutions like the Vancouver Art Gallery under Jerrold Morris in the mid-1950s were arousing popular consciousness of the arts and encouraging contemporary Canadian painters.

In the literary world as well the process of awakening preceded the era of intensive Canada Council activity. The *Tamarack Review*, the first major literary magazine to appear for many years, was founded by Robert Weaver and his associates in 1956, the year before the Canada Council's birth; in 1959 it was joined by *Canadian Literature* and *Prism*. The precursors of the great flood of small presses in the 1960s and 1970s appeared at this time, with Louis Dudek's Contact Press, which issued its first book in 1952, and Fred Cogswell's Fiddlehead Poetry Books, whose earliest title appeared in 1954. In 1957, Jack McClelland founded the New Canadian Library, edited by Malcolm Ross, which not only recognized that Canadian literature was at last mature enough to have classics, but began the process that continued at an accelerated pace during the 1960s — and by then with council help — of building a broad audience for contemporary Canadian writing.

We acknowledge the foresight and enterprise of these pioneers who began to build the infrastructure of a real literary and artistic world before it was evident that the Canada Council would ever have enough money to help them substantially. But they too were dependent on the presence of creating and performing artists, though of course a different kind of symbiosis links artistic institutions and creative artists from that which exists between artists and patrons. Patrons usually stand outside the arts they encourage and support, paradoxically drawn towards them as much by alienation as by affinity. But the people who create the institutions that form the infrastructure of a world of arts and letters are often artists themselves, or merge so intimately into the milieu that it is sometimes difficult to say where the making of a work of art ends and the presentation of it to the public begins.

Literary magazines are frequently founded and edited by groups of writers, and by reason of the aesthetic element that enters into creating a visually and intellectually pleasing journal, they often become collective artifacts in their own rights. This has been the case in Canadian poetry ever since the early modernist days in Montreal, when poets themselves founded and edited such journals as the *McGill Fortnightly Review, Preview* and *First Statement;* the precedent continues to this day. Similarly, the small avant-garde publishing houses that have played such a key role in recent Canadian literary life were often founded by writers who needed some avenue of publication other than the conservative trade houses who refused at first to publish their work.

One can similarly point to the experimental theatre companies where the roles of manager, producer and actor seem to be interchangeable. Indeed in all the arts one finds an interchange in roles between creative and performing artists. Composers are frequently also conductors; in Canada, where native compositions are still not performed as often as one might wish, composers must also be performing musicians so as to survive. Actors often become dramatists; Robertson Davies is perhaps the most notable Canadian example. Dancers become choreographers, as Anna Wyman has done with such distinction. Poets and even prose writers, who in the last three decades have been wandering on reading tours over the Canadian spaces like latter-

67

day troubadours, become their own performers and develop histrionic talents of a special kind. Painters, becoming their own print makers, shade off into areas of manufacture and distribution that puzzle revenue officials, and craftsmen like potters and weavers often become small-scale entrepreneurs, either individually or co-operatively setting up outlets to sell their own work and sometimes that of fellow craftsmen.

Such minglings of roles, of which there has been much evidence as a genuine world of the arts and letters has come into being in Canada during recent decades, are of great importance at times of an artistic upsurge, when one finds the facilities for disseminating art appearing because the people who create them are inspired by the same kind of zeitgeist as the artists themselves. A synchronization of functions emerges, so that when original artists of any kind appear, they do not go long without finding the means to present their works to the public, though recognition, as we shall later see, does not mean that the artist is adequately rewarded in material terms.

Into this pattern of multiple artistic activity the Canada Council entered. Its foundation was inspired partly by the instincts of politicians who saw the advantages of a cultural connection that might best be expressed by patronage of the arts. Partly, though, like the individual artists and the institutions to which they were variously linked, the council appeared in response to the zeitgeist, that strange restlessness which moved through the Western world during the 1960s. In Canada this restlessness was further fuelled by the nationalist fervours that were linked to the centennial celebrations, and achieved a bizarre blossoming in Expo 67 and its fleeting presentation of Canada as an unaccustomed world centre of the arts.

At this point we can observe the political and the aesthetic in their more ambiguous conjunctions. Only a few Canadian writers and painters were really fervent nationalists, though many were temporarily touched by the patriotic fevers of the time, and in retrospect nationalism and the new trends in the arts contributed comparatively little to each other. Indeed, apart from Dennis Lee's *Civil Elegies,* it is hard to think of any work out of this period that enhances the idea of the Canadian nation so impressively or influentially as Hugh MacLennan's *Barometer Rising* and *Two Solitudes* did a generation before. The

nationalism afloat in the 1960s was, however, indirectly inspirational so far as the arts were concerned. It led groups of writers incensed with branch-plant publishing into founding their own houses that were more responsive to new Canadian writers. It broke the strangle hold of New York abstract expressionism in painting and made Canadian painters a distinctive presence in the great international exhibitions like the Venice Biennale. It led to the emergence of a host of small theatres bent on producing plays by Canadian dramatists of which some, but by no means all, were dominated by themes from Canadian history. And, on a material level, it assured that the new parliamentary grants which the Canada Council began to receive in 1965 would continue to increase under the impetus of centennial sentiment until they began to level out as the national euphoria diminished and economic stringency set in during the latter part of the 1970s.

These remarks suggest the complexity, as a social and cultural phenomenon, of any kind of movement in the arts, since personal and collective, aesthetic and economic factors come together and each plays its role, but only in conjunction with the others. The upsurge in the Canadian arts, as I have shown, was already afoot when the Canada Council came into being, and was certainly well advanced by the time it had enough funds to intervene effectively. But once the council was in full operation, it responded to the needs of the situation in its own special ways, keeping alive theatres and magazines and musical groups that had come into existence independently and helping them expand in ways that fulfilled their inherent potential, giving artists the precious time away from noncreative occupations and often the means to travel that would enable them to complete major projects and to realize their goals more quickly. Thus the intervention of the council, and of other cultural agencies that later followed and supplemented it, undoubtedly facilitated an increase in the volume of artistic production, and — by saving many artists from the temptation to dilute their visions for commercial reasons — helped to sustain its quality.

In his conclusion to the second edition of the *Literary History of Canada* Northrop Frye referred to the "colossal verbal explosion that has taken place in Canada since 1960"; one could talk also of a visual explosion, of an explosion in dance and drama

and music. Frye also said that "a quantitative increase eventually makes for a qualitative increase," and it is beyond dispute that Canadian performers and creators have not only, from the mid-1960s onward, been producing immeasurably *more* works than emerged in this country when the Massey Commission began its hearings in 1949 but also, at their highest level, *better* works, showing an ever increasing variety of approach. Variety of approach of course is indicative of maturity in any artistic tradition, and one way of summing up the development I have just traced is to say that all the Canadian creative arts have reached maturity during the past quarter-century. They no longer appear to be derivative from other traditions.

When one remembers how similar was the development of an independent tradition a couple of generations earlier in the United States, it is hard to believe that in its broad outline the situation would have been greatly different in Canada today if the Canada Council and the parallel organizations we shall discuss in the next chapter had not come into being. There was more private patronage in the United States but more public patronage in Canada, and here the countries have faithfully followed their respective traditions. At the same time, remembering that the Montreal poetry movement between the 1920s and 1940s took place in hard economic times with no patronage outside what the poets could pull out of their own pockets, that Hugh MacLennan and Morley Callaghan and Ethel Wilson wrote their memorable novels — as Alex Colville and Jack Shadbolt developed their painting styles — before Canada Council assistance came into being, and that the Stratford Shakespearean Festival and similar performing arts enterprises started off through local voluntary efforts, it is obvious that a great movement in the arts was gathering impetus before the council appeared, and would have continued with or without patronage, generating its own flow of interest and — though doubtless on a less lavish scale — creating its own economic base.

But it is impossible to deny that the whole process has been made easier by the presence of an agency that so often provided funds when they were needed, so that fewer promising enterprises were aborted and more survived to play their due part, while many artists were enabled to carry out the projects that helped them make the once-difficult transition from the roles of

Sunday painter or writer to those of professionals devoting most of their time to their art.

Obviously we cannot confer on the Canada Council the rank of muse, for it was a complex of influences far less tangible than the granting of money, or even the provision of moral encouragement, that inspired the Canadian artistic flowering of the past generation. We can perhaps best regard it as a midwife, helping in the successful birth of a lean and hungry child — a child susceptible to the infant ailments of a young culture.

*Chapter 7*

# A PRIDE OF COMMISSIONS

T he federal government was actually not first in following the British example of giving public aid to artists and art organizations. Some of the provinces were ahead of it; these were in the west, where political unorthodoxy flourished. In 1946 the Social Credit government of Alberta established the Cultural Development Branch under the Provincial Secretary, which eventually became Alberta Culture and the most active organization of its kind in western Canada. And in 1949, the year the Massey Commission was appointed, the CCF government in Regina founded the Saskatchewan Arts Board, which over the years has given modest but constant assistance to individual artists and organizations, and which helped to foster the famous Emma Lake artists' workshop that played a notable role in the emergence of a distinctive prairie school of painting during the 1950s and 1960s.

But in 1951, when the report of the Massey Commission was published, these organizations were still in their infancy, and the Massey Commission became the main model for later public enquiries into the arts and related subjects, just as the Canada Council, rather than its smaller western predecessors, was the point from which the organization of public aid to the arts in Canada began.

Royal commissions — and the humbler investigative committees set up by Parliament and sometimes by government departments — are devices with many uses for governments. Commissions can undertake a more genuine investigation of problems that need more light thrown on them than the usual ministerial sources can, and they can also provide the excuse to delay decisions, leaving problems time to diminish and even to disappear. Canadian commissions and committees devoted to the arts and to wider cultural problems have tended to fulfil both functions, and their achievements can be matched by their failures. The findings of some vanished without trace into the oubliettes of Ottawa neglect. Most had some eventual effect. With two exceptions, one in Quebec and one in Ontario, the important and effective investigations were initiated by the federal government, anxious, after 1949, not to be overreached by the provinces.

The first of them was actually spawned by the Massey Commission itself, which found the question of broadcasting too intricate to investigate thoroughly and therefore recommended that a separate royal commission be set up. The Royal Commission on Broadcasting was established in 1955 under the chairmanship of Robert Fowler. It presented its report in 1957. Eventually, in the leisurely pace of the Diefenbaker-Pearson period, the Broadcasting Act was passed in 1958, removing from the CBC its power of regulating radio and the emergent medium of television and vesting it in a Board of Broadcast Governors.

Radio and television are not in themselves art forms. Despite Marshall McLuhan's famous half-truth, "The medium is the message," they are mainly neutral means of transmission, and they concern us here only insofar as they project the arts — literary and visual, dramatic and musical — to listeners and viewers and thus affect the work and the fortunes of the artists involved. Since it brought little change in programming, the Broadcasting Act in fact had less effect on relations between artists and the CBC than did the appearance of television, on which the CBC first embarked experimentally in 1952, with the full impact of the new medium coming later in that decade. The vast cost of television broadcasting meant that funds were diverted from radio without real compensation in terms of arts or drama programming for the loss

73

in money and employment to radio writers, actors and musicians, comparatively few of whom were absorbed into the television network. Canadian television's tendency to rely on American programs, or to imitate them in the futile hope of competing, became evident early on, except in its French network, where the difference in language offered a degree of protection.

Robert Fowler was called back in 1964 to head the more modest Advisory Committee on Broadcasting, one of whose mandates was to study the cultural obligations of public broadcasting, which had been recognized to a degree in CBC practice, but which even the Massey Commission had never studied in the context of the general Canadian cultural situation. However, it was less culture considered in the sense of the sum of the arts of life than culture in its political aspect as a manifestation of "national unity" that the Fowler Commission stressed when it proclaimed the "need for the broadcasting system to help establish a Canadian cultural identity, particularly in the face of American encroachments" and accused both the CBC and the independent broadcasting systems and stations of failing to interpret the French and English cultures of the country to each other.

Three years later, in 1968, when a new broadcasting act was passed, the cultural responsibilities of the CBC were emphasized and it was enjoined to give proper expression to the cultures and the characteristics of the Canadian regions. This mandate, under successive presidents, the CBC has consistently evaded fulfilling; indeed, since the later 1960s its functions have become steadily more centralized, and real regional broadcasting, which until 1967 preserved a genuine sensitivity to the variety in Canadian arts and literature, has become a receding memory. The new regulatory body, the Canadian Radio-Television Commission (CRTC), which under the 1968 act superseded the Board of Broadcast Governors, was to prove ineffective in its appointed task of seeing that the CBC carried out its cultural mandate; indeed it has turned most of its attention to matters far from the arts and letters, concentrating on such aspects of the industry as dividing the field among private interests in areas like cablevision and pay television. It has certainly done nothing to halt the steady politicization of public broadcasting in Canada.

Literature and the arts played a part in the hearings of another royal commission in the Diefenbaker-Pearson era. This was the Royal Commission on Publications, which sat under the chairmanship of Grattan O'Leary, and whose appointment in 1960 was inspired by the fear that whatever native journals existed in Canada at the time would die off if they were not in some way protected from the massive competition from American magazines that filled the news-store shelves. As a result of the commission's recommendations, taxation privileges regarding advertisement revenue were withdrawn from American magazines, though the process was not complete until fifteen years after the commission's appointment, when in 1976 *Time*'s special exemption from the legislation was withdrawn. The favourable position which was now enjoyed by Canadian periodicals certainly saved the principal mass circulation journals, and national magazines like *Maclean's* and *Saturday Night* weathered the financial difficulties they had experienced during the 1960s and 1970s.

The commission also paid special attention to literary and arts magazines. It concluded that "all these 'little' magazines, cultural publications, and literary and scholarly journals, are a part of our national heritage, reflecting something else than our concern with the market place, keeping alive among us the deeper, sweeter and more spiritual things of life. In the opinion of the Commission, their encouragement and preservation must not be put aside."

It is possible that these remarks by the O'Leary Commission influenced the decision of the Canada Council, shortly afterward, to assist by grants towards their expenses literary and artistic journals and, later, scholarly periodicals. The commission recommended another interesting approach to the problems of literary magazines, which was not that of making grants but of reducing their costs by giving free mailing privileges. The proposal was never implemented, but it contains a principle of negative aid that deserves to be recollected and revived.

Yet no attention was paid by the commission — nor has it later been paid by the Canada Council — to positive or negative aid to the kind of general-interest periodicals that are vital to a nation's intellectual life. The result has been that, while we now have many magazines of poetry and criticism whose flourishing con-

trasts remarkably with the precarious condition of their forebears in 1949, and also a number of large-circulation news and features magazines, we still have no journal similar to the *New Statesman* or the *Spectator* in Britain, or to the *New Republic* or the *Nation* in the United States, in which the arts are considered every week or fortnight in a general context of public affairs.

Two other federal enquiries have had a considerable bearing on the welfare of the arts; neither of them has so far led to much significant action. The first is the Disney Commission, almost forgotten until the artistic community led a dramatic series of protests against methods of taxation during the late autumn of 1983. The fact that the Canadian taxation system, with its tendency to treat people as either employees or manufacturers, had worsened the precarious economic situation of the artistic community became obvious to certain people in government circles as soon as the state, in the 1950s and early 1960s, became involved in the arts. While he was still secretary of state at the beginning of the 1970s, Gérard Pelletier set his staff to examine the effect the Income Tax Act was having on artists and to suggest improvements. Eventually, in 1977, it was decided to call on an expert tax accountant, and Russell Disney, a senior partner of Touche Ross, was commissioned to carry out an investigation and prepare a report.

Disney was not merely a good accountant; he also had a working knowledge of the condition of the arts in Canada, for he had spent ten years as treasurer of the Canadian Conference of the Arts. His *Federal Tax Issues of Concern to the Arts Community in Canada: An Analysis* is better known as the Disney Report. The gist of the report is that the artist's calling is such a precarious one, often involving many years of obscure apprenticeship before the artist earns a reasonable income, that it should — like the occupations of farmer and fisherman — be given a special status, particularly in relation to the writing-off of expenses, the employment status of performers, the tax treatment of donations of the artist's own work, and so on. Basically, by recommending that tax pressures on artists be relaxed, Disney, like the O'Leary Commission, was seeking to establish a negative kind of benefit that would leave artists more of the income from their actual work than the taxman would allow them under existing regulations.

The Disney Report was quietly submerged by bureaucratic process, described succinctly in the *Arts Bulletin* of the Canadian Conference of the Arts for September 1983:

When the Disney Report was completed, it was forwarded to Cabinet, which reviewed the report and referred it to an interdepartmental committee. The Interdepartmental Disney Report Review Committee was comprised of officials from the departments of the Secretary of State, Finance, Revenue Canada (Taxation, and Customs and Excise), Employment and Immigration and the Privy Council Office. A Department of Finance–Secretary of State sub-committee was also struck to deal with taxation issues separately. Both committees contemplated the recommendations of the report and discussed them to a standstill. The work of this committee was then subsumed into yet another interdepartmental committee with a larger mandate, and these deliberations similarly resulted in a stalemate as no consensus could be reached among the participating departments as to what recommendations should be made to Cabinet. The federal Cabinet is still waiting, then, for the advice it requested the interdepartmental committee to provide some six years ago on the recommendations contained in the Disney Report.

Something more than ordinary bureaucratic inertia seems involved here; one is justified in assuming deliberate stonewalling on the part of revenue and finance officials hostile to individuals who do not fit into their rigid official categories and perhaps fearful of the acts of the imagination.

When the Conservative party returned briefly to power in 1979, the new secretary of state, David MacDonald, was still responsible for relations between the federal government and the arts community. MacDonald felt, partly because of the stagnating attempts to implement the Disney Report, that the time had come for a reconsideration of the situation of the arts thirty years after the appointment of the Massey Commission. Before he could appoint a new investigatory body, however, the general election had thrown the Conservatives out of power, and it was Francis Fox, the incoming minister, who established not another royal commission but the Federal Policy Review Committee,

under the joint chairmanship of Louis Applebaum and Jacques Hébert. It was appointed in November 1980, and instead of the neat group of five people who had produced the Massey Report, Applebaum and Hébert presided over an unwieldy group of eighteen, which took twenty-eight months to formulate a report and spent $3 million doing so. Unlike the Massey Commission, it actually included creative artists — the painter Mary Pratt, the novelist Rudy Wiebe and the composer Louis Applebaum — but it also carried a heavy load of Liberal party hacks, and the report it eventually produced was not only less well written than the Massey Report, it was also — as I shall later show — less coherent and less constructive.

At least two provincial enquiries are worth mentioning, because both relate to Canadian publishing and to the fears for native literature and the welfare of Canadian writers that have been inspired by its vulnerability to foreign control. Shortly after the accession to power of Lesage's Liberal government in Quebec and the emergence of the so-called Quiet Revolution, the newly founded Department of Cultural Affairs commissioned an enquiry into the book trade in that province, and in 1964 its report — the Bouchard Report — was introduced into the Legislative Assembly. It is interesting as one of the first of a number of investigations which revealed the weakness of Canadian publishing even at a time when native publishing houses were proliferating and growing numbers of writers were seeking new outlets for their books. It was already common knowledge by 1964 that anglophone publishing of trade and textbooks alike was dominated by English and American publishers, partly through their branch houses and partly through the native publishers themselves, many of whom survived only by the business that came to them through acting as jobbers for their foreign counterparts. What had not been so well known until the Bouchard Report documented it was that, in the field of publishing, being a community of French-speakers in an anglophone subcontinent provided no real protection; 80 per cent of the books sold in Quebec stores were imported, mostly from France, and the native industry was small and fragmented. Although nothing immediately resulted from the Bouchard Report, it led eventually to a strengthening of the Quebecois publishing industry through subsidy and later through protection. During the later

1960s and the 1970s, this growth ran parallel to the literary renaissance in French Canada that, despite its strong roots in regional conditions, in fact sprang from very similar causes to those of the virtually contemporary burgeoning of anglophone literature in Canada.

The Ontario Royal Commission on Book Publishing was appointed in an atmosphere of crisis on 23 December 1970, after two well-known Canadian publishing houses — Gage Publishing Company, which was involved mostly in textbook publishing, and Ryerson Press, which had pioneered in issuing Canadian poetry and fiction — were bought up by American firms. The independence of other Canadian publishing houses seemed imperilled, while the small new independent houses founded in the late 1960s, like House of Anansi and New Press, were sailing in rough financial waters. The Government of Ontario, where the greater part of the Canadian publishing industry was and still is concentrated, felt a responsibility not only to its own province but also to the country as a whole to halt this alarming trend.

Hence the limits of provincial jurisdiction were stretched to their maximum elasticity. The three-man commission (consisting of lawyer and writer Richard Rohmer, publisher Marsh Jeanneret and the Tory king-maker Dalton Camp) was instructed to report on "the publishing industry in Ontario and throughout Canada," in terms of its business viability and "its contribution to the cultural life and education of the people of the province of Ontario and Canada." It was also asked to report on "the economic, cultural, social and other consequences to the people of Ontario and of Canada of the substantial ownership or control of publishing firms by foreign or foreign-owned or foreign-controlled corporations or by non-Canadians."

As the commission proceeded with its broad general enquiry, it also responded to the urgent situations that developed while it was still in session. Its First Interim Report, presented in March 1971, was inspired by the possibility that financial difficulties might drive McClelland & Stewart to sell out to American buyers; the loan recommended at this time effectively averted a takeover. The Second Interim Report, presented in June 1971, urged quick action to prevent, under provincial law, the domination of the sale of periodicals and paperbacks

79

in Canada by alien interests. The Third Interim Report, presented in August 1971, recommended the extension of the availability of loans to Canadian publishers other than McClelland & Stewart.

The final report of the Ontario Royal Commission on Book Publishing, presented on 1 December 1972, is a remarkably well presented document that rivals the Massey Report as a landmark in charting relations in Canada between the community and its artists. It follows the example of Britain and other European countries in recognizing that, while publishing fits uneasily into the usual pattern of creative and performing arts, it is just as necessary to writing as theatres are to drama, or galleries to the visual arts. Not all publishers, of course, are concerned with the arts, and publishing in general has always suffered from being regarded primarily as an industry, a viewpoint that still lingers among economy-minded bureaucrats and politicians dedicated to free enterprise. While the idea of public art galleries and of theatres subsidized by the state or by municipalities is part of Canada's European heritage, publishers have traditionally been expected to live by their profits, and the idea of subsidizing them (which becomes logical once one recognizes that literature has to be subsidized as much as the visual or performing arts) has been slow to penetrate the consciousness of politicians — though of course publishers themselves have long carried on a policy of modified patronage by letting the best sellers compensate for the losses on books that may bring prestige but do not have broad popular, commercial appeal.

It was the danger of virtually losing native publishing that the royal commission highlighted, and it made an impressive case not only in its report but also in the volume of background papers which accompanied it; these papers extended the commission's actual hearings by investigating relations between publishing and writing and by charting the literary resources that justified the encouragement and if necessary the financial support of a vigorous Canadian publishing industry. The commission made a crucial point, which bureaucrats involved in the arts have at times been inclined to forget in their passion for fiscal accountability, when it remarked that "the cultural implications of book publishing far outweigh the economic implications to society, whether the latter are measured in jobs or in the

cost of possible measures to preserve the industry. Thus although many of the problems that face Canadian book publishing may be economic, the issues to be weighed are cultural, and so will be the dividends that flow from sensible solutions."

Apart from the Massey Commission, no body investigating the infrastructure of arts and letters in Canada has had such influential results as the Ontario royal commission. Not only did it carry out an invaluable task of research into the liabilities and potentialities of publishing in Canada; it also, by the sense of urgency communicated through its interim reports, impressed upon other agencies the need to act quickly. Not only did the Province of Ontario devise a complicated pattern of aid to publishers by means of grants and loans, but for once federal bodies followed a provincial example: the Secretary of State supported a rapid increase of Canada Council grants to publishers, so that the council's spending in that area increased a hundredfold, from $60,000 in 1970, when the Ontario royal commission was appointed, to approximately $6 million ten years later. Other provinces, partly in a spirit of emulation and partly through a real sense of the need to sustain local literature and its infrastructure, followed Ontario's example in many ways.

The record of Canadian public commissions and committees on matters relating to the arts seems to offer one important lesson. Provided the funds are available, reports that suggest the solution of problems by wholly new initiatives usually catch the imagination of politicians and the public and lead to definite results that are clearly gains to arts and artists, such as the establishment of the Canada Council and the recognition that publishing is in fact a cultural service that needs and rewards financial support in the same way an opera house or an experimental theatre may do.

On the other hand, reports that seem to attack the interests and the set attitudes of entrenched officialdom, as the Disney Report offended the fiscal orthodoxy of Ottawa's financial mandarins, or as the Fowler Committee challenged the organizational machine of the CBC with its famous statement, "The only thing that really matters in broadcasting is programme content; all the rest is housekeeping," tend to produce few tangible results because they come up against the stone wall of bureaucratic solidarity. And this, given the tendency of even the best

## Chapter 8

# THE PROVINCES BECOME PATRONS

I t is not only in the combination of public subsidy with private enterprise, honoured ever since the foundation of the Canadian Pacific Railway, that official policy towards the arts over the past forty years has followed traditional Canadian patterns. It has also respected the division of federal and provincial powers, and has been largely shaped by the rivalries and compromises such a division creates.

Fortunately, at the time of Confederation, nobody thought to make the arts, under the British North America Act, an area reserved to either level of government. Apart from Thomas D'Arcy McGee and possibly Alexander Tilloch Galt, none of the Fathers of Confederation was interested in the arts, and as far as they thought of them it was probably — like Lord Melbourne — as a political danger zone; the nearest they came to showing a cultural concern was to grant to the provinces the responsibility for education. A little later, by letting itself be persuaded by Governor General Lorne into founding the National Gallery in 1880, Alexander Mackenzie's Liberal government established a precedent of federal involvement in the arts that nobody challenged because the commitment seemed so slight. But it did not attempt to create a precedent for exclusiveness, and during the following decades public galleries and museums were being founded indiscriminately by provincial govern-

ments and municipalities, by voluntary associations and even by private individuals.

It was in keeping with this tradition that, when the Canada Council was established, there was no suggestion that it might have a monopoly on public assistance in the arts. Yet at first, except for the still small pioneer efforts that already existed in Alberta and Saskatchewan, the provinces did not hasten into competition. Apart from a considerable suspicion among Quebec nationalists, the provinces regarded the council's activities with interest and even with a certain amount of self-interest, since the assistance it offered to the universities, with no political strings, provided considerable relief to strained local budgets.

But soon, after the first four or five years when the Canada Council held the field almost unchallenged, the provinces began to move seriously into the patronage of the arts. Their motives were various. Observing the council's success and its widening scope of activity, they saw a danger of the nurturing of the arts becoming dominated by the federal government's patronage. Once Quebec had entered the field in 1961, the other provinces were impelled to follow its lead. There was also a genuine feeling in most parts of the country of the need to protect and foster artistic activities that gave expression to a regional kind of awareness which, it was feared, might go unnoticed in the national viewpoint of the Canada Council. Further, it was recognized that the Canada Council, because of the limitations of its funding, would have to concentrate its grants mostly on professional artists and performing groups, in many cases leaving talented amateur individuals and companies without the means that might enable them to make the step into professionalism. Some provincial governments, with their generally more populist approach, were also perturbed by the Canada Council's inevitable neglect of the crafts as distinct from the arts, and some provinces — notably Saskatchewan — have set out to foster them, thus projecting a culturally democratic sense of the visual and tactile arts as not being limited to what can be put in a frame or set on a pedestal.

As the provinces developed their schemes for aiding the arts and letters, a variety of institutional approaches emerged, from politically dominated branches of government on the one hand,

84

to bodies drawn from the general public and as autonomous as the Canada Council on the other. There was also a great range of financial commitment, and a striking variety of views of the role of the artist in the community.

The Province of Ontario Arts Council was established in 1963; ten years later it became simply the Ontario Arts Council, continuing as an arm's length agency reporting to the Ministry of Culture and Recreation. Like the Canada Council, it makes grants to individual artists, to artists' organizations and to performing arts institutions like the Toronto Symphony Orchestra and the Stratford Festival as well as many lesser enterprises. It supports arts and literary magazines and publishers centred in Ontario, and also administers the program of loan guarantees for publishers in distress that was recommended by the Royal Commission on Book Publishing. In its early years the Ontario Arts Council, like the Canada Council, devoted a disproportionate amount of its grants to the performing arts, which in 1972–73 received two-thirds of the available funds while literature received a twentieth. But with the increased support for publishing since 1973 the proportion has radically changed. The council now feels its responsibilities to writers and publishers alike so strongly that when the publishing firm of Clarke Irwin went bankrupt in 1983, the Ontario Arts Council arranged to meet the unpaid royalties which the firm owed to writers in all parts of the country.

Ontario has shown a certain degree of business orientation in its granting, as shown in the Arts Council's Writers' Reserve program, by which a writer nominated by a publisher is given a grant towards the writing of a book, the idea being that publishers are the best judges of writing that deserves financial support. The danger of such an approach is that the publisher's criterion may well be sales potential rather than literary quality, but though there have undoubtedly been times when this was the case, the scheme seems to have worked well on the whole; the list of beneficiaries, after all, includes the names of many of Canada's best writers.

Ontario's efforts have also, as perhaps befits a province so long governed by Conservatives, tended to balance the Canada Council's stress on the large performing institutions with its own stress on those activities ancillary to the arts which are increasingly

described as cultural industries. In 1975 it actually set up a branch of the Ministry of Culture that was called Cultural Industries; its basic aim was summarized in the Orwellism uttered by its first director, David Spence: "The duality of commercial and creative viability." Publishers and film and record companies who have proved themselves with modest sales but have not become major enterprises (the eligible sales range runs between $150,000 and $625,000) are guaranteed loans and given interest subsidies. A whimsical and original aspect of the Ontario program of aid to literature has been the Half-Back scheme. Under this, holders of nonwinning Wintario lottery tickets are allowed discounts on Canadian magazine subscriptions and on paperbacks by Canadian authors, and both writers and publishers benefit.

None of the other English-speaking provinces can rival Ontario either in the amount of funds devoted to the arts (which by the late 1970s exceeded $14 million a year) or in the variety of means of assistance. Doubtless this is mainly because Ontario had the greater incentive as the main centre of Canadian publishing and broadcasting, with the highest proportion of art galleries and performing arts groups, and a consequent concentration of artists of all kinds attracted by the better career opportunities. Still, a number of the other provinces have elaborated programs which, taking into account their smaller populations and their lesser number of artists, are reasonably comparable, and which often have special characteristics of their own that add to the variety of means by which the arts are being assisted in Canada.

Alberta Culture has the longest record of all. The Cultural Development Branch from which it derives was founded in 1946 and since then, with less aid than might have been expected from oil revenues, a program has been built up which encourages more support to the arts from the private sector by matching in varying ratios all individual and corporate contributions to the arts.

The Saskatchewan Arts Board, apart from supporting the crafts as well as the conventionally conceived arts, has moved out in various directions through the grass roots. Among other things it gives fairly generous support to artists' and writers' organizations, subsidizes a script-reading service so that writers

86

can get professional advice on their books, provides funds for little nonprofit presses and encourages childrens' writers with a series of awards.

In 1965 Manitoba founded its own arts council, which, aside from supporting such prestigious local performing arts institutions as the Royal Winnipeg Ballet and the Manitoba Theatre Centre, has given encouragement to the fledgling local publishing industry, and runs modest programs for helping individual artists. As well, the Prince Edward Island Council of the Arts, founded in the 1970s, and the Newfoundland and Labrador Arts Council, established in 1980, are further autonomous bodies, using public funds on a very modest scale.

The two remaining anglophone provinces, British Columbia and Nova Scotia, and the sole bilingual one, New Brunswick, maintain politically dependent arts services run by local bureaucrats on a penurious scale. In Nova Scotia the Department of Culture, Recreation and Fitness balances the rival claims of athletes and artists for its sparing grants. In New Brunswick it is the Department of Youth, Recreation and Cultural Resources that makes the grants, with the help of advisory committees in the various arts.

The situation in British Coumbia is the most surprising. It is the third most populous province in Canada, containing the country's third largest metropolis, Vancouver. It provides a home for a remarkably high proportion of Canada's best writers, visual artists and architects. It has some of the country's finest theatres and dramatic companies; it has orchestras, an opera company, and dance groups of international standing.

Yet the regular provincial aid to the arts in British Columbia consists of a meagre Cultural Fund, established in 1967 and administered by the Department of Recreation and Conservation. Its budget, beginning at $600,000 and growing slowly, is a small fraction of the Ontario Arts Council's. Dominated by a particularly unimaginative parochialism, it makes grants to community arts councils and offers a few scholarships that are tenable in "recognized and advanced schools of specific cultural disciplines." But the fund's program makes no provision for individual artists, who in British Columbia have to rely on the Canada Council, and only recently, in a meagre way, has it given aid to the active group of publishers that has emerged lately on

the west coast. The fine British Columbian literary magazines, such as the *Malahat Review, Prism International, Canadian Literature* and *Room of One's Own,* have received no aid at all. It is true that in addition to the Cultural Fund the British Columbia government does occasionally make capital grants, as it did towards the new Vancouver Art Gallery, opened in 1983, but even in this instance the provincial contribution had to be supplemented by federal and municipal grants and by a vigorous fundraising campaign in Greater Vancouver, whose success raised one's hopes of finding ways to develop nongovernmental spending in support of the arts.

This parsimony of British Columbia's governments towards its writers and artists, so out of keeping with the vitality of west coast arts, was almost as evident under an NDP as under a Social Credit government. Perhaps it partly represents the pervasive Pacific redneck philistinism that, in B. C. as in California, stands in contrast to a high degree of artistic creativity. But it is also linked to a populism which, whether it finds a right-wing expression in Social Credit or a left-wing one in the NDP, has always tended in Canada to treat the arts with suspicion or at best with indifference. As Bernard Ostry remarks in *The Cultural Connection:*

> The absence of interest in cultural policy by the trade union movement in Canada and the political parties it has tried to influence from its earliest beginnings is particularly curious, given the fact that most of Canada's labour leaders have come from countries where both the trade unions and social movements have rarely failed to place considerable store by the cultural development of their members and indeed of the society in which they live.

Despite the reluctance of some of the provinces to emulate the federal government, the sum of provincial aid during the 1960s became — and has remained ever since — a contribution comparable to that of the Canada Council, and one that for a time increased at a much more rapid rate as the desire to emphasize the distinctiveness of regional artistic traditions spread, particularly during the years immediately before and after the centennial. Between 1961 and 1971, while Canada

Council support for the performing arts increased in the ratio of 7 to 1, from $1 million to $6.9 million, that of the provinces increased in the ratio of 10 to 1, from $0.5 million to $5 million.

To the growing provincial involvement in support for the arts must be added that of the municipalities, which in many cities involved expenditures considerably exceeding those of the most backward provinces. By the late 1970s, for example, the combined expenditure on the arts of Metro Toronto and the City of Toronto was $4 million, not much less than that of Manitoba and several times that of British Columbia. Municipal support for the arts has in its turn been different in character from that of the federal government or of the provinces. It rarely involves the support of individual artists, and where it is not merely a matter of supporting local community arts councils, it runs towards a kind of monumentalism that enhances the city's image as well as giving a more lavish home to its performing arts. The earliest public galleries in Canadian cities, like the earliest opera houses, were founded with the donations of the rich, and later on, as indirectly administered undertakings, were taken under municipal wings. But during the 1950s, as the country took on a celebratory mood, with provincial and city centennials marking a national coming of age that built up to the great centennial of Confederation in 1967, the cities conceived elaborate buildings to provide cultural facilities, often supported by provincial and sometimes by corporate funds, as in the case of the O'Keefe Centre in Toronto, built by the O'Keefe Brewing Company, just as Massey Hall had been built two generations before by the agricultural machine manufacturers who saw themselves as Canada's Medicis; O'Keefe operated the centre from 1960 to 1968, when they handed it over to Metro Toronto. Vancouver's Queen Elizabeth Theatre, Montreal's Place des Arts, Toronto's St. Lawrence Centre and ambitious publicly owned theatres in many other Canadian cities were produced by this orgy of civic pride. Since then these splendid but often largely redundant buildings have drained off a considerable portion of the funds municipalities regularly devote to the arts. In Greater Toronto, for example, about 40 per cent of the annual cultural budget goes to the upkeep of the O'Keefe and St. Lawrence centres.

There has been very little co-ordination between the three levels of government in devising support programs for the arts. A

*Chapter 9*

# QUEBEC AND THE POLITICIZATION OF CULTURE

I t will hardly have gone unnoticed that I have left Quebec to the end in my discussion of provincial initiatives in the arts. The reason is that in matters cultural — and here I use the term in its broadest sense — Quebec has perhaps shown itself more a province *pas comme les autres* than in any other aspect of its policies. This is partly because the arts was an area with no constitutional restrictions, where the province was free to develop to the full the French-Canadian sense of an identity separate from other Canadians. But it is just as much because culture had always been seen by recent Quebec governments, Liberal as much as nationalist or separatist, as a channel for political aims, a manifestation of the national spirit of French-speaking Canada.

This is not only an inheritance from the British Conquest of 1760 and the years during which the people of Quebec strove hard to retain the language and the ways of thought and expression which they regarded as essential to their survival as a nation or, indeed, as a distinct people. It is also a North American manifestation of an attitude that emerged in France during the years when le Roi Soleil first gave his country the shape of a nation, and was further developed during the Jacobin period of the Revolution: the attitude that finds in the arts an expression of

the national will and assumes a *dirigiste* stance towards administering them without appearing to direct their content.

This attitude reached its peak in France under the rule of Charles de Gaulle, when André Malraux was the energetic minister of culture — a great writer who, as well as being a French patriot, was imbued with a profound sense of art as a universal language, traversing the ages and the cultures, and manifesting the glory of man's defiance of death, that ultimate absurdity. It was no accident that the cultural policies of all three ruling parties in Quebec during the 1960s and 1970s, the Liberals, the Union Nationale and the Parti Québécois, should have evolved during the period when Gaullist France was intent on fostering nationalist sentiment in Quebec, just as it was no accident that the attempt of the Trudeau Liberals to politicize federal arts, which we shall describe in the next chapter, should have been initiated by Gérard Pelletier, a friend and admirer of André Malraux. However much the federalist and separatist Quebecois leaders may have disagreed in the political courses they pursued, they were in complete agreement in their Gallic and Jacobin view that art should be used for political ends and that aid should be directed to it with this in mind.

Very little was done for the arts in Quebec under the rule of Maurice Duplessis, probably because the writers and artists in the province were unenthusiastic about his administration and he saw no point in encouraging them. But Quebec intellectuals were already drawing the lines between the federalists and the nationalists, and when the Canada Council came into being in 1957 it was welcomed by some because of the opportunities it would offer and distrusted by others as an unwarranted interference in the province's cultural affairs. The council, in its turn, made a special point of trying to woo Quebec, but it had to give more or less equal treatment to Ontario to avoid an outburst of the historic Lower–Upper Canada rivalry. This meant that, particularly in the performing arts, the hinterland provinces of the Maritimes and the west were systematically starved of funds in order to feed the two central provinces. Quebec and Ontario between them contain just over 60 per cent of the Canadian population; they have received about 75 per cent of the performing arts grants.

The Canada Council was only one among the federal agencies affecting the arts — at least peripherally — that became entrenched in Quebec. Federally controlled public broadcasting in French had begun under the Canadian Radio Broadcasting Commission in 1933, and when the Canadian Broadcasting Corporation was established in 1936, its Quebec branch became virtually autonomous under the title of Société Radio-Canada, operating its own French-language radio and later television networks with little reference to what went on in English Canada. Paradoxically, but understandably in view of the rapid radicalization of Quebec intellectuals during the later 1950s and 1960s, Radio-Canada was to nurture many future separatists, among whom the best-known was René Lévesque, a popular public-affairs commentator who entered politics after playing a leading part in a long strike against Radio-Canada in 1958. A similar situation developed at the National Film Board, which in 1957 moved its head office to Montreal, and shortly afterward established a French-language unit under Pierre Juneau, one of the *Cité libre* circle whose friendship with Pierre Trudeau opened to him a long and varied career as a federal cultural bureaucrat. Many of the since famous French-Canadian film directors learnt their craft in this unit.

However, there were always those in Quebec to whom such favoured treatment seemed a reason for offence rather than pleasure, since they regarded it as an attempt by the federal government to impose its own English-dominated cultural standards on the province which they saw as a nation. Duplessis himself followed a policy of nonco-operation with the Canada Council, but did nothing to counter it with a provincial initiative. After his death in 1959 and his successor Paul Sauvé's in 1960, the new era began in Quebec with the victory of Jean Lesage's Liberals and the precipitation of that long-awaited succession of changes in Quebec life which we know as the Quiet Revolution.

It was inevitable that, as soon as Quebec shook itself awake from the uneasy sleep of the Duplessis years, the new rulers should make one of their prime objectives the assertion of provincial interest in the arts and in other cultural fields. One of the first acts of the Lesage government was to create the Department of Cultural Affairs, a ministry on the same lines as Malraux's in

Paris, which carried its concern for the arts into areas where culture and politics mingled. The first minister was Georges-Émile Lapalme, and his deputy was the historian Guy Frégault. Frégault remarked that "in creating the Department of Cultural Affairs, Quebec brought to an end a virtual federal monopoly on its own territory and placed cultural affairs among the matters which in terms of administration, normally fall within the public domain. In other words, in 1961 Quebec itself finally became the agent of cultural development."

Quebec's policies in support of the arts were centralized and bureaucratically controlled. A provincial arts council was established in 1961 under Jean-Charles Falardeau, but, far from rivalling the Canada Council, its role was entirely advisory, and, as Bernard Ostry remarked, "It rarely, if ever, met." Under the Parti Québécois regime it was revived, again as an advisory body, and again seems to have had no effect at all on the actions of the department. The series of regional cultural councils which Lévesque's administration also established would be similarly limited to "advising the department on regional cultural situations," and the actual work of administering aid or carrying out projects would be kept in the hands of the regional offices of the department. As Ostry remarks in *The Cultural Connection,* "To my knowledge, no Quebec prime minister or minister of culture has ever supported publicly this 'arm's-length' philosophy."

Like the Canada Council, the Quebec Department of Cultural Affairs got off to a slow start but gathered momentum as the years went by. Its initial budget was $3 million, roughly equivalent to the Canada Council's total budget in the period when it had relied solely on its endowment income. By 1963 it had reached $5 million, by 1968 it had climbed to $12 million, and by 1976 to $46 million, which was further increased to $57 million the following year by the incoming Parti Québécois government. This, of course, was considerably more than the Canada Council received when funds for the humanities and social sciences were taken away from it. But the Quebec ministry, with its staff of 960, was concerned with much more than the support of the arts, for its was responsible also for museums, central libraries and the preservation of heritage buildings, though Quebec's rudimentary equivalents of the CBC and the NFB — Radio-Québec and Direction générale du Cinéma et de l'Audio-visuel — came

under another ministry, the Department of Communications, with its own budget of $78 million.

Most of the infrastructure of present-day arts policies in Quebec had already been created under the Liberal administrations. The Department of Cultural Affairs had played an active part in the building of the Place des Arts in Montreal and had been responsible for the establishment of the Grand Théatre de Québec in the late 1960s. It had reorganized the regional museums and established a National Library. Perhaps most important, it had emulated Malraux's ideas regarding the "democratization" of culture by establishing a network of fifty-five local *centres culturelles* in the smaller cities and towns of the province, some of which occupied heritage buildings that would otherwise have been threatened by demolition. Much of this, of course, was outside the customary province of an arts council, but the department also administered aid to the arts in the narrower sense by providing financial assistance to performing companies and to individual artists.

To an extent, when the Parti Québécois came into power, it was thus merely giving more money for already established services and policies. The main change was a greater politicization of the activities of the Department of Cultural Affairs; consequently it was elevated in status to one of the new superministries, the Ministry of State for Cultural Development.

Language, which in Quebec has always been as much a preoccupation of politicians as of literary artists, was an active concern of the provincial Liberals long before the Parti Québécois even came into existence, and well-meant federal initiatives like the Commission on Bilingualism and Biculturalism, with their emphasis on the equality of the two languages in the whole of Canada, and their inevitable drift into multiculturalism, did little to modify the attitudes of the Quebecois, as distinct from French Canadians in other parts of the country, whose interests were well served by the conclusions of the B & B Commission and the subsequent incorporation of bilingual principles into Canadian law. Even Quebec Liberals opposed their federal counterparts in their intention to establish French as the dominant language in Quebec. In 1962, shortly after the establishment of the Department of Cultural Affairs, the Lesage government created the Office de la langue française. Under the

Parti Québécois, when Camille Laurin became minister of state for cultural affairs, Bill 101, which ensured the dominance of the French language, was passed under the department's auspices, and the politicization of cultural programming was further emphasized when the Office de la langue française was brought within the department's control.

Immigration, which had already been declared an area of cultural concern by Pierre Laporte during his term as minister in 1965, was also swept into the department's sphere, and the overwhelmingly political orientation of Quebec cultural policy was demonstrated by the government's publication of a two-volume report, *La Politique québécoise du développement culturel,* which treats culture in the widest sense, embracing almost every facet of society, and essentially argues that a true Quebecois culture, the arts included, can flourish only under conditions of sovereignty and — in the Jacobin manner — under the direction of a nationalistically oriented state. The influence of Gaullist thought as interpreted by André Malraux is evident.

In spite of this emphasis on cultural politics as a means of shaping the society of an autonomous and eventually sovereign Quebec, provincial arts policies in the province have undoubtedly helped the writers and artists who belong to the dominant language group; their English-speaking fellow Quebecois have for the most part had to rely for assistance mainly on the Canada Council and other federal funding agencies. Like Ontario, and like the federal government in more recent years, the Quebec administration has been inclined to stress the industrial rather than the vocational aspects of the arts, and, apart from the direct grants which the Ministry of State for Cultural Development gives to publishers and other arts-oriented enterprises, the Société de développement des industries culturelles was set up to assist them with loans and infusions of capital. Other schemes, like the accreditation of locally owned bookstores which then became the only places where provincial agencies — including schools — can buy books, have helped to bring the infrastructure of the literary and artistic world in Quebec more effectively under Quebecois control.

In Quebec, as in English-speaking Canada, the arts have flourished as never before, and just as the upsurge in the other provinces coincided with the period of the Canada Council's

conception and development, so that in Quebec has been roughly contemporaneous with the life span of the Department of Cultural Affairs in its various manifestations. Clearly, as in the case of federal assistance, the activities of successive Quebecois governments have bought artists valuable time, have saved performing arts ventures from early bankruptcy and have contributed to creating a more efficient infrastructure for the world of arts and letters. In this practical way they have played their part in fostering the changed situation. But the original reasons for the upsurge of recent artistic activity and the frequently high quality of the works produced by contemporary Québecois writers and other artists are deeper and more diffuse than can be explained by the mere effects of intelligent patronage. They are just as difficult to isolate as the causes of the parallel movement in English Canada, which emerged at a period when the two cultures had little knowledge of each other and belonged, like so much else in Canada at that time, to the pattern of two solitudes.

In both English and French Canada at this stage many — but by no means all — of the younger artists and writers were partly inspired by nationalist or radical convictions. Often it was hard to mark a clear line between political radicalism and artistic avant-gardism, particularly since artistic rebellion — especially in Quebec — often seemed to take on a nihilistic or anarchic form and to produce quasi-political manifestations, like the famous 1948 *Refus global* of Paul-Émile Borduas and his associates, an attack on restraints of all kinds, artistic, intellectual and political, that was hardly suited to the aims of any political party.

It is perhaps significant that the accession to power of the Parti Québécois has been followed by a perceptible diminution of political content in Quebec writing and painting and of actual political involvement by Quebec artists. They seem to have found the separatist movement not so appealing once it is institutionalized. This, of course, is the experience of most movements for national or class liberation. They find avant-garde writers and other artists useful allies because these too, for their own reasons, are opposed to the society that exists. But as soon as the immediate aims of the revolutionary movement are achieved and it finds itself with a modicum of power, then it finds that the artists interpret liberation from alien or autocratic

rule to mean also liberation to follow their personal artistic aims. It is at this point that the state often begins to formulate its own goals for artists, to interfere with their freedom of expression and to seek to turn them into its willing servants. That point has not yet been reached in Quebec, largely because the provincial government is neither politically powerful nor fiscally sound enough to attempt the kind of open manipulation of artists that would certainly end in conflict with them. But the cultural bureaucracy is in place, and so is the *dirigiste* attitude that has already devised a blueprint for the development of Quebec culture and would not be unhappy to see the artist become the servant of the nation state.

One should not, indeed, overemphasize the difference between Quebec cultural policies on the one hand and those of the federal government and the English provinces on the other. The Canadian nationalist bent of the Massey Report was evident, and the idea of fostering the arts as an expression of national character is basic to the work of the Canada Council, while, as we shall see in the next chapter, federal policy towards the arts and activities ancillary to them has undergone a steady politicization since the mid-1960s, a steady trend towards seeing the arts as channels of national policy. The main difference is the traditional lack in Quebec of autonomy in any of the funding agencies and of any public participation, beyond that of bureaucrats and politicians, in the process of using public money for the support of individual artists and performing groups. It would have been surprising if a federal government composed largely of men and women drawn from the same Quebecois elite as the Lesage Liberals — and as René Lévesque himself — had been wholly untouched by such a tradition.

*Chapter 10*

# CAUGHT IN THE WEB: THE ARTS AND TRUDEAU POLITICS

T hat politics would sooner or later enter into decisions on the way the state devotes public funds to the support of the arts was inevitable from the beginning, for any action of the state has ultimate political consequences, and the various public agencies established to administer funding for the arts have been obliged from time to time to defend themselves against governmental domination and distortion of their activities. Fortunately, working with artists tends to have a mentally liberating effect on even the most professional of bureaucrats, and those who have found themselves in charge of the cultural agencies that have proliferated over the past quarter-century have by and large adopted the attitude expressed so well and concisely by Bernard Ostry, one of the most versatile of Ottawa cultural mandarins, when he remarked: "To make political demands in the arts and sciences is not only self-defeating, it is dangerous." It is indeed dangerous, not merely because freedom of expression is as essential to the arts as freedom of enquiry is to the sciences, but also because once we have limited those freedoms, we have established a precedent for the limitation, on grounds of political expedience, of all our other cherished and defended freedoms.

When the Canada Council was established in 1957 with its endowment from the death duties on a couple of exceptional estates, it was able to take and keep cover, since those funds had never entered the government's financial system, and while the council spent only the interest on them, it was safe from interference from either Parliament or the Treasury Board, the government agency most closely involved in administering the allocation of funds. As Frank Milligan remarked, "From 1957 until 1965 [the council] functioned essentially as a private foundation." However, the possibility of pressure being applied was clearly in the minds of the council's staff even at that early period, for the 1960 annual report contained this precautionary statement: "In the allocation of its funds, it is important that the Council remain a completely impartial agent attempting in no way to impose its own standards of taste." Or, by implication, the taste of others.

Once the Canada Council began to receive regular parliamentary grants, it became a legitimate object of attention not only on the part of the Treasury Board but also on that of Parliament itself. In 1965, in view of the proliferation of governmental ventures into the cultural field, Prime Minister Lester Pearson agreed to the establishment of the Standing Committee on Broadcasting, Film and Assistance to the Arts. Ever since, cultural agencies have been subject to investigation by such a body under a variety of titles; at present it is the Standing Committee on Culture and Communications. The relationship is a curiously oblique one. The minister — at first the secretary of state and now the minister of communications — is responsible for approving the budget estimates of the agencies, which are, in status, Crown corporations; it is he who speaks for them in Parliament, though he has no control over their internal workings. Indeed it is laid down in the Canada Council Act that the Canada Council is not an agency of the government and that its staff shall not be considered part of the federal civil service. But the officers of the various agencies, and the chairmen of whatever boards of directors they may acquire, appear before the Standing Committee when their estimates come up for consideration to explain rather than to justify their activities.

This has not prevented parliamentary criticism and parliamentary pressure. Sometimes this takes place on the pettier

levels of patronage, as when an M. P. approaches the Canada Council on behalf of an aggrieved constituent who has been refused a grant; sometimes it is conducted on a level of real or simulated principle as an expression of the tastes or prejudices of the M. P. personally or of some group whose spokesman he may have become.

The record of the various Standing Committees has not been an entirely negative one. During the famous 1966 debate over CBC internal censorship in connection with the television program "This Hour Has Seven Days," the committee — which then included exceptional individuals like Gordon Fairweather and David Lewis — strongly criticized the management of the CBC, not because of the program's alleged excesses, of which some individual M. P.s had complained, but because of the CBC management's restrictions on the freedom of producers and hosts to use their program for frank commentary as well as to report on public affairs. It transpired during the enquiry that no governmental pressure had been imposed on the CBC management, and that its actions had been dictated by fear of hostile criticism rather than in response to any concrete threat. The Standing Committee made recommendations which, had they been accepted, might have ensured more freedom for creative personnel within the CBC and prevented the progressive deterioration of programming that began in the late 1960s. The CBC management chose — as was its right — to ignore the committee's recommendations, and, in one of the most discreditable episodes in the corporation's unhappy record, fired or forced the resignation of all the people involved in the program during a kind of Night of the Long Knives that is still remembered with resentment among CBC producers.

The efforts by parliamentarians to interfere with the Canada Council through the Standing Committee were usually directed against the moral or political unorthodoxy of individuals or groups to which the council granted funds. Frank Milligan said of the situation: "To the champions of the Council, and especially the artists themselves, the support of the unorthodox — in art or politics or even in styles of living — may seem the strongest justification for the autonomy of status it claims; to its critics, those disputed grants invalidate that claim."

In the political field the most acute criticisms came when the Canada Council gave grants to Quebec artists who were declared separatists. Such grants were challenged by members of the Standing Committee on Broadcasting, Film and Assistance to the Arts — as it was known in 1977. Gertrude Laing, speaking as chairman for the council, admirably stated the non-political position that must necessarily be taken by a public agency concerned with nothing more than supporting artists and finding those who in terms of their art are most worthy of support. She told the committee:

> We are not in the business of giving grants to people of separatist opinion or of any other particular political faith. We are in the business of promoting the arts. It is, however, I think, a matter of reality to recognize that many of those who are concerned about the independence of Quebec in the positive sense, who are promoting it, if you like, are among the intellectuals and artists and therefore they appear before us with requests for grants in the pursuit of their artistic and scholarly functions. We do at that time consider their applications only on that basis and it is our desire and intention to continue to fulfil that function.

Something much nearer to a witch hunt took place in broadcasting when commentators and producers employed by Radio-Canada in Quebec were accused of using the network and its facilities to promote separatist viewpoints. The federal government forced the CBC to accept an enquiry which in the end turned up nothing that could be defined as improper behaviour on the part of any of the staff involved. The whole issue reflected the inability of partisan politicians to understand that journalists — whatever their media — are, like writers of other kinds, all the better for being strong in their personal convictions, which need not be those of the governing party or, indeed, of any party.

In 1978, the year after it had been criticized for giving money to good artists who also happened to be separatists, the Canada Council again ran into rough water with the Standing Committee, this time on the grounds of supporting writers whom some M. P.s regarded as pornographic — indeed so pornographic that one member, Bob Wenman, attempted unsuccessfully to gain

102

acceptance for a motion suspending the activities of the council until it could be made completely accountable to Parliament.

The poets in question were bill bissett and Bertrand Lachance, and to many of those who eventually became involved in the arguments surrounding the incident, it seemed to present the issue of the council's autonomy with startling clarity. Some of those who supported the council were admirers of the poets involved. I, for one, was not. Although I have never been shocked by the verse of bissett and Lachance, I have also never regarded either of them as even a moderately good poet; from an aesthetic point of view, I agreed with one member of the council who described the decisions to give repeated awards to such minor versifiers as "horrible mistakes."

Nevertheless, when an advertisement defending the council's right to give the awards was published, I added my signature. I was defending the principle that the Canada Council should be free to make decisions which I thought mistaken without interference from politicians or zealous bureaucrats or evangelical moralists. The M. P.s who had involved themselves were attempting to impose a moral censorship on aesthetic judgements, and I felt — like many others — obliged to resist what, if Bob Wenman's motion had been accepted, would have meant the end of the council's role as in independent agent of public patronage. Enough people did resist at that time to enable the Canada Council to weather the squall and continue making its grants without surrendering to parliamentary pressure.

But Parliament has long been a factor of declining significance in Canadian political life. Little of importance actually originates there; the initiatives that alter the course of national events are made within government departments or, when it is a question of broad issues, in the Cabinet or among the two elite groups of civil servants who operate the Privy Council Office and the Prime Minister's Office. And it was from these latter sources that flowed, during the years following the foundation of the Canada Council, the policy decisions that rapidly broadened the federal government's intervention as patron of the arts and at the same time increased the danger of attempts to politicize that patronage.

Many of the first steps in increasing and rationalizing the federal government's involvement in the arts were taken during

103

those fruitful years of the Pearson minority governments between 1963 and 1968. Concerned about the number of disparate cultural agencies that had come into being over the years since the National Gallery was founded in 1880, the government gathered them together under the supervision of the Secretary of State. This was of some importance to the arts, since the National Gallery — with its modest purchase program for works by Canadian painters and sculptors — the Canadian Broadcasting Corporation and the National Film Board all in their own ways contributed to the income of artists either by purchase or by employment, though not — like the Canada Council — by direct patronage.

This was also the period when the approach of the centennial celebrations of 1967, and of the World's Fair at Montreal, better known as Expo 67, was a major preoccupation of all levels of government in Canada. A Centennial Commission was established; one of its duties was to plan and construct the National Arts Centre in Ottawa, which was to become the permanent federal monument to Canada's hundredth birthday. Owing to conflicts within the commission, the team involved in planning and building the centre was separated and transferred to the secretary of state's department. The National Arts Centre — one of those great performing arts complexes that were appearing during the 1960s in so many Canadian cities — was given by an act of parliament in 1966 the same status of an arm's length agency as the Canada Council. The centre was finally opened in 1969, having cost $46.5 million, several times the originally estimated $9 million. It has remained a somewhat anomalous institution, a manifestation of what happens when national pride becomes involved in the organization of the arts. Far from becoming a genuinely national institution, the NAC has remained essentially an Ottawa arts centre, whose performances have rarely been made available to audiences other than inhabitants of the capital and visitors to it. Efforts during the 1970s to establish touring English and French theatre companies came to nothing, and it is only through its top-level orchestra, which performs mainly the traditional cosmopolitan repertory, that the National Arts Centre maintains a tenuous contact with the hinterland of the nation whose arts it was created to represent. It is a white elephant which is not

even very well fed, for in 1983 lack of funds forced it to suspend its opera productions and in 1984 it had to shelve its English theatre company.

In 1967 the Canadian Film Development Corporation was established to encourage the production of feature films in Canada. From 1963 onward the National Film Board had been moving outward from its original concentration on documentaries and had produced a few feature-length films, but it was recognized that a Canadian film industry could not be established on such a slender base. Following the Canadian pattern of developing parallel public and private endeavours, the CFDC was therefore created to assist film makers with investment money, loans and grants, but not to play any direct part in the production of films, which so far as the state was concerned was still restricted to the NFB and, to a growing extent, the CBC as its television programming increased.

In 1968 the system of museums that had grown haphazardly over the years, with institutions under the vague supervision of a number of departments and later loosely gathered together under the Secretary of State, was finally rationalized by the creation of yet another autonomous body, the National Museums Corporation, which was given responsibility for the National Gallery, the National Museum of Man, the National Museum of Sciences and Technology and the National Museum of Natural Sciences. All these were housed in Ottawa, but under the new dispensation they were encouraged to reach out to the hinterland. The National Gallery had pioneered in this direction during the 1930s under its first full-time director, Eric Brown, and now its touring program notably increased. The National Museum of Man did much more than organize touring exhibitions; it also established in the 1970s a network of small satellite museums in places as far apart as Harbour Grace in Newfoundland and 'Ksan Indian Village at Hazelton, British Columbia. Later it redressed an old injustice by returning to the Kwakiutl Indians of British Columbia the traditional regalia that the RCMP had seized at potlatches in the 1920s, and helped to provide museums to house them in the Indian villages at Cape Mudge and Alert Bay. These were programs of dissemination that were artistically and ethnographically educative without having any identifiable political intent.

Unfortunately, however, the immunity of the National Museums, organized as a Crown corporation, from direct political dictates was matched by a lessening of autonomy for the individual institutions gathered under its aegis. In the past these institutions had enjoyed a good deal of actual if not formal independence because of the looseness of their ties to whatever departments had theoretically supervised them. Under the National Museums Corporation, the links were tightened. Because she felt the National Gallery's freedom to make its own decisions on policy and purchase were being encroached on, and because of the delays in giving the gallery a permanent building, Jean Sutherland Boggs, one of its best directors, resigned in 1976. Her resignation created something of a sensation in the world of the arts, for it was one of the first overt signs that government involvement in the arts was changing in ways that artists and even, in the end, cultural bureaucrats would find disturbing.

Another sign came in the same year that Jean Sutherland Boggs resigned. The incoming director of the Canada Council, Charles Lussier, a Trudeau appointee, initiated his term in office with a warning. He told performing groups to make their programs accessible to "wider publics" (which implied a radical change in council policy towards directing rather than supporting artists) on the grounds that such a broadening of appeal was necessary if the council hoped to gain adequate funding from Parliament. He was suggesting, in other words, that a politically required "democratization" might become a condition for artists to continue receiving public funds. Such a statement seems distant indeed from the Massey Commission's declaration of faith that not abstract political concepts but "arts and letters . . . lie at the roots of our life as a nation," but nobody who has followed the politics of Trudeau's various administrations towards cultural matters should have been surprised at such an incident.

The Pearson government, as it steadily broadened the state's involvement in the arts, had tended under Maurice Lamontagne and later Judy LaMarsh to extemporize without any overall policy. This was why the initiatives taken during this period resulted in a series of new institutions that were modelled on the Canada Council and received public funding without being

106

politically answerable to the Cabinet or to Parliament. When Trudeau and his associates moved into dominant positions, with Trudeau eventually becoming prime minister, they were able to impose their views of cultural politics on a series of cabinets largely because they had a clear philosophy in this field while the rest of the Liberal party did not. Trudeau's view was basically that the control of a nation's cultural life, and especially of its arts, is essential for the consolidation of political power, and cultural policies should be directed towards supporting a government's principal aims. In the case of Trudeau's Liberal government, the most important of these aims was the transformation of Canada from a genuine confederation with a balance of federal and provincial powers into a centralized state, a transformation to be carried out in the name of "national unity."

The change in policy began in 1968 when Judy LaMarsh was edged out from the Secretariat of State and replaced by Gérard Pelletier, whose presence automatically raised the status of the portfolio; later, in 1969, the Cabinet Committee on Culture and Information, presided over by the Secretary of State, was established. The same year, the Department of Communications was established, parallel to the Department of State, but concerned with the technical aspects of the dissemination of information and, ultimately, with propaganda, as all ministries of information are. The growing importance of this department was shown when Pelletier was transferred to it in 1972. The industrial viewpoint towards the arts that inevitably emerged in an office concerned with the technical aspects of communication and information processing became more influential as the department gained more power and eventually, under the final Trudeau administration of 1980–84, took over responsibility for all the cultural agencies from the Department of the Secretary of State. At this time organizations like the Canada Council and the National Film Board, dedicated to fostering the autonomous workings of the artist's imagination, were incorporated into an alien complex whose emphasis was on the technology of processing information and its use for essentially political ends.

A key occasion in this process was a little-publicized seminar held at Sainte-Adèle in May 1969. It was organized by the Canadian Conference of the Arts (an organization heavily subsidized

107

by the government, to the tune of $205,000 in 1976) in association with the Associated Councils of Arts in the United States, and the report of the seminar, with some of the key papers, curiously appeared not in any Canadian publication, but in the American organ of the Associated Councils, *Cross Currents,* which perhaps explains why the occasion aroused less than its merited attention in Canada. The seminar's aim was to discuss "the political realities of government support of the arts," and it is significant that the two hundred and fifty people present were overwhelmingly organizers of creative activities rather than creators. Of the participants whose speeches were featured in *Cross Currents,* two were members of the government, Pierre Trudeau and Gérard Pelletier; several were officials in public bodies dedicated to organizing the arts, and there was only one independent figure, the journalist Robert Fulford. No practising creative or performing artist attended, and the creative process was in no way discussed.

The statements of the prime minister, the secretary of state and other public figures there, coming so early in the life of the new government, made it evident what Liberal policy in the arts would henceforward be. It was clearly a policy directed towards a growing politicization of the support of the arts and a growing tendency to see them as an industry rather than as a cluster of muse-ridden vocations. It is true that Pierre Trudeau opened the seminar by remarking that the arts are "an essential grace in the life of civilized people," and that he ended his speech in what seemed a statement of reassurance: "I do not think that modern society, or the artist as a member of that society, need fear a generous policy of subsidy to the arts by governments as long as those governments have the courage to permit free expression and experimentation — and, for that matter, to take it in good part if the mirror held up to their faces is not a flattering one." This conclusion would have sounded comforting if Trudeau had not in a previous unguarded moment admitted that the government "sets a general course for development" in its aid to the arts, and that even so vague a policy can materially affect the artist's situation.

In this connection two contributions to the Sainte-Adèle seminar were of special significance, partly because they were presented by men closely involved in public programs for the arts

108

and partly because of the indications they gave at this early date of an official approach to cultural matters that has persisted through the whole period of Liberal government down to the point of Trudeau's resignation. These speakers were Gérard Pelletier, the advocate not merely of public- but of state-directed intervention in the arts, and Duncan Cameron, national director of the Canadian Conference of the Arts, successor to the Canadian Arts Council and by then a heterogenous federation of many organizations in which those whom Cameron called "arts administrators" wielded most influence and in which the role of real artists had become inconsiderable. At least one of the conference's main functions at that time was to serve as a liaison between the government and those who profited from the arts.

The tone of Cameron's paper was set in the first sentence, in which he remarked that "national organization of the arts . . . is a relatively new phenomenon in North American society," that it is "an experimental means of achieving the goals essential to the health of the arts and the flourishing of creative expression," and that it is the experiment of the moment; the implication clearly being that because it is the experiment of the moment we have to go through with it!

It is clear from the rest of his paper that Cameron believed in the organization of the arts from above or at least from the outside, and saw himself as the spokesman of what he described as the "total arts community, or arts industry, as it is more commonly now being called." The phrase *total arts community* is of course a particularly ominous one: it suggests something monolithic, on the edge of totalitarian; it brings a political concept into the heart of the world of creativity. Similarly, to talk of an *arts industry* means that, like the Marxists, one sees the products of art as primarily commodities; such a view, of course, reverses the true situation. For works of art are commodities only in a secondary way. In order to continue creating, artists sell what they produce so that they may buy materials and food. Once the work of art has left the artist's hands, it survives as an object of contemplation, an icon, and only becomes a commodity again when it passes from hand to hand for cash. Thus there may be a trade in objects of art, but art itself is not an industry.

Moreover, ever since the first days of Dada more than sixty years ago, there have been artists who have become anti-art in

109

the sense of rebelling against the restrictions of studio and study, the limits of the picture frame or the printed page, and have developed forms of expression that do not involve the creation of salable objects or even, in some cases, of art that can be ascribed to individuals. The collages created during World War I by Hans Arp, the later Found Objects proffered by the surrealists, the "happenings" of the interwar years, such as recitations of incoherent poetry and mass lectures (one had thirty-eight people speaking at the same time), the actual destructive manifestations like the Cologne exhibition of 1920 when visitors were given axes to chop up the exhibits — all these were the beginnings of a tradition, or antitradition, that revived in the 1960s and is still with us. It is revealed in phenomena like video and performance art, like installation art and environment art. It often eliminates not only the concept of the art work as icon, but even that of the individual artist, since many of these people work in collectives, producing no lasting work and seeking no individual credit, just as in the new live theatre of Canada the performances are often developed in a living collaboration without individual creators or set scripts. Such situations represent the anarchic verge of art, perilously poised on the verge of disintegration, yet even more than studio painting or printable literature they project a total rebellion against the very idea of the arts as an industry or the artist's work as a commodity.

Having raised these objections, one must grant that in a country like Canada, as the Massey Commission agreed with some misgivings, a degree of organization may be necessary in some of the arts. Performing arts largely depend on it. Both attendances and private patronage have grown during the past quarter of a century in Canada, yet operas, symphony concerts and what we call serious drama are still only feasible by means of planned and recurrent public subsidies. A Statistics Canada survey of 144 performing companies in 1977 revealed that only 48.8 per cent of their revenue came from ticket sales, and 11.7 per cent from private donations. The remaining 39.5 per cent was made up of public grants from federal, provincial and municipal sources. Where planned subsidy exists, obviously the framework of a national organization of the arts emerges, and the mere selection of the theatrical or musical groups that will be

supported by the state — or the Canada Council or other such body as its representative — will establish the criteria on which patronage is based. Nothing so crude as an overt censorship need ever be tried. The power to influence what is performed will be there, even if it is not exercised, and that is one of the most important reasons why not even the slightest tinge of political influence should enter into the process.

Creative artists — except for orchestral composers and choreographers — are generally much less dependent on this kind of organized aid. They do not have to face the vast expense involved in putting on even the most modest performing arts show at a professional level of excellence, and unlike the performing artists who usually have to work full time to sustain their craft, writers or painters can if necessary survive by taking some job unrelated to their vocation that leaves time and energy for their artistic production. Henri Rousseau was a customs man, Duncan Campbell Scott an Indian agent, Stendhal a consul, Wallace Stevens a successful corporate executive; but I have yet to hear of a great actor or a notable conductor or even a good first violin who doubled as a businessman or a civil servant. There is a clear division between the good professional and the good amateur in the performing arts; the boundary is more nebulous in a field like writing or even painting. This situation has two consequences. First, the performing artist is much more inclined to accept — even demand — organization than the creative artist, who is usually a solitary worker. This can be seen by comparing the power and solidarity of organizations like the Musicians' Union and Actors' Equity, which embrace virtually all the artists in their respective fields, and the weakness of an organization like the Writers' Union of Canada, to whose individualist-minded members the very idea of a closed shop would be anathema. Secondly, the productions in which performing artists work are much more vulnerable to lack of support than are the works of writers who, with their pad of paper and their typewriter and some hole-in-the-corner job, are much better equipped to weather the lean times.

Still, even for the writer, the lean times are not the best times. They restrict the quantity of the writer's work and perhaps its scope of concept; they may even lower its quality. And thus the creative artists, because they welcome support, are also affected

111

when the state decides to organize aid to the arts. Perhaps, as happened in 1982–83, Canada Council awards to individual creative artists may total only an eighth of all the grants made in that period ($7.5 million out of $60.7 million), but they give time for work to many writers and painters, and such artists have come to depend on at least occasional help of this kind.

All this means that creative as well as performing artists are likely to be in some degree affected by the philosophies of those who control whatever programs exist for what Cameron called "the national organization of the arts." That is why Gérard Pelletier's speech at Sainte-Adèle in 1969, which laid down the line of policy followed by Liberal secretaries of state, was so important, and also so ominous in the way it applied a politician's criteria to the arts and at the same time supported a modish inclination to equate with art the more mechanical and commercialized ways of filling leisure time.

Pelletier, through whose statement the idea of the need to "democratize" culture ran as an insistent leitmotif, was speaking at the end of a decade during which — as we have seen already — actual participation in the arts had increased phenomenally. He himself referred to the four hundred amateur theatrical companies performing regularly in Canada, and he might have referred also to the proliferation of potters and print-makers and Sunday painters, to the vast increase in private presses and little magazines supporting the swarm of new poets, to the fact that for the first time in Canada people were actually making a living (even if only a few people and a modest living) from practising the arts. But this was not enough for Pelletier. With a politician's eye to the mythical democratic majority, he was not content with making the *arts* available to as many as might wish to partake; he also hoped to sell *culture* to the unwilling.

> Many identify the use of theatres, concert halls, museums, art galleries and libraries with the middle class and conclude that culture has nothing to do with them. The problem of winning over this non-audience is not merely financial. Above all, it is a question of ideas or concepts. If we are to democratize culture, without debasing standards of quality, we must not only open the doors to much larger numbers of people; we must also induce them to enter.

Of course there is no more reason — at least in the mind of anyone who recognizes that we live in a pluralist society — why an ice-hockey fan should be cajoled into an art gallery than a chamber music aficionado should be dragged to a football game. The whole naive concept that two ideas of how to use one's leisure cannot exist side by side brings us back into the haunting presence of that homogenous majority viewpoint which is the politician's favourite phantom. Yet one might have culled reassurance from the phrase *without debasing standards,* if such comfort had not been immediately dispelled by a highly publicized policy speech which the secretary of state delivered during the same spring of 1969 at Lethbridge.

It may be necessary to transform completely the notion of culture, to replace the notion of a middle class culture with that of a mass culture. Why should the theatre and opera have a monopoly of culture? Why should not movies, jazz, popular songs and psychedelic happenings also be a means of culture expression? . . . When culture has become a source of alienation — and this is increasingly the case with middle-class culture, it is high time for us to examine it. The democratization of culture will not otherwise be achieved.

Such a frankly philistine statement, emanating from a minister responsible for organizing aid to cultural activities, begged a whole series of questions. First there is the choice of politically emotive terms — the contrasting of *middle-class culture* with *mass culture,* and the use of *alienation,* the great contemporary crybaby word available to any group that cares to lay a claim to special attention. In this context I fail to see how alienation enters at all; Pelletier was using the word solely for political effect. The traditional arts are there for anyone who knocks at their doors; indeed they are becoming increasingly available to those temperamentally inclined to respond, and the response is there. A survey made by Pelletier's own department in 1972 revealed that at that time, three years after the Lethbridge speech, 2.5 million people a year were attending live theatre and ballet performances, 1.8 million attended classical music concerts and opera and 3.1 million visited art galleries and museums. These figures were growing in steady ratio to mass enter-

113

tainment attendances, for which the comparable figures in the same year were: movies, 8 million; nonclassical music, 3 million, and fairs and exhibitions, 2.5 million. The traditional arts in fact seem to have been doing very well on their own accord, and there is no spectacular way in which — *without debasing standards* — one can create a sudden upsurge in an interest that is already growing with its own steady momentum.

I have used the term *traditional arts* because I could not accept Pelletier's term *middle-class culture;* I find his term *mass culture* repulsive and totalitarian, for it ignores the immense variety of tastes and pleasures and estimable activities which take place among those who do not feel the immediate appeal of the arts. There is nothing intrinsically middle-class, I would say, about opera, which in Italy has always been a popular art, or about classical ballet, which in Russia has exchanged an aristocratic for a proletarian following. Such sociological labels have no lasting relevance in cultural matters; Mozart wrote for a long-dead aristocracy, but today his appeal is wholly classless, as is the appeal of all art that survives its immediate time and place. The traditional arts are those that display the potential of a civilization at its best and most generous; the tradition is an ever growing one, and imaginative films, inspired jazz and fine ceramics belong within it as much as Greek drama or easel painting. For that reason, such arts have special claims on our consideration and our support, and when we try to equate them, as Pelletier did, with the trivialities of commercialized popular entertainment we are not only belittling our humanity; we are also robbing the people who may live in a more leisured, less fearful and less self-conscious future of some of the means to develop themselves, spiritually, aesthetically and culturally. The logical end of the cultural depreciation which Pelletier advocated and promoted in 1969, and which has played its ominously growing role in government policy towards the arts in Canada ever since, is the kind of moonscape of the mind which the so-called cultural revolutions created in China. The Marxist echoes in Pelletier's statements are not accidental; he has shared with contemporary Marxists a simplistic political view of the arts that his successors in the Department of State and to an even greater extent in the Department of Communications have inherited.

114

The reasons why I deplore the transfer to the arts of the concept of democratization, as interpreted by political leaders, will now be evident. In a recent article on the theatre in Canada, which he contributed to a special issue of the *University of Toronto Quarterly* on the arts of Canada over the past half-century, Robertson Davies discussed the Dominion Drama Festival and praised its amateur virtues, but went on to say that the festival "had at its root a democratic spirit which is not the spirit of the best theatre. Art is ruthlessly aristocratic; there is no way in which one can ensure that talent will be distributed equally." Such a statement, which accords with all one's observations of the creative process, would no doubt be dismissed by people like Pelletier as "elitist." But if the label "elitist" has any meaning in the discussion of a policy, it can surely best be applied to those who seek to impose from above — because they claim to know best — an unproved concept of mass or popular or majority culture. If there are any democratic concepts that can, at least analogically, be applied to the arts, they are surely those we derive from direct and participatory theories of democracy — that where any organization is needed in the arts, it should be as far as possible in the hands of those involved in artistic creation, the artists themselves, as the Canada Council has implicitly recognized through its system of juries of artists and writers. This does not mean that I reject the argument, put forward by William Morris and developed by Herbert Read in his crucial work *Education through Art,* that art must enter deeply into education and daily existence if humanity is ever to live in harmonious self-fulfilment. But that process can only be a permeative one, moving outward from the community of the arts; it cannot be achieved by policies devised by bureaucrats and dictated by politicians.

The attempt to dictate policies and even practice in granting funds to the arts has in fact characterized the attitudes of civil servants and successive ministers throughout the Trudeau period. At first there was no direct attempt to interfere with the way the Canada Council administered its grants. Instead parallel programs were created under the direct control of government offices. In 1971 the Department of the Secretary of State established the Opportunities for Youth (OFY) program, which provided summer employment for students between sixteen and

twenty-five years old, and shortly afterward the Department of Manpower and Immigration initiated the Local Initiatives Program (LIP), which encouraged citizens to devise and organize community development projects.

Neither of these was devised primarily as an arts program, but in practice many of the projects did involve the arts — particularly the dramatic arts — and a number of experimental theatres which played an important role in encouraging Canadian dramatists were actually started under LIP grants. Participatory democracy was being much talked of in Ottawa at this time, and LIP programs were run with a minimum of bureaucratic interference. But both LIP and OFY were politically inspired, aimed primarily at solving youth unemployment and only secondarily at promoting the arts, and they remained at the mercy of changes in government employment policies, so that by the end of 1975, when participatory democracy had been abandoned by an increasingly partisan and authoritarian Liberal government, the programs had virtually vanished. Only the most vigorous of the projects started under LIP grants were able to survive, either with private funds or through having proved their competence sufficiently to be regarded as professional enough for Canada Council support.

The presence of LIP and OFY forced the Canada Council to modify the emphasis on professionalism which dominated its major grants programs, and in 1971, under pressure from the secretary of state's office, it made at least a token gesture towards the Sunday artist and the amateur scholar by initiating the Canadian Horizons Program, which two years later became known as Explorations and which, for all its limitations, has certainly proved useful in fostering creative projects and eccentric talents that do not fit into the professional pattern.

When government interference with the Canada Council reappeared later in the 1970s, it came in the form of the granting of funds earmarked with a clear political intent. The first earmarked funds had in fact been granted to the council by the secretary of state's department as early as 1972; these were specifically intended to subsidize a publishing trade in crisis, and had no political strings attached, but even then Kildare Dobbs, at that time literary editor of the *Toronto Star*, gave what turned out to be a justified warning when he suggested that by

accepting funds earmarked in any way the council might be compromising its independence.

In 1977 the government interfered directly on a major scale in the affairs of the Canada Council, depriving it of its role in the academic life of the country by setting up a separate funding agency, the Social Sciences and Humanities Research Council. In doing so, it openly abandoned the arm's length principle, since under the Government Reorganization (Scientific Activities) Act, the new council was set up as a corporation subject to a governmental "directive power . . . of unlimited scope." No attempt was made for the moment to similarly restrict the Canada Council's autonomy, but the threat was clearly there.

Meanwhile the practice of earmarked grants resumed, and in a way the council itself took the initiative, for in 1972 it established the Art Bank on a special allocation which it had requested. The Art Bank is a project in which advantages and disadvantages are closely mingled. Clearly it has been a benefit to artists that there should be a reliable major customer for their works, and over the years hundreds of individuals have benefited. On the other hand, the way the collection is administered takes art into the heart of the political realm, for instead of making the $8 million worth of works it has accumulated available to the small-town galleries and museums of the hinterland, which would be an appropriate place for them, the Art Bank rents them to government offices, so that one can see them only when visiting bureaucrats. Art in these circumstances becomes an appendage to the workings of the state.

Having itself asked for earmarked funds to be spent in this quasi-political way, the Canada Council found it difficult in 1977 to turn down an offer of $1.7 million in earmarked funds which the Secretary of State specified must be spent on initiatives tending to promote "national unity," or to refuse the $900,000 offered the next year specifically to promote a national book festival. The latter grant may have been only marginally political in its intent, but the former was overtly so. At the same time, the National Arts Centre was offered $1 million to put on touring shows that would serve the cause of national unity. These politically oriented grants were offered at a time when the government was planning to cut general funding for the arts, as it did in 1978 when it announced, among

other things, that the appropriation budget for the Art Bank would be eliminated for the following year.

At this point the council found it necessary to assert its independence, and it decided that, despite the Treasury Board's action, it would continue its purchases for the Art Bank on a diminished scale, and make up the difference by cutting some of the activities that had been launched during the previous year with the funds granted to promote national unity. Gertrude Laing forthrightly expressed the council's attitude when she declared in the 1978 report that "the willingness to fund 'national unity' through the arts, but not adequately to fund the arts themselves, is evidence of an attitude to cultural policy that gives me great concern."

Such a stance did not endear the Canada Council to the more politically minded ministers who regarded all government agencies as instruments of Liberal policy to be used with partisan intent. John Roberts, then secretary of state, interpreted it as an act of gratuitous defiance. The Conservative victory in the 1979 elections, however, gave the council and the other cultural agencies a brief respite. David MacDonald, the new secretary of state, began to develop a positive program of assistance to the arts. He restored to the Canada Council the money that had been cut out of its funds; he proposed more generous aid to publishing; he planned a new commission to investigate in every aspect the situation of the arts a quarter of a century after the establishment of the Canada Council. Unfortunately for the arts, the Clark government was short-lived, and the Liberals returned in 1980.

To an extent the policies initiated by MacDonald seemed to survive, since the commission he had planned finally came into being, not as a full-fledged royal commission, but as the Federal Cultural Policy Review Board. The shift in title was significant. It was no longer concerned specifically, as the Massey Commission had been, with the "Arts, Letters and Sciences." "Cultural Policy" was far less specific and far more ominously all-embracing, and, as the event would show, it allowed for a degree of imprecision and even of evasion that would play into the hands of the bureaucrats. More alarming was the merging of the roles of secretary of state and minister of communications under a single Cabinet minister, and the

subsequent shifting of the cultural agencies from the care of the Department of the Secretary of State to the Department of Communications, where they came into the province of civil service mandarins who gave assistance to the arts second place to the game of power and profit involved in establishing the lines of control for the rapidly developing communications technologies. To such bureaucrats the arts played a minor role, important only to the extent that their creativity could be tapped to provide the content for the various media of communication.

The attempt to subordinate the arts to the requirements of a cultural industry which emerged from this situation will be discussed in the next chapter. Here I am concerned with the more urgent and immediately dangerous attempt to make the Canada Council and its fellow arm's length agencies subservient to a political control that would have virtually destroyed their credibility as independent bodies capable of reasonably objective judgement. Fortunately, it turned out in the end to be a comedy of All's Well that Ends Well, with Big Brother defeated at the last moment in his home year of 1984. But the threat was real and the attempt almost succeeded.

The attack, which would have put an end in practical terms to the whole concept of arm's length agencies that the Massey Commission set on foot in Canada more than thirty years ago, was an oblique one, and all the more perilous for being so. Repeated scandals about the financial irresponsibility of certain Crown corporations like Canadair has led to demands that the 336 such organizations, 90 per cent of which had been spawned in the past two decades, should be subject to closer governmental and parliamentary supervision; Bill C-24 was prepared and presented by Treasury Board president Herb Gray with this intent. The Treasury Board was doubtless chosen for the task because any funding Crown corporations receive must pass under its scrutiny. The essential idea was to make the scrutiny more searching, so that money from taxpayers' pockets should not be expended without proper accounting and investigation.

The bill undoubtedly responded to a deep sense of public unease about vast sums of money vanishing into inexhaustible wells of expenditure in the many failing industrial projects which the government preferred to take under its wing rather than see them collapse and increase unemployment. The public

had to be assured that the spending of its money on such speculative ventures was in fact adequately supervised.

But the framers of the bill went beyond that area of public concern. They decided to include within its scope the various cultural agencies with their theoretically entrenched autonomous constitutions. It seems clear that a number of ministers were using the occasion to express their annoyance that in the past the cultural agencies had shown themselves reluctant to accept political directives. In Cabinet, apparently, three senior ministers insisted that these bodies — the Canada Council, the Canadian Film Development Corporation, the National Arts Centre and the Canadian Broadcasting Corporation — should be subjected to the provisions of Bill C-24. The ministers were all men who in their careers had shown themselves highly partisan in handling public issues: Jean Chrétien, Lloyd Axworthy and John Roberts. Pierre Trudeau seems to have supported them, insisting that he wished to secure the bill's passage before his resignation from the prime ministership became effective. Francis Fox, who as minister of communications was responsible for representing the interests of the cultural agencies, did not protest. Indeed the rapid and rather sensational series of events suggests that he stood not with the agencies but with his fellow ministers.

Two of the agencies — the Canada Council and the National Arts Centre — refused without active protest to accept the situation threatened by the bill. On 26 March 1984 the Canada Council issued a press release objecting to the legislation. On 4 May it released a background paper in which it pointed out the ways that, if the provisions of the bill were to be applied to it, the council would lose all real independence and be reduced to the status of an advisory body in a system where the decisions, given the customary demands on a minister's time, would almost invariably be made by the higher civil servants. The background paper listed four specific areas of increased control.

*Control of the corporate plan and operating budget*
Each year the Council will have to submit a detailed corporate plan to the Minister for the approval of the Cabinet on the Minister's recommendation. The corporate plan must encompass all activities of the Council,

including its objectives for the year and the strategies to be employed to achieve them. An operating budget must also be submitted each year to the Minister, for approval by Treasury Board on the Minister's recommendation. If during the year the Council intends to diverge from either the approved plan or the approved budget, it must seek and obtain approval of the changes before implementing them.

### The power to impose directives

On the recommendation of the Minister, the Cabinet can give directives to the Council. Such directives can take effect 31 days after tabling in Parliament. Once in effect, a directive must be carried out by the Council and the Council must thereafter report to the Minister that it has implemented the directive.

### Control of the by-laws

The Bill gives the Cabinet the power to direct the Council to make, amend, or repeal the by-laws of the Council.

### The power of dismissal

The Bill gives the Cabinet the right to remove from office at any time the Chairman of the Council, the members of the Council and the Director of the Council.

Clearly, no organization accepting such controls could any longer be regarded as the kind of autonomous decision-making group which the Massey Commission and the Canada Council Act had originally contemplated.

It is possible that these presentations, and the statements which Canada Council director Timothy Porteous and chairman Maureen Forrester intended to make to the parliamentary committee prior to the act's third reading, would have been unsuccessful if it had not been for the intervention of a high civil servant, Robert Rabinowich, deputy minister for Culture and Communications. Rabinowich, according to Porteous, rang him up and told him that public criticism of the bill by him or his staff or any members of the council would not be tolerated. This was an extraordinary procedure, since the Canada Council Act

states specifically that "the members and employees and the director and associate director of the council are not part of the public service of Canada." Rabinowich was not, as he seemed to think, addressing bureaucrats of the Department of Communications, nor, though the minister reported to Parliament for the council, did the deputy minister have any legal standing at all in relation to it.

Porteous stood his ground, and continued to protest. Minister Francis Fox unconvincingly denied that Rabinowich had issued any threat. Deputy Prime Minister Jean-Luc Pépin said that Rabinowich had indeed talked to Porteous, at Fox's own request. Then Donald MacSween, director of the National Arts Centre, reported that he had received a similar call from Rabinowich, and made his own protests before the parliamentary committee in defiance of the deputy minister. Shortly afterward, Brian Anthony, executive director of the Canadian Conference of the Arts, said, "We have been led to believe that it would be inappropriate for any agency to risk its good standing and well-being at this moment by speaking out against Bill C-24."

Robert Rabinowich's intervention in fact proved *in advance* that the misgivings which its critics had harboured about Bill C-24 were justified; that once it was passed and the cultural agencies were made vulnerable, the bureaucrats and the politicians would not fail to make use of their newly acquired powers. As one Canada Council official remarked to me, Rabinowich "provided a concrete example of what might otherwise have appeared to be abstract or paranoid fear." There is no doubt that the courageous stands of Porteous and MacSween, the wide support of the arts community, the action of a few perceptive M. P.s and the criticism of certain newspapers, notably the *Globe and Mail*, played crucial roles in the battle, but it seems to have been the timely revelation of bureaucratic overeagerness that forced the government to beat a retreat, and to agree, at the very last minute, to the Canada Council, the National Arts Centre, the Canadian Film Development Corporation and the Canadian Broadcasting Corporation being exempted from the provisions of the act.

Bureaucracy does not easily admit defeat, and this may well not be the last attempt to bring the cultural agencies — and by implication the arts themselves — under political control, so that

the granting of funds may be dominated by considerations other than the perceived ability of the artists. A Department of Communications document, "1983 Strategic Overview," states that "we will examine the need for Cabinet to be given the power to issue broad policy direction to the cultural agencies." Note that it is the Cabinet, not Parliament, that is mentioned, and Cabinet direction in effect means bureaucratic direction.

Patrons have not really changed over the ages; private or public, sooner or later they seek to impose their standards, and then it becomes necessary to be resolute in biting the hand that feeds and in showing a benefactor the limits of his rights.

# THE PERILOUS MYTH OF CULTURAL INDUSTRIES

I f becoming the servants of the urge to power is one danger the arts run in their association with the state, the other is becoming the victims of the profit motive. To a great extent the two perils have come together in the increasing tendency of bureaucrats within government departments, and even some within the agencies (especially the CBC), to treat the arts as the junior and lower-paid partners in the "cultural industries." The industrial concept, as we have seen, has fascinated politicians and some of the cultural bureaucrats at least since the 1960s. It is a concept that is kept alive if we talk vaguely of culture when in fact we mean the arts. And of course it is a convenient concept for government officials in their dealings with the arts. To treat the artist as a businessman simplifies matters for taxation officials who have no desire to trouble themselves with the special circumstances under which artists work. And to treat the arts as part of an industry simplifies funding and organization so far as the bureaucrats in offices like the Department of Communications and the Treasury Board are concerned. It also satisfies the business-minded average Canadian who lives by the profit motive and finds it hard to accept

that artists make to the community a contribution that cannot be valued in money. But it does endless harm to the cause of the arts.

Of course, if one accepts the broader definition of culture, there is no doubt that cultural industries exist. Any industry that satisfies needs which are more than physical can be called cultural. Cutting trees and smelting steel are not in themselves cultural activities, but designing houses in which they may be used is cultural. Growing potatoes or artichokes is not in itself cultural, but the way one cooks them is. Equally so are the technologies and the distribution systems that deal with information and entertainment. Publishing is a cultural industry whether one is concerned with Harlequin Books producing formulaic romances or Sono Nis Press printing poetry or the university presses publishing scholarly texts. Sound recording is a cultural industry, whether it enables us to listen to Doug and the Slugs or to a chamber orchestra playing Vivaldi. Mass-produced visual art is cultural, whether it is a matter of velvet paintings of tropical sunsets or commercially produced reproductions derived from paintings by Jack Shadbolt or Toni Onley.

Considered in this way, the cultural industries not only exist; they involve considerable investments and often offer wide possibilities of profit as well. In his 1983 book *Canada's Cultural Industries,* Paul Audley shows the surprising magnitude of what he terms with obvious satisfaction "a Growing Market," whose "increase of 265 per cent" between 1970 and 1980 "was significantly greater than the 238.2 per cent increase in the Gross National Product over the same period."

Expenditures on cultural products and programs in Canada are made by advertisers, by public and private consumers, and also through direct government support of production, particularly in the field of film and television. Total expenditure from these three sources in 1980 for newspapers, magazines, books, sound recordings, films, radio and television was $5.4 billion. These products are sold both in the advertising market and to the public. Revenue from sales of these products and programs to consumers accounted for the largest share of total expenditure, 47 per cent in 1980, while revenue earned from the advertising market accounted for 42 per

cent. A further 11 per cent of revenue came directly from the federal government through its support to the National Film Board and the Canadian Broadcasting Corporation.

Assuming the same rate of increase as Audley revealed during the 1970s, one can reasonably speculate that by 1985, even taking into account a lessened rate of inflation and less generous government grants, the total will have reached between $8 billion and $9 billion.

These are figures that will astonish and should anger the professional writers whose average income in 1982 was a little over $6,000, and the professional actors who in the same year earned round about $9,000. It is significant that while, in framing his estimates, Audley includes the most banal of newspapers and the most sleazy of disc-jockey radio stations, he leaves out, as though it were of no real importance to him or to the Canadian Institute for Economic Policy that employed him, the amount spent by the Canada Council in supporting individual artists and performing companies. He also leaves out not only live theatre, opera and ballet, but the very considerable "cultural industry" that centres around the visual arts, with their network of galleries and art museums, the last of which provide employment for the well-paid curators who are dependent on ill-paid artists for the works they curate. He leaves out too that invisible contribution which the Applebaum-Hébert Committee acknowledged when, in one of the most truthful and moving passages of a confused report, it said: "The largest subsidy to the cultural life of Canada comes not from government, corporations or other patrons but from the artists themselves, through their unpaid or underpaid labour."

In other words, in the minds of the advocates of cultural industries a hierarchy exists quite different from that generally accepted by the artistic community and followed in practice by the Canada Council. What we have already noted as the consequence of a general emphasis on culture rather than a particular emphasis on the arts comes into being when entertainment, mass media and true art are confused together, invariably to the detriment of the last, for there is a kind of Gresham's law operating in the world of cultural industries where bad art tends to

drive out good because it is more profitable. The great cultural industries are those technologically developed ones that stand a chance of making a profit and, through doing so on the world market, increasing national prestige as well as improving the trade balance. The place which the arts are given in such a pattern is shown by the following passage from the Department of Communications's "1983 Strategic Overview," which is typical of general governmental approaches to the question, but which seems all the more alarming because it comes from the very ministry that is now responsible for aid to the arts and which should see its role as their protector.

*The globalization of culture through the communications marketplace.*
Improvements in long distance telecommunications systems, culminating in satellite development, as well as overall bandwidth expansion have largely eliminated distance as a cost factor. The result had been increasing integration of the Canadian communications system into an emerging North American and global grid. While large areas of the Canadian market have opened up to increased foreign exploitation, new areas of enterprise have been created as a result of the trend to a global marketplace. Today the so-called "cultural industries" represent a major (and growing) industrial activity which is (and will continue to be) labor-intensive. They also promise an outlet and audience for the creative and performing arts. Their continued vitality is essential to sustaining and developing the cultural life of our country, to strengthening our sense of national identity and to maintaining our cultural sovereignty. Although technological developments pose obvious threats to the viability of Canadian cultural policies, industries and institutions, we must also recognize that the transition to an era of increased competition presents a tremendous opportunity to reach larger audiences.

It is clear from this passage that the important elements so far as the bureaucrats view the situation are (a) resistance to foreign exploitation, (b) gaining a profitable position in the "global marketplace" (the newest manifestation of McLuhan's

127

global village), (c) the provision of employment through a "labor-intensive" industry and (d) the achievement of the essentially political goal of "strengthening our sense of national identity and . . . maintaining our cultural sovereignty." Clearly subordinate to all these goals is the possibility that the cultural industries will "also promise an outlet and audience for the creative and performing arts."

Unfortunately the cultural-industry approach to the arts, which sees them in terms of profit rather than of the kind of special service to the community that artists and the arts provide, has led even the Canada Council at times into the kind of defensive tactics that play into the hands of the profit-minded. I am thinking, for example, of a document called "An Assessment of the Impact of Selected Large Performing Companies upon the Canadian Economy," which was undertaken on behalf of the council in 1974 by the management consultants Urwick, Currie & Partners. The firm took three representative performing groups that received considerable subsidies from all levels of government, federal, provincial and municipal. It calculated what was "accruing to the three levels of government in direct and indirect taxes, and revenue from government services (for postage and electricity)" and found that in each case they represented "very substantial proportions of government grants to the company." In the case of the Royal Winnipeg Ballet, the federal government received back in taxes and other payments 74 per cent of its grants, the provincial government received 194 per cent of its grants, and the municipal government received 70 per cent of its grants. Taken together, 96 per cent of all grants were repaid in taxes or payments for service.

The situation of the Théâtre du Nouveau Monde was rather similar to that of the Royal Winnipeg Ballet; the equivalent of 86 per cent of all grants from governments went back in taxes to the respective authorities. The case of the Toronto Symphony Orchestra was even more striking; against grants totalling $662,750, the government revenues from direct and indirect taxes reached an astonishing $1,225,400.

But this, as the report revealed, was not the sum of the benefits which, as a result of the grants they had received, the three companies offered in material terms to the communities that supported them.

Further, the three companies demonstrate a combined annual demand for local goods, materials and services — including outlays by members of the public attending performances — to a combined value of some $2,897,000 annually. In addition, the three companies pay their artists and other employees as a whole wages and salaries of which approximately $2,813,000 remains as disposable income after taxes. Thus, the total value of demand purchases by the companies, plus disposable income earned by their artists and employees, amounts to about $5,710,000 annually. If this amount is combined with the value of direct and indirect tax receipts, and revenue from government services, attributable to the companies ($2,152 million), the resulting sum total is $7,862 million. This total is approximately four and a half (4.64) times greater than the total value of grants to the three organizations, combined. In other words, the three organizations as a whole are not a drain on the public purse.

These are indeed impressive figures with which to counter the arguments of those who regard the arts as an unjustifiable financial extravagance, since they show that, even if performing groups may not show a profit on the books, they make a notable economic contribution as well as provide work for artists and technicians. Such arguments can hardly be made with as much certainty for the creative arts. It would be much harder to determine the economic benefits to the community of providing support for a poet whose books sell in the hundreds and whose tax contribution, no matter how hard the revenue officials may try to shake the poet down, is bound to be negligible. And the fact is that even in the case of the performing arts, the real contribution they make to the community, the contribution that is the very reason for their existence, is ignored in the equation. One cannot judge the inspired insights of the artist by financial criteria any more than one can weigh a butterfly in the scales against a bar of gold.

In fact, by making calculations of the kind I have just been discussing and using them to justify public aid to the arts, one plays into the hands of those who wish to subordinate artistic values to material ones, who want to turn the arts into cultural industries. The capitalist ethic demands something for its

money, an economic tit-for-tat, just as the communist ethic demands a political tit-for-tat; Tweedledum and Tweedledee. But the arts are only viable, and only justifiable, if they serve values other than economic or political. Their real contributions are not in taxes paid or jobs created or propaganda provided, but in the irradiation of our lives by the gifts of the imagination, and it is for this reason that the community, which in present political circumstances happens to operate through the state, must support them, and that whether or not they make money in any way is quite irrelevant.

In fact, no sensible member of the public expects a profit out of the performing arts, or thinks a theatre economically reprehensible because it needs regular injections of funds from the public purse. As the publisher Michael Macklem said in an eloquent essay that defends publishing, like the performing arts, from the assumption that it must be an industry like others, "Nobody thinks that running a ballet company or an art gallery or a symphony orchestra is a risky business. Nobody thinks that the Stratford Festival, for instance, is a *business at all,* still less a *risky business.* The Festival doesn't *lose* money. It *spends* money, and spends it, one hopes, in the public interest." Even less do some of the more radical art forms, like video or environmental art, take account of profit, while they have their own, often bizarre, ideas of what is in the public interest.

To spend money in the public interest, but not to lose it on artistically ill judged ventures, was the essence of the Canada Council's original mandate; no question of inducing a profit from its interventions, so long as the books of the agency were well kept, ever entered the thoughts of its founders. They may have hoped for political benefits, but the act establishing the council and setting its general course made no mention of them and released the body it created to become — along with the prototype Arts Council of Great Britain — a model of an arm's length agency that has been imitated in other English-speaking countries that have embarked in programs of public support for the arts.

And, despite the pressures exerted by less disinterested governments than that of Louis St. Laurent, despite the temptations of earmarked grants, despite the pressure to present profit-and-loss justifications of its grants, despite the most recent attempts

under Bill C-24 to expose the cultural agencies to the forays of power-seeking bureaucrats, the council has on the whole performed well, largely because it has resisted the trend to absorb the arts into a complex of cultural industries that in the end would be as totalitarian as any political autocracy. One may have criticisms of council procedures or of the balance of granting between various categories — and some of these criticisms I shall eventually voice — but one can only agree with the consistent general policy that has been maintained from Peter Dwyer's day to the present, and that was reaffirmed in a remark Timothy Porteous made in 1982 when the Applebaum-Hébert Report was released. The report recommended that the Department of Communications funding of publishers, which is tied to sales and therefore is industrial in approach, should be merged with the Canada Council's grants, which are more closely related to the quality of the books published. "I see book publishing — like theatre," said Porteous, "as a cultural service, not an industry."

Publishing is in fact a vital frontier area so far as the relationship between arts and industry is concerned, and I use it to illustrate the problems aroused by the concept of "cultural industries." It uses print, an older medium, so that its relationship with the new electronic media is tenuous. It was in fact condemned to death some decades ago by Marshall McLuhan and his tuned-in disciples, but has remarkably survived the prophesies of death by obsolescence. In some areas, like the production of textbooks or of do-it-yourself manuals or cookbooks or formulaic novels and romances written for mass sale, it is indistinguishable from any other industry bent on acquiring maximum profits by mass-production methods. Yet at the same time, healthy and vigorous publishing is the mainstay of a strong literary culture in any country, and here in Canada the element of profitable activity begins to thin out as one advances from the publishers whose entire aim is to make money without regard to the literary merits of the books they publish, through those who are still intent on making profits but have enough respect for publishing traditions to bring out a few books for their intrinsic quality, to the surprisingly large number of small publishers who are dedicated to the cause of serious literature and are willing to take great risks and accept small returns in order to publish it.

131

There are, at present, two ways in which the federal govern-
ment is giving money to publishers. One is through the Can-
ada Council, which has given grants determined by the literary
quality of books. In the most recent figures I have at hand, for
1982–83, Harlequin Books does not figure among those
receiving block grants, nor do a number of publishers whose
profit-making orientation is well known; on the other hand,
houses which place literary quality above economic consider-
ations, like Sono Nis Press and Coach House Press, like
Talonbooks and Véhicule Press, receive larger allocations than
publishers nearer to the commercial end of the spectrum like
McClelland & Stewart and General Publishing. It is a way of
robbing Peter to pay Paul that, in accordance with the coun-
cil's general principles, rewards quality that would otherwise
go lacking.

The other way of supporting publishing is represented by the
program which the Department of Communications has devel-
oped parallel to that operated by the Canada Council. It repre-
sents current government policy, related to the general stan-
dards of the business community, as distinct from long-term
council policy, related to the general standards of the artistic
community. It is the attenuated remnant of the much more com-
plex Canadian Book Policy Development Program devised under
David MacDonald's supervision when he was Conservative sec-
retary of state, and it grossly simplifies the intentions of that
quite elaborate scheme by offering financial assistance that will
be wholly tied not to the quality of the books that are published,
but to their sales potential. Within limits — they must have a
certain minimum level of sales — publishers are aided in
accordance with the performance of their books on the market.

This is a typical cultural-industry approach, and encourages
the industrial rather than the cultural side of the question, since
there are many reasons why a publisher may successfully sell
books quite apart from their value in literary terms. He may have
an excellent publicity department; he may have an aggressive
distribution service; he may be wise enough to sustain an
exceptionally active backlist. All these are laudable achieve-
ments, and they are likely to please any published author, since
they mean in the long run increased royalties and a broader
exposure to public attention. But they do not necessarily

enhance the quality of the books issued or their eventual importance in our country's literature.

For in the long run the immediate commercial (or *industrial*, to use the more fashionable word) viability of any work of art is of little relevance. In the short run it is the original, the experimental, the uncompromising writers who are the hardest to sell, but in the long run they are often the easiest because their subterranean influence brings public taste to the point where they are understood and appreciated. And so we see writers like D. H. Lawrence and James Joyce, read only by a discriminating minority when they were first published, now selling in large popular editions year after year because their books have become essential elements not only in the literatures of English-speaking cultures but also in the literature of the world.

Thus a heavy responsibility lies with publishers, and many of them take it seriously. If one wants to succeed commercially, in the sense of making an easy fortune, publishing is a much more risky business than most. When publishers make business news it is usually because their houses are recurrently on the verge of bankruptcy. Some publishers, it is true, spend their careers producing safe lines, and they can probably best be regarded as part of an industry, the business of bringing out printed matter that is neutral artistically or intellectually. But even among these houses apparently committed to commercial ends, there are many who recognize the other side of publishing, its importance precisely as a vehicle for bringing the literary arts and the exercise of the mind into the lives of the reading public. Quite often they use the proceeds of their profit-oriented publishing to bring out the kind of books that in their hearts they regard as the most important.

Beyond these publishers who occasionally use the profits of commercial publishing for the benefit of literature there are those little-press publishers like Contact Press and Coach House who work with no real expectation of profit, entirely for the sake of poetry or drama or fiction, and who form the necessary counterparts of the originative and experimental writers whose works they publish. They sell their books like any other publisher, and profit may occasionally result, but their mission is to bring to the public literary works that would otherwise go unpublished, and in no real sense can they be considered

commercial enterprises. It is these publishers who are helped notably by the Canada Council's kind of publishing subsidies and hardly at all by any kind of assistance based on sales. Yet because of the currently scanty market for the books they publish, they are most in need of aid given in the right way. The commercially enterprising publishers can and often do — like Harlequin Books — look after themselves very well.

The same applies to the matter of loans. These are most acceptable when a publisher is on the verge of ruin; no one disputes the timely appropriateness of the Province of Ontario's loan to McClelland & Stewart in 1971. But the idea of a loan presupposes either that it can be repaid or that — in the case of a government loan — some benefits accrue to the community even if it is not repaid. But, as Michael Macklem points out in the essay I have already quoted, "in publishing financial risk is not the problem. A book can win a Governor General's Award and still lose money — in fact, many do. The problem is that Canadian books — at least the kind that we care about — are intrinsically unprofitable. In such a situation, a loan, guaranteed or otherwise, is useless to a publisher unless he keeps the money and refuses (or is unable) to pay it."

The recurring crises at McClelland & Stewart emphasize Macklem's point. Caught in the trap of rising costs and a slumping market — which had already put old-established firms like Clarke Irwin out of business — and not well endowed with management talents, McClelland & Stewart slipped further and further into debt. From 1971 to 1984 it received an additional $3 million from the Ontario Development Corporation and still in the fall of 1984 was on the verge of bankruptcy.

The prospect of the foundering of the most important Canadian-owned publishing firm struck such fear in the hearts not only of writers but also of fellow publishers (who received far less in Ontario government aid), that the Writers' Union of Canada and both publishing trade associations, the Association of Canadian Publishers and the Canadian Book Publishers' Council, appealed for aid to enable McClelland & Stewart to reorganize itself on a firm financial footing. The Government of Ontario responded by giving the firm an outright grant of $1.5 million, by releasing it from an Ontario Development Corporation loan of $1 million and by opening a new credit line with the ODC of

134

$500,000. These concessions enabled McClelland & Stewart to attract a group of private investors, including several of its own authors, who together put up $1.1 million.

Perhaps this is the only really positive element in the situation. For though it is doubtless a good thing in the short run for Canadian writers and readers that McClelland & Stewart should have been rescued from imminent collapse, it is not a good long-run solution for publishers to end up as perpetual debtors to governments. It makes them more vulnerable to the will of the state, and the will of the state, when the concept of cultural industries prevails, is that a publisher should become, first and foremost, a good businessman, which is not necessarily the same as a good publisher. On the other hand, the collective involvement of people like writers, concerned with good publishing rather than business success at any cost to quality, offers the positive vision of co-operative ventures. These could bring together writers and people experienced in the trade, which might be less perilous than relying on more massive government aid. At the same time it would be more practical than the efforts of past collectives of writers entering publishing without experience, which have only rarely succeeded.

Because it is so varied in its aims and procedures, publishing probably demonstrates more clearly than any other commercial activity ancillary to the arts the perils of the cultural-industry approach, with its inevitable homogenizing tendencies. At one end publishing is indeed entirely industrial, devoted to books written according to set formulae with the sole aim of making the maximum profit. At the other end it shades off into the very arts it serves, when poets run presses for publishing the works of other poets, almost entirely with the aim of getting into print material too experimental for commercial publication; in such cases the publisher expects little or no profit, the writer expects little or no royalties, and the industrial factor is imperceptible.

Roughly the same range exists in the world of the visual arts between the mass publishers of prints and the small art dealers who are often painters anxious to help themselves as well as other artists. Such people are hardly businessmen, let alone the representatives of an industry.

In the other so-called cultural industries the situation is more complicated, largely because in broadcasting, film making and

music recording much larger investments of private capital are involved, together with either larger public subsidies or corresponding tax breaks. Another aspect of these areas where the arts and business interests come together is that, like ordinary noncultural industries, they tend to be heavily unionized, and the technicians they employ earn, on an average, far more than either creative or performing artists in Canada. The result of high capitalization and high unionization is that though such industries fit into the cultural pattern as anthropologists conceive it, they have relatively little to do with the arts as they are practised in Canada.

The Canadian Radio-Television Commission, for example, has offered a record of dismal failure in its attempts to use the regulation of cablevision and pay-TV to support a reasonable degree of arts programming; it has not even forced the CBC to live up to its obligations in this area, so that though radio has improved in recent years, even public television in Canada remains lamentably deficient in its exposure of the arts, in its commissioning of original dramatic and musical works and in its employment of performing artists.

In the film industry 100 per cent tax breaks have resulted in a relatively high degree of investment in privately made feature films, which is now in the neighbourhood of $155 million per annum, but although there have been a number of small triumphs in critical terms, Canadian film making is beset by many problems, of which financing is perhaps not the most important. In other words, something more than tax breaks is needed. Even the minority of Canadian feature films that have been hailed as fine examples of the cinematographic art are at a disadvantage because up till now distribution in Canada has been almost wholly in the hands of two chains tied in to Hollywood interests, Odeon Theatres and Famous Players. This had meant in the past that somewhere near 97 per cent of new films available for distribution in Canada have been of foreign origin.

Possibilities for change in the film-distribution situation have arisen. The Canadian-owned Cineplex Corporation is taking over the Odeon chain of cinemas in Canada. Also, the Department of Communication has announced that it is working on a voluntary agreement with both Odeon Theatres and the still-American-owned Famous Players for a better distribution of

Canadian-made feature films. The Quebec government has gone a step farther by legislating in Bill 109 that distributors invest a portion of their gross annual revenues in Quebec films, which means support for one of the most vital sectors of Canadian film making. Federally, about $8 million a year is being added to the Canadian Film Development Corporation's budget for the start-up, marketing and promotion of films. More ominously, in the year of Big Brother, the CFDC was renamed in authentic Newspeak; it is now Telefilm Canada.

The other ominous feature of the package being offered for the salvation of Canadian films is the mutilation of the National Film Board, which unfortunately was not among the institutions exempted from the provisions of Bill C-24. The changes that Francis Fox proposed cannot take place until Parliament agrees to amend the National Film Board Act, but if this happens its existence as an autonomous and publicly funded film making institution will virtually end. It will become largely a training and research unit, collaborating — when it does produce — with private film makers. In this event, it will be effectively removed from competition with the private sector, whose representatives naturally rejoice; according to *Maclean's*, Stephen Ellis, president of the Canadian Film and Television Association, which represents private film makers, remarked on hearing the Department of Communications's proposals: "Fox has taken our cause to heart."

Clearly the cultural-industry approach has led to the end of the National Film Board in the form with which we were familiar. It is being cut down to a remnant, and may not survive the operation. One must admit, of course, that like the CBC, and to a lesser extent the Canada Council, the NFB has recently been suffering from bureaucratic ossification, and that the days when one felt a pride in its continuing achievements are long past. But there are ways of dismantling the bureaucracy of such an agency and returning control to the artists that might have revived the enterprise as a subsidized co-operative devoted to the production of films that preserve a people's heritage, as the best NFB films did in the past, without ever aiming at box office success.

Under whatever name it operates, the CFDC is another matter. It has always been an ambivalent kind of institution, in spirit

137

halfway between the autonomous Canada Council and the bureaucratic Department of Communications. In itself it has produced nothing, and has so far been mainly a channel for funds — seed money at the start of a film — and for tax breaks, though it may shortly be embarking on distribution. In granting money and authorizing tax breaks it has been in some ways more intrusive and in others more lax than most other arts-funding institutions. As James Lorimer points out in his "Cultural Politics" column in *Quill & Quire* in 1980:

> To try to ensure Canadian films are being made in this country, the Secretary of State's Department and the CFDC set up criteria to judge whether a film is indeed Canadian. Only certified films are eligible for a tax break. A point system gauges the citizenship of stars, directors, scriptwriters and others, and conducts what industry people term "political inspection". Listening to complaints about how stringent all this is, it sounds impressive.
>
> Hollywood, however, sees it differently, and Hollywood is nothing if not realistic. U. S. producers lost their tax break in 1976 in that country. Now American movie producers are rushing around putting together deals with Canadian front men as partners. Most of the movies actually being made under the tax break in Canada are second-rate American films.
>
> Commercial film producers see nothing subversive in making U. S. films in Canada. They see not two separate countries, but one big North American market.

I suspect that the situation has not changed greatly since Lorimer wrote those lines. Certainly my experience tells me that the CFDC is reluctant to sponsor Canadian films that are more experimental or more serious than the general box office run, while it is willing to promote junk films with a North American appeal so long as they are adequately financed and meet the letter of the tax break regulations. One soft porn film, financed largely by Vancouverites with spare money, intended for the American skin market and starring a well-known but aging sex kitten from Sweden via Hollywood, had no difficulty getting the appropriate tax breaks. On the other hand I was personally involved in a film project with an internationally recognized

138

director who is a political refugee from a country high on Amnesty International's list; we devised a film that would express universal political concerns but was intensely local in its setting so that everything would be transformed into and voiced in Canadian terms. We asked only for seed money. We were offered it on condition that our script be rewritten to CFDC specifications. We naturally refused. It might be appropriate for an agency employing artists, like the CBC, to specify changes in a submitted script, but such a suggestion, with its hint of political pressure, is quite outside the competence of a funding agency; the Canada Council would never have made it.

A situation like this, it seems to me, is the inevitable result when the cultural-industry approach takes over. However much officials in the CFDC might be interested in the artistic approach of a film, its potential for commercial success will be their real criterion, and therefore we can fairly expect the inferior Hollywood project, once the regulations have been satisfied, to seem preferable to the more intellectual and commercially difficult film that a Canadian team might put together. The role of the arts and of genuine artists in cultural industries like film and television and music recording is bound to be precarious, as in Hollywood it always was. The fates of Scott Fitzgerald and Nathanael West, splendid writers mangled by the film studios, and of a great novelist like Aldous Huxley pathetically waiting for jobs from half-literate producers, should be in our minds. There is no reason why a successful Canadian film industry should be a kinder place to the country's artists, and nothing that the Canadian government is at present doing to promote the industry is likely to change that situation.

The industrial side of cultural industries like film, television and recording is likely to be as frankly financial as that of any other business: a matter of profits, tax breaks, good pay for unionized technicians, precarious returns for artists who happen to find their way into the maze. The cultural side is likely to be political, a matter of governments striving for tangible control over the various media so that they can use them for whatever more abstract goal may lie in their minds, such as the satisfaction of nationalist urges or, in recent years, the pursuit of centralized power under the guise of "national unity." For this reason we must be sure what we are talking about, and if we are

talking about the arts, let us do so and not talk about culture. It is clearer, and it is safer. It does not land one in the contradictions that beset the Applebaum-Hébert Committee, which accepted the impossible task of considering the arts, the cultural industries and the historic heritage as well, and in some way framing a comprehensive report that would cover them all and usher in a new era for artists in Canada.

It was a grandiose enterprise, with an overcrowded membership that included artists and arts entrepreneurs, cultural bureaucrats, cultural industrialists and the usual scattering of Liberal party faithful gaining their rewards. It cost $3 million or 40 per cent of the Canada Council's annual grants to individual artists. It listened to even more people than the Massey Royal Commission. And it eventually produced a thick report of four hundred pages, with 201 recommendations.

Since no government is again likely to fund such a venture in the near future, this is probably the last full-scale enquiry we will see into the state of the arts and related areas for at least a decade, and perhaps much longer. Some of it has found an echo in government policy. Much will be ignored. And the fate of the rest will depend largely on the policy of the new Conservative government, which up to December 1984 had done little more in the field of the arts than to threaten reductions in grants while vowing to sustain the arm's length relationship between government and cultural agencies.

In the first two years after the report appeared, very few of its recommendations were implemented, because many of them did not suit the policies of the Department of Communications. But one has the feeling that it is also because of the lack of a consistently commanding vision such as that which inspired the Massey Commission, a vision which eventually transformed the situation to such an extent that now there is an often bewildering profusion of schemes to nurture the arts at the same time that the artists, though vastly more numerous than in 1951, are — as Applebaum, Hébert and their associates recognize — not much better off individually than they were a quarter of a century ago.

There is no single recommendation in the Applebaum-Hébert Report that has the grand simplicity or is likely to have the eventual consequences of the Massey Commission's recommendation regarding the Canada Council. Indeed its most

sweeping statements really do no more than echo and confirm what Massey and his associates already said: that "the artistic profession should be put on the same footing as any other honourable and vital vocation," and that "to the extent that the functions of cultural agencies and offices require the exercise of impartial critical judgment in support of cultural activity, they should be exempt from political directives of either a general or a specific nature." How seriously the last recommendation was taken by the Trudeau government has been eloquently demonstrated in its attempt to deprive the cultural agencies of their arm's length status under Bill C-24.

Many of the other recommendations have a cosmetic flavour and seem to bear only peripherally on the immediate concerns of the arts and artists, such as the suggestion that a Contemporary Arts Centre be established with museum status or that the National Arts Centre should cease to be a producing institution and instead should provide facilities for national and international companies. A few excellent minor recommendations that did not require legislative approval have been acted upon by the cultural agencies. The Canada Council, for example, has already increased its rate of subsidy to translators and has introduced a long-needed program of grants for nonfiction prose writers.

The most disturbing aspect of the report is its tendency to respect the profit motive and its resultant lurching towards the more commercial aspects of the cultural industries. The respect for the profit motive even appears where no industrial element is involved. To everyone's surprise, for example, in recommending the recognition of a public lending right that would bring writers remuneration for the loan as well as the sale of their books, it suggested that payment should be based, not on library holdings or on library loans, which would bring rough justice to categories of authors whose books do not sell greatly in bookstores, but on royalties, which would mean that commercially successful writers would get even more and poets would hardly benefit at all. "To him that hath shall be given" is hardly a sound principle in aiding artists.

In publishing, the committee's recommendation to merge the Department of Communications subsidies based on sales and the the Canada Council subsidies based on quality of books published bespeaks a remarkable naiveté, since it fails to recognize how

far in such an arrangement the DOC bureaucrats could be expected to press for the implementation of their cultural-industry approach as opposed to the Canada Council's publishing-as-an-ancillary-art approach. Proposals to assist Canadian-owned pop recording companies with loans for equipment and assistance in marketing takes us right into the jungle of mass entertainment where the profit motive is undisputed king. Still, the proposals of the Applebaum-Hébert Committee that aroused the most astonishment and the most justified criticism were those recommending the virtual dismantling of the Canadian Broadcasting Corporation and the National Film Board as we have known them.

Both these organizations, and especially the CBC, have been the targets of reproach for many years, and I have been one of the CBC's most active critics, on the grounds that it has increasingly neglected the arts and it has become progressively more commercialized and Americanized through its pursuit of advertising revenue and the ratings necessary to obtain such revenue. As well, it has denied its mandate to bring Canadians together by virtually eliminating the autonomy of regional units and centralizing decisions on programming, if not production, exclusively in Toronto for English-language and in Montreal for French-language broadcasting, so that the regional dialogue that is needed for mutual understanding between Canadians has not developed. What we needed, in the case of both the CBC and the NFB, was their retention in public hands, but with a massive inner reconstruction that in both cases would have led to a creative revivification.

Instead, the committee recommended that both the NFB and the CBC be virtually stripped of production facilities, the NFB doing a few coproductions, the CBC producing only news. In the case of film the emphasis would shift to a more heavily funded CFDC, so that, with public film production virtually at an end, the emphasis would move to private production, subsidized by grants and tax breaks, and to the eventual creation of a cultural industry, commercially motivated and almost certainly dominated by the continental attitude towards markets and hence towards cinematographic style that is already too prevalent in the Canadian film industry. These are the only recommendations accepted and enthusiastically acted upon — as we have seen

142

— by the government, since the emasculation of the NFB and the encouragement of the private sector at its expense suited the cultural-industry project of the Department of Communications.

The CBC has remained untouched largely because it is at present the fiefdom of one the more powerful of Trudeau's companions, Pierre Juneau. Juneau has shown no inclination to reform the CBC from within, and indeed has merely encouraged the centralization of decision making. He is likely to resist externally imposed change, though how successful he will be under a Tory government, with his personal influence steadily diminishing, is hard to say. But he may be able to delay change long enough for saner counsels to prevail when it comes inevitably to reconstructing the CBC as a genuinely creative entity.

It is hard to understand the reasoning behind the Applebaum-Hébert Committee's recommendations in this case, though it is said that they were made at the insistence of Jacques Hébert, the cochairman, one of those Quebec Liberals who still believes that Radio-Canada is operated with a separatist bias; Hébert, it is also said, wanted to take even news production away from the CBC, which would have been the final blow to its reasons for existence.

As they stand, the recommendations seem notably inconsistent, but there is a bias in the inconsistency. The suggestion that commercials should be eliminated from CBC television has long been pressed by the corporation's critics and by the best of its production staff, but with the assumption that the CBC would then be free to produce better programming and to take risks in drama and the arts that were not possible within the straitjacket of the ratings system. It was assumed that in accepting this proposal, the government of the day would recognize the importance of public broadcasting enough to provide funds to make up for the loss of advertising revenue. Commercial broadcasters would of course benefit from the elimination of a competitor in advertising, but at least the CBC would be less dominated by the industrial aspects of broadcasting and more able to weigh its cultural aspects.

The Applebaum-Hébert Committee, however, proposed to take away from the CBC *both* advertising revenue and production, and hand over the first to private broadcasters and the second to private film makers and television producers; this, of

143

course, since there would be no advertising revenue to pay for production, would mean just as large a public grant as would be needed if the CBC lost advertising and kept production. The CBC, except for its news service, would remain little more than a planning bureau, farming out its programs to entrepreneurs who have so far shown little evidence of being superior to CBC production units. But to operate such a system in a way that might inspire private film makers and weld their contributions into a seamless garment would require just the same renewal of vision that could transform the CBC into a viable and entirely public institution. So the Applebaum-Hébert recommendations seem pointless except as an expression of some of its members' deep hostility towards the CBC, and as a tendency to accept the bureaucratic inclination to sweep everything into a single cultural industrial pattern. One can only accept the acerbic remarks of Ioan Davies, reviewing the report in *Canadian Forum* shortly after it was issued: "The report, in spite of the bromides, is structured by those who will make the decisions, by fiat or by stealth. Massey-Lévesque had a vision (albeit an elitist vision) which it imposed on a torpid bureaucracy; Applebaum-Hébert's vision is muted by their hypersensitivity to that bureaucracy."

*Chapter 12*

# THE LEFT HAND OF THE STATE

In 1983–84 artists of all kinds in Canada, whether perform-
ing or creative, visual or literary, were confused and dis-
tressed because the state, like one of those benign yet
malignant Hindu goddesses, had chosen to show its evil face to
them. Enduring a year of extraordinary attacks from National
Revenue authorities, they might well have echoed Job when he
said, "The Lord gave, and the Lord hath taken away," though I
have yet to hear any artist paraphrase Job so far as to add,
"Blessed be the name of the State." Their reactions were anger
and bewilderment, and others outside the world of the arts
shared this response to the inexplicable inconsistencies in the
government's treatment of artists. As the tax lawyer Arthur
Drache remarked when he gave evidence before the parliamen-
tary Sub-Committee on the Taxation of Visual and Performing
Artists in April 1984,

> It seems to me that the major problem we have is a kind of
> governmental schizophrenia here. On the one hand, it is my
> view, Canada is among the most generous countries in the
> world in direct support of its artists through Canada Council
> and other grants. I have yet to run into a deserving artist who
> had not had a good shot at government money. The govern-
> ment, through Canada Council, has been bold enough to

145

underwrite projects that are not necessarily terribly politically attractive, if you will, in the nature of the work that the artists do. I think the system has worked extremely well. . . .

On the other hand, having given them all this preferential treatment, you turn around and you nickel and dime them to death in the tax system. Artists tend not to be terribly sophisticated in financial areas. Some are, but as a group they are not. They really cannot seem to grasp why the government giveth with one hand and taketh with the other. To be perfectly honest, I do not understand it either.

The situation that arose in 1983 and reached a crisis point that autumn was not caused by any change in the law to discriminate specifically against artists. It was due to sections of the existing law that, unimaginatively reinterpreted and rigorously applied, would lead to great inconveniences to many artists and a rapid worsening of their already precarious economic situation. That such problems might arise had been foreseen in the early 1960s when Gérard Pelletier instructed his staff in the Department of the Secretary of State to investigate the tax problems of writers and artists and see whether adjustments to the tax structure might assist them to make a better living in practising their arts. The same concern was behind the appointment of Russell Disney in 1977 to analyze the situation and prepare recommendations. As we have seen, Disney's recommendations, whose implementation would have gone a long way towards preventing the crisis of 1984, were allowed to vanish in a morass of bureaucratic committees, so that the Cabinet never had a chance to consider them properly.

The question of artists' taxation had been on the agenda of the Applebaum-Hébert Committee, but no expert evidence was called, little research was done, and the committee gave the subject a very low priority when making its recommendations. Instead of attending in detail to artists' tax problems, the committee ended with a general recommendation that was worse than meaningless: "Tax provisions respecting the employment status of artists and such matters as the calculation of their costs against income, the valuation of works given for public use and enjoyment, and their entitlement to income averaging must

afford equitable treatment in comparison with those applicable to other classes of taxpayers." Here the very committee that was presumed to be seeking how best to give artists an economic security befitting the value of their contribution to society failed completely because it did not draw attention to the special circumstances of the artists' calling, which differentiates them from other producers and makes identical treatment under the tax laws discriminate against them and in many cases worsen their already difficult situation.

Some months after the Applebaum-Hébert Committee failed to draw attention to the threats to artists embodied in the Income Tax Act, Revenue Canada, substituting computers for imagination, began to move in on the arts community from a number of directions.

The problems of the performing artists and the companies and theatres with which they worked tended to centre around the question of employment. If artists were regarded as employees, then, if the tax laws were strictly applied, they could claim only the statutory $500 as expenses. The situation was most serious in the case of musicians in symphony orchestras, who had to supply their own instruments, often worth $50,000 or more, and keep them in good shape. A variety of interpretations had been applied in different parts of the country: the musicians of the Vancouver Symphony Orchestra were treated as employees and those of the Montreal Symphony Orchestra as self-employed, while those of the Edmonton Symphony Orchestra had been ruled employees but had gained a reversal of the ruling on appeal. The point of crisis came when the musicians of the Toronto Symphony Orchestra, against their will, were ruled to be employees and thus became unable to deduct from taxable income not only the cost of keeping their instruments in good shape but also the capital cost allowances and interest charges on the instruments. The players' committee estimated that this change in the rules would mean an extra $1,500 a year in taxes on incomes averaging, for symphonic musicians across the country, less than $18,000 a year, though some Toronto musicians may receive a maximum of $30,000. A great deal of publicity surrounded the Toronto decision, and the matter was put in abeyance, although Revenue Canada did not explicitly retreat from its position.

A bizarre situation arose in February 1983, when the actors in a children's theatre, the Carousel Players of St. Catharine's, Ontario, were deemed to be employees. This meant that the theatre was faced all at once with a bill — which it was unable to meet — for arrears in payroll deduction on the actors' salaries, as well as for unemployment insurance premiums and Canada Pension Plan contributions. When the theatre disputed the decision, Revenue Canada seized $17,000 in Canada Council and Ontario Arts Council grants. This was not the first time such a situation had arisen. The Mermaid Theatre in Halifax had earlier been treated in the same way and had won on appeal, as the Carousel Players eventually did when professional organizations took up its case and the press gave it widespread publicity.

The grotesque situation of one branch of government seizing the grants given by another branch of government highlights the anomalies of the condition of performing artists, who have heavy expenses incidental on their careers. Whether the performer is a salaried employee of a theatre or an orchestra or works on a freelance basis, there is no such distinction when it comes to having much greater costs linked to their profession than an office or a factory worker has. Indeed, as Disney points out in his 1977 report, many Western countries, including France, the United States, Sweden and Denmark, "have recognized the fact that the pattern of work relationships found in the occupational group is unique, and have therefore provided similar treatment for all members of the group regardless of their legal employment status."

Such situations are partly a result of pressure on tax officials, in a time of financial stringency, to shake down every citizen for as much cash as possible; the revelations in late 1983 of a quota imposed on tax auditors with the approval of Bruce Macdonald, then deputy minister for National Revenue, bear this out. But they also betray a bias on the part of civil servants against individual performers who maintain a certain freedom in their choice of employment and whose occupational circumstances do not easily fit into bureaucratic categories. This explains why, though tradition forces Revenue Canada to recognize the special nature — beset by the elements — of the situations of farmers and fishermen, and to treat them differently from either employees or ordinary businessmen, revenue authorities have so

148

obstinately resisted the simple conclusion that the artists' needs and their ways of earning an income are as much dependent on the caprices of the muses and public taste as those of farmers are on the weather and those of fishermen on the tides. Being therefore distinctly abnormal in an industrial society, artists should be treated abnormally: concepts of employment and tax rules deriving from them are irrelevant to the artists' situation.

A similar attitude emerged in 1983 in the cases of visual artists and writers who were subjected to Revenue Canada's attentions. Here the situation reflects the desire to incorporate the arts into an industrial framework, and to use profitability as a criterion in judging an artist's efforts. Visual artists, because they make and sell physical objects such as paintings, sculptures and prints, are classed by Revenue Canada as manufacturers in the same way as are mass producers of tourist souvenirs or, for that matter, of motor cars. They are expected to maintain inventories of their stocks of art works, and to present their tax returns, like other businessmen, on the accrual basis. With this type of taxation, expenses are related to sales in such a way that the cost of manufacture (whether that means canvases or travel expenses or casting of sculptures) cannot be regarded as a deduction until the manufactured goods have been sold. This may suit manufacturers who have an assured market and a regular turnover, but in the case of artists, who sell what they can when they can and when they are inclined, the system is unworkable. An artist, for example, may go on a trip and come back with a mass of sketches and some finished work, such as drawings and water colours. The finished works may take several years to sell; the sketches may provide the artist with notes to be used for a lifetime. To try in such a case to relate expenses to sales is clearly absurd. It was in fact a case of this kind in the autumn of 1983 that triggered the dissatisfaction among artists that swelled into a general tax revolt.

It started with the Vancouver artist Toni Onley, whose salable style of painting has made him one of the exceptions to the customary poverty of Canadian artists. A yearly income from paintings and prints running well into six figures has enabled him to acquire such objects (used in his work but also symbols of his success) as a Rolls-Royce and two aircraft which he flies very expertly — a water-plane and a ski-plane for the glaciers

among which he works. Onley was an obvious target for taxmen anxious, in the old Indian phrase, to shake the Pagoda Tree, for he had proclaimed rather than concealed the extent of his earnings. His kind of painting, which depends on landscape for its inspiration, involves him in constant trips to the mountains near Vancouver, to the coastal fjords of British Columbia or to farther regions like the Arctic, Japan and his native Isle of Man. In the winter of 1982–83 he and I went to India and Burma where he painted and I wrote. It was after our return that Revenue Canada proposed to disallow his travel expenses until he had sold the paintings or prints that were the outcome of his trip. This meant that if, for example, he painted fifty water colours on a trip and sold nine in the same year, he could only claim in that year 18 per cent of the expenses of his journey, and he would have to pick up the rest in dribs and drabs as the years went on. Then, when all fifty paintings arising from the trip had been sold and all the expenses had been accounted for in this way, he would be expected to write a letter promising not to paint — or turn into a print — anything further from that particular journey.

Such demands revealed the bureaucracy's complete failure to understand the artistic process or the ways works of art are marketed. Sometimes, if a show catches the public eye and the economic climate is favourable, almost all the paintings made on a trip will sell quickly. When the market is sluggish, as it has been through most of the early 1980s, selling may be slow. Apart from that, artists often choose to retain some paintings in their own collection or to give them away to friends or to charity; frequently they keep sketches in a kind of image bank on which they may draw throughout their painting careers. Much the same thing happens with writers and their travel diaries, and with writers as well the products of a trip may be sold over several years. In the meantime, however, money will have been laid out, for travel, for materials, and in various other ways, and if the writers or painters are unable to gain credit for their expenses, their tax payments will be disproportionately high.

Such arguments seemed incomprehensible to taxation officers used to dealing with ordinary businesses, and since the laws treated painting that brought in a profit as a business, they felt justified in applying the normal rules regarding inventory. Any artist was bound to disagree, and Onley felt his disagreement

should reach high places. I felt he was right, so one afternoon we discussed his strategy and together drafted letters which he sent to the minister of communications and the minister of national revenue. Then we released them to the press. From that moment the campaign assumed amazing momentum, fanned by the collective anger of the whole artistic community, and my role was henceforward confined to a couple of television and radio statements and an occasional letter to the press. As soon as articles on Onley's complaint appeared in newspapers, there was an extraordinary response from writers and artists who had also been enduring unprecedented demands and assessments from Revenue Canada.

Toni Onley then decided on even more dramatic action. He had been told by the tax auditor that to reduce his inventory he could either sell off his paintings cheaply at the end of the year, or he could follow the example of manufacturers who melted down unsalable products and recovered the raw materials. The first was out of the question, since it would have depressed Onley's future prices. So, to combine a blow at the tax authorities with a dramatic gesture, Onley threatened to burn a thousand prints publicly on Vancouver's Wreck Beach.

From Ottawa, where a major scandal was clearly feared, Minister of Communications Francis Fox quickly wired Onley asking him to postpone his action until consultations could be held between financial and cultural officials. Leader of the Opposition Joe Clark telephoned and promised to press for serious action in the House of Commons.

In the end, Onley burnt just one print as a symbolic gesture for the benefit of the photographers and film crews assembled on Wreck Beach, and Clark kept his word. In one of the most eloquent speeches of his career he pleaded the cause of the artists, asking for a better understanding of the peculiarities of their occupation, and he secured the support of all parties for a motion calling for early meetings of a sub-committee of the Standing Committee on Culture and Communications that would deal specifically with the taxation of visual and performing artists and of writers.

When the committee started its hearings at the end of February 1984, it had a number of issues to discuss besides inventory. One of the most important was profitability as a means of deciding an

artist's authenticity, the other side to the Department of Communications's compulsion to turn the arts into financially viable cultural industries. The Income Tax Act allows business losses to be claimed as a deduction only if there is a reasonable expectation of eventual profit. But in art there is no relation between the quality or authenticity of a painter's or a writer's work and its profitability now or in the near future. Some artists we now regard as the great masters of their ages hardly sold at all during their lifetimes. For others it is many years before they come to recognition, or even to maturity, for the rhythms by which artists develop vary from person to person. By trying to impose the expectation of profit rule, the tax authorities created some grotesque situations. It was not so much a matter of the young and totally unknown artists making their slow way into recognition, since in many cases — as one tax auditor cynically remarked to me — they have incomes that do not even come to the attention of Revenue Canada. The problems occurred much more often in the case of mature artists who work irregularly, or who spend long times between projects, or who sell well some years and badly in others, or who combine the practice of their art with some related occupation like teaching.

A typical case was that of a well-recognized writer of children's books, whose works had sold more than 100,000 copies. When her accounts were audited by Revenue Canada for two years in which income was low but expenses on forthcoming books were substantial, she was told she had "no expectation of profit"; her earlier profitable years were ignored and she was charged $10,000 in back taxes. Biographers, who often spend years gathering material for an important work, were especially hard hit. Dale Thomson spent almost ten years working on his book *Jean Lesage and the Quiet Revolution,* which was finally published in 1984. Shortly before it did appear he was told that his costs could not be accepted as legitimate deductions because for several years his writing had not shown a profit. That the importance of a book might justify working on it for several years without visible income did not impress the auditors.

Particularly vulnerable were recognized artists who taught in universities. Such a combination of occupations is often necessary for artists who cannot earn enough to live by what they

create, though they can only keep on teaching if they produce works of art to sustain their reputations. For many years Revenue Canada allowed such artists to claim expenses on their creative work against their regular incomes. In 1983, however, the department's computers were programmed to search out employed people claiming deductions on income from self-employment. Four hundred artists, mainly doubling as university professors or art teachers, were among those turned up by the search. They were told that in the eyes of the tax law they were not professional artists but hobbyists, and had no right to charge losses on their "hobbies" against professional income. Many artists found that deductions they had claimed for years in good faith, without challenge by the tax auditors, were suddenly disallowed, and these people were faced with demands for large sums in back taxes plus interest. A well-known engraver was asked for $20,000, to be paid immediately; his case was not exceptional.

A different twist was given to the pattern of extortion in the case of Phyllis Grosskurth, an internationally known critic and biographer and a winner of a Governor General's Literary Award. For some years she has been writing a definitive life of the classic psychoanalyst Melanie Klein, a work needing extensive and costly research. Revenue Canada declared the expenses incurred on this book unallowable, again because they were not balanced by current income from writing. The irony in this case was that among the income taxed, without expenses being allowed, were subventions given by the Canada Council precisely because the work could not make a profit.

Thus had the state begun taking away with the left hand what it gave with the right. There were numerous cases where Revenue Canada refused to accept as legitimate expenses costs incurred when an artist or a writer was carrying on work subsidized by a Canada Council grant. Some artists, given travel grants by the council, have found that they are not allowed to claim the cost of the very travel for which the grant was made. The Canada Council has reacted with concern over such actions by a government agency — actions that seriously undermine the work it is attempting to carry on. The head of the council's visual arts section, Edythe Goodridge, is quoted by Gordon Pape in the *Financial Post Magazine* as pointing out that artists'

grants have been picked for especially adverse treatment: "None of the other forms of grants — research, small business — has been touched. In the case of research grants going to small business or industry, the money is classed as business income, so deductions and depreciation are allowable. None of this has been applied to artists."

There are many other inequities in the tax system so far as artists are concerned. One is that though a collector can buy a work from a painter, keep it for a while, and then notably benefit by donating it to a public gallery and receiving a tax exemption at an enhanced valuation, painters cannot benefit in this way from gifts of their own works to a public gallery. They have to take the value into income, and they can then make a deduction under their 20 per cent tax allowance, which means that they receive no benefit whatever from the gift.

This particular inequity has always been present in the law, and has generally been administered. But most of the attacks on artists have arisen not from any change in the laws, but from an arbitrary change in bureaucratic practices under a continuing law. While actors and orchestral musicians were formerly accepted as freelancers, suddenly they became employees; while artists were in the past allowed to operate under what was virtually a cash system of accounting, now they are moved into the accrual system imposed on ordinary businesses; while the profitability rule was loosely applied in the past, suddenly it became a central test of an artist's status; where deductions of the costs of painting were tacitly allowed to painters whose daily work was to teach painting, their status outside the classroom was all at once changed to that of hobbyist. The laws had been massively reinterpreted — obviously at the orders of highly placed officials — to bring in more money when the government needed it, and the artists were caught in the trap.

It was fortunate that the media — press, radio and television — generally responded sympathetically, even though this reaction could in part be ascribed to the general anger against the government that marked the last months of the Trudeau era. Added to pressure in Parliament, this left the Liberals little alternative but to agree to Clark's proposal for the appointment of the House of Commons sub-committee. The committee considered the situation with exemplary diligence, hearing testimony from

154

representatives of all the arts, from independent taxation experts and from officials of Revenue Canada. It listened sympathetically to the complaints of the artists, who emerged for the most part as one of Canada's most underprivileged groups of citizens, and the interventions of the sub-committee members were themselves often searching and valuable. In the end a series of recommendations were made that responded to all the major complaints of the artists, and tacitly urged what amounted to special status for them. Finally came the pointed remark: "The Sub-Committee urges that its report shall not suffer the same fate as the Disney report. The insecurity of the previous decades must be resolved."

The findings of the sub-committee represented a moral defeat for Revenue Canada, but whether the department accepted it as such is another matter. Certainly the minister, Pierre Bussières, after obstinately and ineptly defending an impossible position for several months, made a strategic withdrawal, and his department made concessions in procedures which for the time being at least will mean that artists will be less thoroughly plucked by the auditors.

In March 1984 the minister agreed that artists might deduct travel expenses related to the production of their art works in the year the travel took place. Later concessions, after the publication of the sub-committee's report in June 1984, allowed self-employed performing artists to deduct the cost of lessons needed to develop their talent, made the profitability rule more flexible — granting that "artists and writers may need many years to realize a profit from their work" — and agreed that reassessments in the case of artists should go back for two instead of four years, with refunds to those who had been penalized. But the minister's statement did not explicitly clear up the situation of the artists wishing to deduct losses from their salaries in art-related posts, nor did it clear up the confusion between employed and self-employed status in the case of symphony musicians and actors. Moreover, certain of the concessions suggested by the sub-committee, such as those regarding the change of artists' taxation status from an accrual to a modified accrual basis (which would bring them nearer the situation of farmers) or the allowance of deductions for gifts to public galleries, were set aside as needing special legislation.

155

It is certain that there will be a temporary lull in attacks on artists by Revenue Canada, and perhaps some greater understanding of the artist's occupation will penetrate the ranks of the service. But it would be foolish to accept as a final victory these concessions that the department has so unwillingly made. One tax lawyer said that he felt the solution as it stands at present is far from ideal because "so much of it relies upon Revenue Canada's assessing policies and as we have seen, these can be changed arbitrarily. I personally would be much more comfortable when a lot of the changes are embodied in the Income Tax Act."

It seems indeed as though the task of the Canada Council, the Canadian Conference of the Arts and the various artists' organizations, all of which rallied well in the fight to change Revenue Canada's practices in assessing artists, will not be over until the special conditions under which artists work are recognized in specific legislation. In the meantime artists should not feel any confidence that the left hand of the state has yet ceased to itch for whatever the right hand may give them.

There are, of course, other perils in the artist's relationship with the state, though these in recent years have seemed less urgent than those linked to taxation. They especially relate, in the case of writers, to libel laws, and in the case of all artists to laws relating to obscenity — the censorship laws, as we generally call them.

Libel laws vary from country to country. In general those of Canada tend to follow the British lead and to be stricter than those of the United States. To prove the truth of a statement is the beginning of a defence in any case of libel, but in British and Canadian courts it is often not enough. One may have to prove also that the statement of truth is fairly made, whereas in American courts the accuracy of the facts is sufficient. And here, of course, a vast area is opened up where the defendant is vulnerable to the caprices of the judge or the jury in the assessment of fairness.

Various kinds of writers and artists are vulnerable to libel actions. Historians, dealing mostly with the dead, are usually immune, and so in general are poets, because poetry is not widely read. I suspect some judges might have ruled libelous a

few of Irving Layton's attacks in verse on fellow poets, but none of his victims chose to take up the legal challenge, mainly because as writers they were opposed to the present libel laws. There was a time when newspaper cartoonists were regarded as privileged, because they never said anything explicit in words, but a fairly recent decision in the British Columbian courts against an artist who had lampooned a provincial cabinet minister (even though the decision was reversed on appeal) has shown that, in Canada at least, court decisions are becoming more protective towards public figures.

Few people are more vulnerable to the capricious operation of libel laws than novelists. Journalists usually take a calculated risk when they attack a public figure or make an accusation against a private person that, if not justified, may be considered libelous. But novelists, even when they are not consciously representing a person they know, can never be sure that they will not be involved in a libel action brought by some stranger who thinks he recognizes himself in a character. The situation was admirably put by Anthony Burgess in his article on the novel in the current *Encyclopaedia Britannica*:

> In some countries, particularly Great Britain, the law of libel presents insuperable problems to novelists who, innocent of libelous intent, are nevertheless sometimes charged with defamation by persons who claim to be the models for characters in works of fiction. Disclaimers to the effect that "resemblances to real-life people are wholly coincidental" have no validity in law, which upholds the right of a plaintiff to base his charge on corroboration of "reasonable people." Many such libel cases are settled before they come to trial, and publishers will, for the sake of peace and in the interests of economy, make a cash payment to the plaintiff without considering the author's side. They will also, and herein lies the serious blow to the author, withdraw copies of the allegedly offensive book and pulp the balance of a whole edition. Novelists are seriously hampered in their endeavours to show, in a traditional spirit of artistic honesty, corruption in public life; they have to tread carefully in depicting purely imaginary characters and situations, since the chance collocation of a name, a profession, and a locality may produce a libelous situation.

The circumstances in Canada are little different from those in Britain, as was shown in the recent case in which Ian Adams was accused of libelling a former RCMP officer because in one of his novels he portrayed a policeman, vaguely resembling the real-life individual, who acted as a double agent. What Anthony Burgess had to say about cautious publishers applied in this case. Although a powerful campaign was mounted by the Writers' Union of Canada and other groups, aimed at using the case to modify Canadian libel laws, Ian Adams's publishers wrecked the effort by coming to an arrangement out of court.

There really is no protection for novelists against the possibility that some person they have never known may come forward and say, "You've portrayed me as a villain." Fortunately it happens rarely. When it does, all one can do is to deny any intent of libel and hope the jury will award the traditional farthing damages. Journalists who have deliberately attacked someone are often better off, since they already have facts in hand, and if they can prove that the plaintiff is as bad as or worse than they have said, then the jury will be swayed.

The solution to the problem is to be found in a broad review of the law of libel and how it works to restrict the freedom of writers and the liberty of journalists to make criticisms in the public interest. I am not advocating total license for journalists who pry, often in tragic circumstances, into the lives of private citizens. Indeed I feel there should be a stricter code within the profession concerning people who do not choose to be public figures, but I suggest it should be a matter for the journalists' guilds rather than the courts.

In the case of imaginative writing the situation is quite different. Where a novelist has inadvertently portrayed a character who resembles a living person, a public statement that no libel has been intended should be sufficient. Public figures, when they give up private status, automatically accept the occupational risks of their positions. The most they should be granted is protection against false statements. The interpretation of the truth, however unfair it may seem to those criticized or their supporters, should be unrestricted where the public interests are concerned. That is essential not only to the freedom of literature and journalism; it is necessary also for the health of society and the well-being of its citizens.

There is not a great deal of ambiguity about libel laws in Canada. They affect the writer more than they affect other kinds of artists, and they have a clearly inhibitive effect not only on investigative journalism but also on any serious treatment of public affairs and even on such forms of imaginative literature as fiction and drama.

There is a great deal more uncertainty about censorship based on moral criteria. A battery of laws of potential severity exists already. Customs regulations prohibit the importation of books and visual materials of "an immoral or indecent character," and at one time these were freely used to keep out of Canada not only suspect literary classics like Joyce's *Ulysses* and Henry Miller's *Tropic of Cancer*, but even politically radical tracts. The Canada Post Corporation Act, like previous laws relating to the Post Office when it was still a government department, prohibits sending equally ill defined obscene material through the mails. And Section 159 of the Criminal Code makes it an offence to sell or distribute "obscene" material, which is defined as meaning the "undue exploitation" of sex or the portrayal of sex coupled with crime, horror, cruelty or violence.

In practice, and particularly since the Supreme Court of Canada's decision in 1962 that *Lady Chatterley's Lover* was not obscene, the tendency has been for what are loosely called "community standards" to prevail in dealing with material deemed pornographic. To all appearances, compared with the situation in the late 1950s, there has been a wide relaxation of standards in accordance with the greater permissiveness in life styles. But it has been an unequal relaxation, since the bringing of charges under Section 159 of the Criminal Code comes under the jurisdiction of the provinces, and in practice this has meant that local police authorities and prosecutors have tended to act differently in different parts of the country.

The most dangerous censorship nowadays is in fact directed less against the printed word than against that area of visual presentation — film, video, television — where art and mass entertainment most strikingly cohabit, and where more people are involved as audiences. Provinces can and do set up censorship boards to deal with films, and the criteria applied by these bodies vary considerably, so that what passes in British Columbia may well not be accepted in Nova Scotia. The Ontario Censor

Board, which tends to be one of the most arbitrary in its decisions to cut and ban films, in effect acts as a censorship authority for all of Canada, since most films enter the country through Toronto and most other provincial film boards go along with the cuts made in Ontario. In 1984 the Ontario Censor Board extended its powers by seizing videotapes which an art gallery proposed to show publicly, and though a judge ordered the board to return the tapes because they were seized without a warrant, he did not rule on whether it had the right to forbid their actual showing.

At present, in fact, we stand in an uneasy interregnum so far as censorship is concerned. We have still a great deal of the freedom that was gained tacitly, rather than being granted explicitly, as a result of the growing permissiveness in society over the past two decades. We can read unexpurgated books that make D. H. Lawrence seem like a Victorian lady writer and even the Marquis de Sade like an adolescent shocker. We can look, if we wish, at a variety of visually scatological jokes solemnly presented to us by experimental artists. We can, if we are willing to take a little trouble, see a wide variety of bizarre, if usually boring, pornographic films. And in recent years attempts at censorship outside the area of films have tended to be localized, like the campaigns against placing books like Margaret Laurence's *Diviners* on school library shelves; or furtive, like the decisions of police forces to take morality into their own hands and terrorize the proprietors of news stores who stock porn magazines; or oblique, like the attempts of petty politicians at various levels to cut off funding either for artists whose work they consider obscene or for the publishers or galleries that promote such work.

This existence of sporadic censorship within a generally permissive society has never been satisfactory, since laws like Section 159 of the Criminal Code remain as a considerable potential threat. What freedom the arts have enjoyed in recent years has depended on subjective and shifting "community standards," and now, with the prevailing conservative trend in Western societies, we are likely to see a shrinking of tolerance and a trend towards censorship, first of the more public and popular art forms, such as film and drama, then progressively of the more private ones, such as literature and the visual arts.

160

The rising wave of moralism had been evident since the later 1970s, and it has caught public and politicians alike in its path. A loose and bizarre alliance has emerged, consisting of a wide variety of special interest groups. They include intensely conservative fundamentalist religious movements and the five misguided anarchists who firebombed the Red Hot Video outlets in Vancouver, militant feminists and a variety of ethnic groups who feel they have been derisively portrayed in books ranging from *Oliver Twist* to *Huckleberry Finn*. Even members of artists' groups have surprisingly been carried along on the surf. The executive committee of ACTRA (the Alliance of Canadian Cinema, Television and Radio Artists) issued in 1984 a directive discouraging its members from participating in productions deemed to involve excessive violence and abusive sexual behaviour. It took an angry revolt in the alliance and the vote of 1115 members to overturn the directive.

The more vocal advocates of increased censorship are supported by a great mass of people who see a rise in social violence emerging parallel to the greater license in film and television, and who, without any deep examination of the problem, link the two and fear for their children and themselves. A poll in 1983 showed 58 per cent of Canadians in favour of censoring television as well as films shown in cinemas, and the percentage is probably rising.

There is in fact no need to change the laws to satisfy these people. If police chose to be zealous in their inspections of bookstores and art galleries, if film censors chose to be stricter and if judges chose to interpret the mood of society in the conservative way accepted by the Moral Majority, even the existing legislation is sufficiently vague and sweeping to allow a disastrous onslaught especially on films, video and books, and eventually also on other forms of art.

But politicians always feel that they have to respond to the public mood by new and visibly drastic action, and in February 1983 Liberal minister of justice Mark McGuigan introduced a bill into the House of Commons to amend the Criminal Code so that it would be an offence to distribute or exhibit degrading and violent material even if it did not include a sexual component. The bill died when the House of Commons was adjourned in June, but McGuigan had already established a commission

headed by Paul Fraser to look into the question of pornography and evaluate public attitudes. The Conservative government of Brian Mulroney has promised to act "swiftly and decisively" to control pornography. It seems likely that we shall have not only new and more inhibitive antiobscenity laws but also the atmosphere in which their stricter application will become inevitable. How strong a protection the Bill of Right and Freedoms can give to freedom of expression in such a situation is untested and problematic.

Artists have no alternative but to resist such changes in the law as well as to try to abolish whatever censorship now exists. It has never been proved that there is in fact a causal connection between pornography and sexual offences or violent behaviour. Many sociologists and criminologists deny such a link, and there is good reason to believe that in most cases pornography actually diverts its audience from action towards fantasy, and that the causes of behaviour lie deeper and earlier on in offenders' lives than the films they have recently seen or the books they have recently read.

Censorship laws of any kind are dangerous because, no matter how well-intentioned their framing may be, they will never be made so precise that good artists whose works offend bigots will not be in danger. The burning of books, or its equivalent, has always been the sign of a society moving backward into obscurantism, the kind of society in which the special interest groups who now clamour for censorship are not likely to find their desired freedoms greatly respected, for once the banning mentality takes hold, there are no limits to its spread. From the censoring of morals it is only a step to the censoring of ideas; people are already being kept out of the United States and Canada because of their political philosophies. And from censoring ideas it is only a further step to censoring form and style, as happened in both Nazi Germany and Stalinist Russia.

Censorship laws should be entirely abolished. The state has no more business in the studies and studios and theatres than it does in the bedrooms of the nation. Milton's fine statement in *Areopagitica* still stands good 340 years later, for, like Milton, we too live in an age afflicted with puritans and authoritarians.

We should be wary therefore what persecution we raise against the living labours of public men, how we spill that seasoned life of man preserved and stored up in books; since we see a kind of homicide may thus be committed, sometimes a martyrdom, and if it extend to the whole impression, a kind of massacre, whereof the execution ends not in the slaying of an elemental life, but strikes at that ethereal and fifth essence, the breath of reason itself, slays an immortality rather than a life. . . .

Banish all objects of lust, shut up all youth into the severest discipline that can be exercised in any heritage, ye cannot make them chaste that come not thither so: such great care and wisdom is required to the right managing of this point. Suppose we could expel sin by this means; look how much we thus expel of sin, we expel of virtue: for the matter of them both is the same; remove that, and ye remove them both alike.

# CANADIAN ARTISTS TODAY

T he wealth of a few exceptional writers and painters only emphasizes the dedicated penury in which even today most Canadian artists work. People who set out on a literary or artistic enterprise, whether it be a publishing house or a theatre, with the expectation of profit, are as likely to be disappointed as individual artists. The arts may thrive in Canada; they do not prosper. It is not only a question of their not being profitable in the marketplace; to imagine they ever can be so is to succumb to the bureaucratic illusion of "cultural industries" whose fallacies we have already examined. More pressing is that, in spite of assistance the community has been providing for more than a quarter of a century through the Canada Council and other organizations and programs, circumstances still hinder artists from contributing to the imaginative life of the country.

It is true that from the beginning of public patronage of the arts in Canada, with the establishment of the Canada Council in 1957, there has been — as I have shown — an extraordinary quantitative explosion in the arts of this country and a qualitative movement towards both maturity and variety. In the 1980s we can see our literature, our visual arts, our drama, holding their place internationally, our orchestras and dance groups hailed when they tour abroad. Canada is no longer an artistic or intellectual desert with a few precarious oases, as it was in 1949

when the Massey Commission undertook its historic task. In every art there are thousands of dedicated professionals where thirty years ago there were hundreds of gallant amateurs. Theatres, publishing houses, orchestras have arisen and survived in amazing numbers; Canadian readers and lovers of visual objects have an unparalleled range of books and works of various arts created by Canadians to delight their leisure time. And despite the negative efforts of taxmen, censors and libel lawyers, Canadian governments through their funding agencies have contributed in many ways to that result. Yet for all this splendid record, the majority of artists in Canada live below the poverty line, which in 1982 for cities of more than half a million inhabitants was $8,970.

This chapter is devoted to considering the present situation of the creators and performers without whom there would be no Canadian literature, no Canadian painting, no Canadian drama, no Canadian music and, at least in the traditional sense, no Canadian culture: the men and women who, like the Celtic bards and the epic poets of Greece and India, have given voice in their various artistic languages to their visions of our many regions and our many peoples, who have defined in imagery our land and our selves. What has been their reward? How, a generation after the Massey Report aroused Canadians to the importance and the needs of their arts, do Canadian artists live?

Most of them, like their less numerous predecessors a generation ago, pay in poverty and insecurity for the increasingly rare privilege of inner liberty, of being among the last men and women whose occupation is almost defined by its freedom to pursue the limits of the imagination. A few artists, a few writers, a few actors, are relatively well-to-do, but whenever the situation of most artists is brought to public attention, as it was during the 1983–84 dispute with Revenue Canada, what we always learn is the extent of the dedication that impels them to accept, voluntarily, a standard of living that any unionized worker in the country would despise.

Often the arts, as distinct from the artists, seem to be flourishing financially. The last twenty years have seen the building of fine theatres and resplendent art galleries in many Canadian cities, so that the performing and the visual arts often have palatial houseroom. Theatre companies, orchestras, performing

165

companies of all kinds may at times run into difficulties, but they rarely expire of financial anemia, because they have traditionally had first call on the funds of the Canada Council and of most provincial funding agencies. Similarly, except in cases of exceptional incompetence or ill luck, publishers these days rarely fail dramatically, though they may sometimes fade away from lack of impulse. They are kept alive in various ways, and most of them share modestly in the general steady expansion of the trade.

Yet in one sense, as Robert Fulford said more than a decade ago, "the great Art Boom never happened at all. At the level where it counts, the level of the artists, it never existed." A lot of money has indeed been made in the arts over recent years. Small fortunes have been accumulated by the sale and resale of paintings. In 1975 a chart in *Artscanada* showed that while the value of shares listed in the Dow-Jones Industrial Index rose by 18 per cent between 1970 and 1975, the value of contemporary art objects according to the London *Times*–Sotheby Index showed gains over the same period of between 50 and 70 per cent. The rate of increase slowed down with the recession, but contemporary art still remains a good investment for the patient buyer and a sound way for investors to beat the tax collector with judiciously delayed gifts to public institutions. But of these profits in present circumstances the artist see nothing.

There are usually great discrepancies as well between the incomes of artists and of those who in one way or another service or arrange the arts. Former Canada Council director Charles Lussier once remarked that "those who make a living in the arts are the administrators," and since he spoke from the administrative side he knew what he was talking about. The most humble secretaries helping to administer the council's awards to individual artists earn more per annum than most of the artists whose applications they process will make in a grant-less year. Susan Crean sums up the situation mordantly in *Who's Afraid of Canadian Culture?*

> The art world, as it is constituted, works on the principle that, the further removed you are from the work of art or the act of creation, the greater the rewards. The collector makes more than the scholar, who makes more than the curator, all of

whom make more than the artist. An arts consultant, for example, can make as much as $500 a day advising wealthy collectors and corporations about their art investments, while an artist is extraordinarily lucky to clear $5,000 a year.

Arts administrators, like the staffs of publishers and periodicals, have the advantage over the full-time artist or writer that their income is not only, on the average, higher; it is also more regular. In many cases unionization among ancillary workers in the arts means that even the tenure of their jobs is protected, whereas the writer works from book to book and story to story and the painter from canvas to canvas, never sure what will sell or how much it will bring in.

Even when the artists have made the effort at unionization, the freelance nature of their occupation renders it ineffective. ACTRA, the organization of radio and television writers and actors, has over the years been able to negotiate with the CBC considerable increases in fees, but has been quite unable to ensure regular employment, and in spite of the union's presence the opportunities for freelance writers and actors in the CBC's programs have been sharply decreasing. In such situations the weak unions of the creators and performers come up against the strong unions of the technicians. It is an axiom of the theatre that stage hands earn more than most of the actors, whose work is often intermittent; certainly in the CBC the regular workers, through their unions, have a first claim on the budget, so that people involved in the housekeeping of a broadcasting system — sound engineers, maintenance men, cameramen, office workers, managers — are made to seem more indispensable and are better paid than those who, as writers, actors or musicians, make the creative contributions that keep the programs alive. The same applies in publishing, where editors are usually better off than the writers whose work they prepare for the printers. So we see that the great infrastructure of institutions and services and quasi-industries that is necessary for the maintenance of a vital and expanding world of the arts is by a strange paradox a parasite on the very arts that it fosters.

There have been a number of informative surveys from Statistics Canada, the Ministry of Communications and elsewhere regarding the financial situations of both creative and perform-

ing writers, and testimony before the parliamentary Sub-Committee on the Taxation of Visual and Performing Artists and Writers has produced much enlightening information.

A Statistics Canada survey of writers' incomes in 1978 showed that the average full-time writer (working at least thirty hours a week) earned $14,095, counting all kinds of writing. But this figure was elevated by the inclusion of a number of best-selling authors; 50 per cent of full-time writers in Canada in fact earned $7,000 or less a year. The figures offered by the Writers' Union of Canada are even more dismal. According to Eugene Benson, the union's chairman, writers earned from royalties in 1983 an average of $1,050; the rest of the $7,000 median income is made up from peripheral literary tasks, such as periodical, radio or television writing. Low as it is, that median of $7,000 does not compare unfavourably with the incomes of writers in other western countries; in 1984 Herbert Mitgang, in the *New York Times,* asserted that "the average author earns less than $5,000 a year from his writings in the United States."

The literary earnings of most prose writers are thus below the recognized poverty level. Poets are so far below it as to be hardly worthy of note financially. John Wilson, executive director of the League of Canadian Poets, gave evidence before the sub-committee on the taxation of artists:

> I can tell you that in recent conversations with one of Canada's most senior poets I discovered that he has never made more than $2,000 in any year from his books — from his royalties or his permissions. That is a substantially higher figure than the average. There are one or two who have crossed into the realm of media stardom and I am sure their incomes would be in excess of that, but those writers who are known by their creative writing alone cannot hope to make a great income. Another poet, a recent winner of the Governor General's Award, assures me that he has never made more than $250 per annum from his royalties on a dozen titles in print, which, for all their cultural significance, may never achieve an edition greater than 1000 copies.

Obviously no poet can live entirely from his art. Even poets like Irving Layton and Al Purdy, whose works have sold surpris-

ingly well, have had to supplement their royalties and fees by giving readings and by taking at least occasional employment as poets in residence or as teachers in English or creative writing departments. For the less successful of these poets, such secondary occupations become regular. In a statement to the subcommittee on taxation Gary Geddes gave a vivid and moving account of the shifts by which most poets live.

> In order to support my habit as a writer, I teach creative writing for a living. My credentials have given me access to a job in which I am able to teach what I know about literature and writing to a group of budding poets. This work, which takes about 20 hours per week, keeps me and my family alive. The actual writing, including reading, research and time spent at the typewriter, takes up another 40 to 50 hours per week, all of which is subsidized in whole or in part by my work in the writing workshop. Doubtless, writers, musicians and painters of the past have had to pay their dues to patrons by teaching children and relatives of the patron, giving lectures to learned societies, and putting in appearances at social gatherings, or government seminars, when they would rather be at home at work on a new poem, painting, or composition.
>
> The 40 or 50 hours of work that goes into my poetry each week might otherwise go to my family, to a lucrative consulting business, or to advancing my position in the politics of the university or the community. In other words, I might even be running for the Liberal leadership. The least I can expect from my society, which will benefit in the long run from this work, is that I be treated as a serious worker and creator, and that I be allowed to deduct very real expenses from my income.

The income of writers, in prose as well as in verse, is subject to the vicissitudes of fashion, and, combined with the growing cost of producing books, these have had a double effect. They lower the sales of books whose higher prices often deter buyers, and they make publishers more cautious by raising the number of copies of a book that have to be sold before the break-even point arrives and even a slight profit becomes possible. The late 1970s saw a perceptible shift in writers' fortunes for these various reasons.

169

The large poetry audiences of the later 1960s have melted away as the counter culture shrinks, and readings are less easy to arrange and less profitable. As the market for poetry declines, the major publishers tend more and more to leave books of verse, except by a few exceptionally popular poets, to the little presses whose publications offer a minimal income in royalties, particularly as booksellers have become less receptive to experimental writing.

In fiction the position has hardly been better. *Quill & Quire* in February 1981, when change was well underway and writers, like everyone else, were suffering the full rigours of the recession, printed an enlightening article on the current publishing situation by Joyce Wayne, with the curious title "The Atwood Generation: Notes on Surfacing from the Underground." The views of publishers on the problems then — and now — being encountered all tended to stress the fact that small editions of fiction were becoming more frequent — and small editions were uneconomical. Doug Gibson of Macmillan of Canada remarked that the market for first novels has "if anything shrunk," and added that while the sale of 2000 copies constituted success for a first novel, such a printing was "crazy" in terms of 1981 costs. Jack McClelland confirmed this, saying, "Money can't be made in the short term on a 5000 printing." And Michael Macklem of Oberon expressed the view that the sales spread between commercially successful books and good books with limited sales was broadening. Macklem's press had pioneered in publishing volumes of short stories, but in 1981 he was saying: "Today it is difficult for Oberon to sell 1000 copies of a collection of short stories, while in 1969 2000 copies were not unusual." If publishers suffer from these conditions and become more cautious in their acceptance of titles, writers suffer because it is more difficult to get their works into print and into the bookstores, and because in general advances and royalties tend to be lower.

In areas other than book publishing the incomes of writers are affected by even more drastic fluctuations. In television, radio and film, writers come together into a single organization with actors: this is the Alliance of Canadian Cinema, Television and Radio Artists (ACTRA). ACTRA has grown from 5500 members in 1977 to 7000 members in 1984, but it remains a union consisting

170

mainly of casual and unemployed workers. In 1984 the gross earnings of its members were $56 million, which meant that their average income from television, radio and film work was $8,000. Some writers earned money in other ways, some actors worked also in live theatre, but on the whole most ACTRA members earn very small incomes: in 1977 more than half (3000) earned less than $1,000 for work under the union's jurisdiction, and just over 2 per cent (115) earned more than $25,000 a year. It is clear that here, as in writing for print, we are entering an area where, no matter how incomes are split between the electronic and other media, writers and actors are among the lowest-paid groups in Canada.

They are also among the workers most susceptible to fluctuations in their semi-industrial fields. Changes in CBC programming, as I have already indicated, have drastically reduced the opportunities for freelance writers and actors to participate in the corporation's programs. And in the unstable world of independent film and television production they have been particularly vulnerable to rapid changes of fortune. Paul Audley in *Canada's Cultural Industries* explains that

the general pattern of employment in the industry is to rely on freelance workers. While Statistics Canada data for the period since 1980 are not yet available, there is clear evidence of a rapid decline in payments by private-sector independent producers to freelance workers.

In the case of writers and performers, figures provided by their union, ACTRA, indicate that after increasing sharply from $2.9 million in 1978 to $11.2 million in 1980, the earnings of writers and performers from independent producers dropped 32 per cent to $7.6 million in 1981. For the period January to July 1982, there was a drop of a further 39 per cent from the comparable period in 1981. While revenue from independent producers accounted for 22 per cent of the total earnings of Canadian film and television writers and performers in 1980, up from 8.5 per cent in 1978, it will probably account for less than 10 per cent in 1982. The largest percentage of the revenue of ACTRA's members continues to come from the Canadian Broadcasting Corporation which accounted for 38 per cent of their total earnings in 1981.

Moving over to performers in live theatre, we find that their income is perhaps even lower than that of radio and television actors. "In 1973," says Susan Crean in *Who's Afraid of Canadian Culture?*, "the average earnings of Actors' Equity members was $4,500, and a more recent Equity survey shows that 60 per cent of the 2,000 members earn less than $2,500 a year." Evidence given before the sub-committee on the taxation of artists shows that while the membership of Actors' Equity has grown to 2800, the average earnings of its members have risen only to $5,000 which, given the massive inflation over a decade, constitutes a considerable loss of real income. It would mean that, if we were to assume that every ACTRA performing member also worked under Actors' Equity jurisdiction, the combined average income for actors in Canada would be about $13,000 per annum, no adequate return for training and talent. Representatives of the Union des Artistes, the Quebec equivalent of Equity, testified to the sub-committee that 86 per cent of the union's 3000 members lives below the poverty line.

Among professional classical musicians, of whom there are about three thousand in Canada, the eight hundred members of the eighty-five professional symphony and chamber orchestras are in every respect the aristocrats: the best trained, the best regarded and the best paid. Yet while there are orchestras which pay their musicians up to $30,000, the lowest level of payment reported to the parliamentary sub-committee was $5,040, the average was $17,800, and, apart from the three top Canadian orchestras — the Montreal Symphony, the Toronto Symphony and the National Arts Centre Orchestra, which are in a class by themselves — the rest, according to a spokesman for the musicians, "run from $5,000 up to probably $14,000 or $15,000." Engagements outside the orchestra supplement incomes in very minor ways — perhaps, as one witness testified, to the extent of about 5 per cent.

If performing musicians earn such meagre incomes, composers are even worse off. A national survey of Canadian composers in 1974 found their average income was $2,646; it certainly did not increase during the next decade. Perhaps more than any other creative artists, composers rely on employment related to their work. Of six composers I know personally, one has become a cultural bureaucrat, four are present or retired teachers

172

in the music departments of universities or colleges, and one enjoys independent means; none of the six expects ever to live even modestly on their earnings from composition.

Because of a boom in the sale of paintings during the late 1970s, and because a few artists like Toni Onley, Alex Colville and Ivan Eyre command high prices and therefore attract attention in a society impressed by financial success, the average Canadian is inclined to overestimate the earnings of visual artists of all kinds. In fact the incomes of most painters and sculptors and print-makers are very similar to those of other creative and performing artists — below or a little above the poverty level.

Surveys made over the past decade have — taking inflation into account — been surprisingly consistent in their estimates of artists' earnings. Susan Crean quotes a 1974 survey which found that 90 per cent of visual artists were making less than $5,000 a year from sales, including 30 per cent who made no sales at all. In its preliminary discussion guide, *Speaking of Our Culture*, the Applebaum-Hébert Committee quoted an unpublished 1978 survey of the incomes of full-time visual artists from the sales of their art works; it concluded that 50 per cent received less than $6,000, 14 per cent received between $6,000 and $10,000, and only 36 per cent received more than $10,000. In the 1981 census, 5400 people filled in their forms as full-time self-employed artists; their average income was $7,800. And, in testimony in 1984 before the sub-committee on the taxation of artists, the representative of Canadian Artists' Representation (CARFAC) claimed:

Of the visual artists in Canada, 80 per cent earn less than $7,000 in direct art sales every year. This includes sales, commissions, exhibition fees — which CARFAC initiated — rentals, and the odd reproduction. However, this is not the artist's profit; this palatial amount is the amount earned before figuring the artist's expenses of production, promotion and marketing the work.

Thus in all Canadian arts incomes are remarkably similar. In every art there are a few artists with high reputations and six-figure incomes. The majority barely reach five figures, and considerably more than half our writers, actors, musicians and

painters have earnings from the practice of their arts well below the recognized poverty line, which in 1984 ran very close to $9,000 a year. Some supplement their incomes by teaching, by editing, and in various other occupations that verge on the literary or the artistic. Some earn extra money by tasks quite unrelated to their vocations. But a considerable number have the dedication to live in poverty in order to spend their whole time following their arts.

This is the situation thirty-six years after 1949, when I returned to Canada, found it a cultural desert, and watched with some skepticism and a good deal of interest the foundation of the Massey Commission, and twenty-eight years after the foundation of the Canada Council. As we have seen, many of the aims of the commission and the council have been fulfilled, largely through cultural mutations that were outside any action or capability of the state or its agents. More than ever before, the performing arts survive and even flourish despite hard times. Many thousands of people live in various ways as creative or performing artists, and the artist's role is socially accepted as in the past it never was in Canada. Most people, and even most politicians, in some way recognize the contribution that the arts make to public — if not always to private — life, and agree that this contribution must be paid for. Yet despite all that has been done by governments on all levels to sustain the arts, despite the more favourable social climate, despite the fact that more people attend theatrical and musical performances and visit art galleries than ever before, despite the fact that, pace McLuhan, more books than ever before are being sold in Canada, the actual income of most Canadian writers and artists places them economically below any other class in the community except its old age pensioners.

Public patronage, whatever it may have done to sustain and glorify artistic institutions, has only marginally improved the lives of individual artists. Giving with one hand, the state has taken with the other. It requires a degree of heroism, perhaps not to become an artist in Canada, but certainly to remain one.

Our artists are far from being the pampered pensioners of the state, and indeed one would not wish all elements of hazard to be removed from their material lives, for, as the examples of countries like Holland and Sweden suggest, comfortable security is not a condition conducive to inspiration, any more than

the censored security of the totalitarian countries. The element of venture in life cannot be separated from the element of imaginative originality in the arts. But destitution is not a necessary condition of venture, and the poverty so many Canadian artists endure is a price in discomfort and in lost work that need not be paid for the imagination's freedom to roam at will. In the next — and last — chapter I snall suggest ways and means of assisting the artists without trespassing on their imaginative freedom, without drawing them too far under the shadow of the state, and without having them rely so far on the public purse that they may be seen in the general community as parasites rather than benefactors.

*Chapter 14*

# WHAT IS
# TO BE
# DONE NOW?

T he preceding chapters have charted the history of public
support for the arts in Canada and its relation to the
extraordinary cultural renaissance that has taken place
over the past thirty years or so. They have also shown that,
despite such support, and despite a striking increase of interest
and active participation in the arts, Canadian artists still experi-
ence great difficulties in carrying on their vocations and are
usually less well rewarded than those "cultural bureaucrats and
middlemen" who, as Bernard Ostry remarks in *The Cultural
Connection,* are justified only by "the extent to which they help
artists and writers to do their work and share it with fellow
citizens."

We seem indeed to have reached a crucial point in the history
of the arts in Canada where one battle has been decisively won,
in the sense that very few people — and consequently very few
politicans — would deny that the maintenance of museums and
art galleries, of theatres and orchestras and dance companies, is
a service as necessary to society as the maintenance of an
official school system. When theatre companies and ballets
have been subsidized for decades to the extent of 45 to 50 per
cent of their annual costs, and when 80 to 90 per cent of the
subsidies have come from federal, provincial or municipal

sources, precedents have been established that are unlikely to be abandoned, and though the established performing arts institutions, like the National Ballet, the Stratford Festival and the Montreal Symphony Orchestra, may go through their periods of difficulty, they are as unlikely to be jettisoned as the National Gallery of Canada or the National Museum of Man are, since they have become objects of national pride, and therefore have acquired political as well as artistic significance.

In the case of the so-called cultural industries, the problems connected with them appear to lie in the grey areas between industrial and aesthetic criteria. Are we to support them because they represent a growing area of investment and income, another field in which Canada can compete in export markets? Or are we to give first place to their importance in providing an infrastructure for the arts? At stake here is not merely the fate of private enterprises. It is also the fate of respected Canadian institutions that in the past have played their parts in fostering the arts, like the Canadian Broadcasting Corporation and the National Film Board. The NFB is already threatened with being reduced to an almost meaningless research and experiment unit, while significant work on film is likely to become the province of the private sector subsidized by government funds; the CBC's fate still hangs in the balance and is closely tied to the political destiny of its incumbent president, Pierre Juneau. As has perhaps been shown most clearly in the case of publishing, the inclination of the Department of Communications, more obviously business-oriented than the Department of the Secretary of State under Jack Pickersgill when it supervised the foundation of the Canada Council and brought the other cultural agencies under its wing, has been to stress commercial efficiency — the capability of making sales — in giving its assistance to publishers, rather than the imaginative selection of books that will over the long run contribute to our literary or artistic heritage. Its help to films and broadcasting seems similarly oriented.

In the case of individual artists the problem lies in finding new means of ensuring them the incomes that will give the time and the peace of mind they need to develop their potential to the full. Since how to save the artists from poverty without making

177

them the permanent pensioners of the state has been and continues to be the most obstinate problem connected with public support for the arts, I will turn to it first of all.

The principal means of public support to individual artists consists of the awards of various kinds given them by the Canada Council. Provincial bodies offer fewer and usually smaller grants to individuals, and some provinces offer no awards at all of this kind. Municipalities in general avoid grants to artists on a personal basis, and so do private benefactors of the arts, who are more likely to make their gifts to institutions or for edifices by which their names can be preserved. A few Canadian writers still benefit from at least one American source of fellowships, the John Simon Guggenheim Memorial Foundation, which has a long and fine record of discriminating aid to individual literary artists and scholars.

But, taken together, these sources of assistance to individual artists mean that only a relatively small sum is spent each year. Such awards have run fairly consistently, since the Canada Council's foundation, at between 12 and 13 per cent of its total grants budget. In the early years of the council's history these awards did bear some relation to the number of eligible artists in various fields, but now the ratio has been so greatly reduced that competition has become much more acute, and the grants can no longer be taken seriously as making a major contribution to the economic situation of writers as a whole; rather they appear as prizes presented to a few individuals selected by a rather capricious system of juries. Given the figures that have come from various sides, it is reasonable to estimate that there are at least ten thousand to twelve thousand creative artists working full-time in Canada, counting writers, visual artists, musicians, choreographers, photographers, and so on. Yet in 1982–83 only forty-nine senior, or A, grants were offered for artists who had proved themselves, of which nineteen were for visual artists and fifteen for writers. In one year, when the Canada Council funds were particularly tightly stretched, the senior arts grants were dropped entirely, which speaks rather eloquently of the priority given in the minds of council members to the needs of the creators; interpreting Shakespeare at Stratford clearly had precedence. It is true that there were also the

somewhat more numerous B grants for younger artists with fewer exhibitions or books to their credit, but even these were few in comparison with the number of possible beneficiaries; there were only thirty-four for writers, bringing their total of grants to forty-nine, which spreads thinly over a company of full-time authors now several thousand strong.

As soon as one has a situation where the ratio between rewards and beneficiaries is so broad that no writer can feel sure of receiving a grant in a foreseeable number of years — when the chances against a writer in any one year have increased from eight to one to something nearer forty or fifty to one — two things happen: the system of Canada Council grants ceases to become an effective means for an appreciable proportion of artists to increase their meagre incomes, as it was in earlier days, and the sheer process of making choices becomes an agonizingly difficult one.

I cannot think, in principle, of a more effective system of selecting the beneficiaries of Canada Council largess than the peer system by which artists' qualifications and their proposals are judged by a panel of their fellows in their own field. As the Advisory Arts Panel to the Canada Council said in 1978, "artists judging artists, though far from a perfect system, is the best there is." But it is a system that demands good judgement not only on the part of the jurors but also on the part of those who select the jurors, which means the officials of the Canada Council.

Bernard Ostry has pointed to one of the perilous areas, in *The Cultural Connection.*

In dealing with applications for personal grants, the Canada Council has resorted to outside assessors, often meeting in juries, chosen from among the best available professionals in the disciplines or activities concerned, and these rosters are frequently changed. This seems to be the fairest way to proceed, but there is a danger, increasingly a subject of criticism, of inbreeding; an assessor is likely to favour an applicant whose skills or techniques or ideas resemble his own, thus creating a succession of potential assessors who are likely to perpetuate a particular school of thought.

Another peril, perhaps even more ominous, is that of establishment-mindedness. For example, in 1984, for the fourth year running, a brilliant younger novelist, Chris Scott, was refused a senior arts grant, although in 1983 he had been nominated for the Governor General's Award. The situation could not even be reviewed. There is no provision for writers who have suffered what they feel is an injustice to appeal — or for their sponsors to appeal on their behalf — the decision of a jury.

Council officials are only too happy with the jury system as a potential defence for the agency's occasionally ill guided decisions to modify it. When I wrote to the council about the Scott case, Timothy Porteous, the director, answered that the grants had been assessed by peer juries; what other system could one use? But when I looked at the lists he offered me of recent juries for senior grants in writing, I began to wonder just how peerly they were. Every member of the juries for the three years in question was palpably a member of the literary establishment. I have nothing to say against the literary credentials or the personal integrity of the eight people involved. (One appeared on two of the three juries.) I know them all, and two are my valued friends. But these facts disturbed me more than they reassured me, since they showed the close circle of "safe" figures from which the council picks it jurors.

I was even more disturbed when I calculated ages. The youngest juror at the time of judging was forty-four, but the preponderance of sixty- and seventy-year-olds pulled the average age up to fifty-nine. Two of the eight jurors — a quarter of the total — had published nothing substantial for almost twenty years; they could no longer be regarded as active writers. And in each jury there were two men and one woman. It is surely stretching points to count such people — whatever their excellence as persons or as writers — as *peers* of writers in their twenties or even thirties, capable of understanding in every way their intentions or achievements or comparing them on an equal basis with those of older writers.

It is time the jury system were opened out. I personally have long refused to take part because I think younger people should be involved. If the arts-grant juries were to include at least one person under thirty-five and one under forty-five, then the third might appropriately be an elder writer, but as matters stand it is

absurd to claim that a real peer system exists.* If there were more awards available to be granted in proportion to the number of competing artists, as in the early days of the council's operations, one would have less reason for alarm. The process of choice would as a whole be less imperilled by those instances of cliquism or conservatism or self-conscious avant-gardism on the part of juries which mean that in some years whole tendencies (or lacks of tendency) among writers and painters are excluded from serious consideration.

It is true that in a broad sense the Canada Council tries to keep the scope of its granting process as open as possible. Recently it has filled a long-lamented gap by extending literary grants to nonfiction prose writers, and it has followed the ancient example of the Chinese and Japanese by recognizing the point where craft passes into art and making a senior award to one of Canada's most remarkable potters, Wayne Ngan. Yet for all these efforts there remains no doubt that the intention of the founders and early administrators of the Canada Council to assist all artists of acknowledged accomplishment has been frustrated not just by the inadequacies of the jury system so long as juries are selected by the Canada Council's officials, but even more by the fact that the proportion of the council's funds allocated to individual artists — still not much more than an eighth of the total grants — is demonstrably inadequate for the situation in 1985.

There are several ways of redressing this state of affairs. The immediately obvious one is to increase the amount of money available; given the irreducible demands of the performing companies and public galleries that have become the council's perennial pensioners, this can only be done by conjuring more money out of Parliament. To increase the number of grants so that each artist might have, say, a one-in-eight chance each year

*I am not emphasizing the jurying for the Governor General's Literary Awards, since these are prizes awarded to a few individuals and there is no prospect of their affecting the fortunes of the mass of writers. But these too have aroused considerable criticism, and certainly in the past there have been some strange choices, like Igor Gouzenko's *Fall of a Titan,* and some strange omissions, like Margaret Laurence's *Stone Angel.* Most Canadian writers of any significance have in fact received Governor General's Awards, even if not always for their best books; perhaps the strangest and most unfortunate case is that of Earle Birney, honoured for a relatively minor book, *Now is Time,* in 1945, but not for the much more impressive volumes he published in his later period, especially in the 1960s and 1970s.

and so might expect two to four years in their career of working free from financial anxiety, would mean quadrupling the funds for individual grants to $30 million a year. If a few more millions, say $8 million, were added to replace the encouragement to artistic experimentation lost when the LIP grants were cut in the 1970s, the cost would not exceed that of one of the CF-18 Hornets which Canada is at present contracted by buy. A Parliament aware that vigorous arts are a better defence against cultural invasion than fighter planes against military invasion would not balk at such an expenditure.

However, this would merely put the Canada Council back in the position where it would be able to buy a little time for most artists just at the crucial periods in their development. It would not solve the greater problem of the widespread poverty of Canadian artists. On the other hand, any broader extension of the system of grants would bring us nearer to the point when artists would become pensioners of the state and as such would be subject, in order to keep their status, to whatever requirements might at some less liberal time be imposed upon them. The attempts of Trudeau-era Liberal governments to attach political conditions to the funds they gave the Canada Council should be sufficient warning that here — no less than in openly totalitarian countries — the artists who rely on the largess of the state were liable to become the servants of the state rather than independent creators.

Some critics of the present system advocate a complete abandonment of grants to artists, which they regard as unworkable because a fair way of administering them is impossible to devise. As an alternative they suggest forms of negative encouragement. Barbara Amiel, a writer given to saying sensible things with abrasive arrogance, is nevertheless one of the more intelligent among the right-wing critics who have advanced this argument. Five years ago, criticizing David MacDonald's actions as Conservative secretary of state, she said, while advocating the cutting of grants to artists and producers:

The simplest way to create a flourishing climate for the arts seems to be to combine a minimum of regulation with a maximum of incentives. And the best incentives seem to be *tax* incentives for producers (everyone who publishes a book, sets up a TV station, writes, sings and so on) and consumers

(everyone who goes out and buys a Canadian book, sees a Canadian film, etc.).

Insofar as they affect the artists, negative encouragement proposals that involve tax cuts presuppose that artists will earn enough to be liable for taxes in the first place, which in many cases they are not. Yet actually, as we shall see, there are ways in which such proposals can help the artist to be so. But before we consider them, there are other more positive ways that are worth discussing in which the incomes of artists in general can be increased without the inevitable discrimination that accompanies a grants system. A general raising of the level of income is the most desirable objective of any program in support of the arts, and any measure that might benefit artists — or at least a majority of artists — across the board by increasing their actual earnings should be encouraged, even if it means dipping into public funds.

The most obvious way to increase writers' earnings is, of course, through the Public Lending Right. When books are bought by a library, the authors receive the same royalty — 10 per cent of the retail price — as they would if the books were sold to an individual buyer. But while the book sold to an individual is usually read by between one and three people, the library book will be read by thirty to fifty people without the author receiving anything more than the royalty on a single sale. The injustice of this situation has long been recognized, and now all the Scandinavian countries, as well as Britain, Australia, New Zealand and Germany, make regular payments to native and sometimes also to foreign authors for the loan of books through their libraries. (Twice a year I receive a modest but welcome cheque for the use of my books in German libraries.)

The Public Lending Right has been discussed in Canada for many years. It has been demanded by writers and endorsed by librarians. The Canada Council has prepared an initial scheme; the Applebaum-Hébert Committee endorsed the idea, though its scheme was different from the Canada Council's. Successive secretaries of state and ministers of communications have signified their approval, though they have often taken refuge behind the argument that libraries are a provincial responsibility — as if that could prevent payments made directly from Ottawa

to writers. The delays, whatever their reasons, are inexcusable, for if every party recognizes — as all parties do — that payment for library use is a right of authors, then means should be found to implement it.

Exactly how PLR payments should be assessed is still a matter of argument. The Applebaum-Hébert Committee proposed that they should be related to royalties, but this would mean that Pierre Berton and Farley Mowat would reap large awards and poets and short-story writers would get very little. The Writers' Union of Canada has advocated payment based on library use, with a built-in maximum so that the best-sellers shall not scoop the pot. My own suggestion is that a rough but effective justice might be achieved by basing payment on library holdings. This would mean (a) that little-read but good authors — including most poets — would get more than by the use system, and (b) that older writers whose production has diminished but whose needs remain, and other writers with a slow production cycle (say a novel every seven or eight years), would benefit from their books remaining in collections through periods when they were in low demand because their authors were not in the public eye. Clearly there should be some minimum standards that would prevent vanity publications from putting a writer on the list for payments. Perhaps a writer should have at least one hundred or two hundred purchased volumes on public library shelves across the country, and then, once the standards of acceptance had been agreed, there might be a minimum payment of $500 for any qualifying author; it would hardly be worth administering the scheme for less. At the other end, a maximum PLR payment of say $7,500 a year would prevent the scheme becoming merely a matter of "To him that hath shall be given" by swelling the incomes of best-sellers. Assuming that a maximum of five thousand writers would qualify, and that the average payment would be around $3,000, it would mean a total outlay of $15 million a year, less than half the cost of a dubiously efficient military airplane. But it would make a real difference to the situation of full-time writers whose mean income from all literary sources is $7,000 a year, particularly if a negative benefit were added to this positive one by exempting PLR payments from taxation as a compensation for the many years during which writers have been denied this elementary measure of justice.

There are other ways in which artists' incomes can be increased merely by introducing a measure of equity into their relations with those who in some way enjoy or use their works. We are at last moving towards the kind of copyright situation in which writers, painters and musicians will be better protected against the fugitive and unpaid use of their works by means of modern reproduction and recording techniques. Thanks to the efforts of Canadian Artists' Representation, visual artists are beginning to receive fees for the exhibition of their works, and this right, like any other copyright, should be enshrined in appropriate legislation. The returns would be slight, but justice would be done. Besides, when one is as poor as most Canadian artists, every extra bit of cash is useful.

There remains the great question of the enhanced value of works of art and literature as a painter or a writer moves from obscurity towards fame. All writers of any staying power come to the point when they see their early works, which sold slowly when first published, and which were perhaps even remaindered at the time, steadily growing in value in the antiquarian bookshops. Most of my own out-of-print books now fetch between five and ten times their original selling prices. Some of my scarce early pamphlets are selling at one hundred times their original price, and I know that this is also the case with the early collections, published by little presses in small editions, of poets like Al Purdy and Irving Layton. It is annoying for any writer to see others benefit from the greater attention now paid to their early works, and the same applies to painters who in their lifetimes see dealers and collectors gaining large profits from works that bring their creators no return after the day they are sold for the first time from the studio or the gallery.

Most politicians who give the arts a thought recognize the injustice of this situation, but up to now in Canada the ways and means of rectifying it have not yet become even a subject of public discussion. France has already moved ahead of the Anglo-Saxon countries by acknowledging a *droit de suite*. A tax is now imposed there on the sale of works of contemporary art, based on the difference between the most recent and the previous sale, and the amount received is handed to the artist whose painting or other work has been sold. It should not be difficult to create such a system of sharing in the profits on their own works for living

artists in Canada, keeping a check on auctions and on the comparatively few antiquarian bookshops and galleries that specialize in the sale of Canadian books and art objects. Such a measure would be an act of elementary justice as well as a great assistance to artists during the middle and late periods of their careers.

A further area of possible income to artists of all kinds is the sale of their manuscripts, sketches and so on as archival materials. At one period, in the 1960s and early 1970s, libraries and archives were fairly well funded, and a considerable number of sales of this kind were made; these were particularly helpful to older writers and other artists whose incomes from actual production were declining and whose freelance way of life had left them with little to expect in the way of pensions. In the growing financial stringencies of the later 1970s the funds available for this kind of purchase sharply declined, with the double consequence that collections of material important to the literary and artistic history of Canada have become increasingly likely to be bought by dealers and dispersed, and that an important source of funds to writers and artists has largely dried up. A program should be established in connection with the Cultural Property Export and Import Control Act so that institutions can be aided in purchasing, directly from artists, collections or works that are certified under the act as being of national importance.

These three proposals for positive aid to artists — PLR, *droit de suite* and purchase assistance — differ from the existing programs of awards because they are not gifts made in anticipation of the artist producing works, but are rather payments linked to works the artist has already produced, and aimed at ensuring artists a juster return for efforts than they receive under existing circumstances. Two of the proposals would demand modest allocations from public funds. The third would be funded by the proceeds of a special tax on some of those who profit by the creations of artists without being creators themselves.

The other benefits I would suggest for artists and writers would be negative and move in the same direction as Barbara Amiel's proposals. It is better to increase artists' real incomes by tax concessions than to make them dependents of the state through too many grants. Some interesting suggestions in this direction floated to the surface during the hearings of the Sub-Committee on the Taxation of Visual and Performing Artists and

Writers when the members of the sub-committee were considering the generally low earning capacities of these groups compared with members of other professions. One of the Liberal members of the committee, Robert Gourd, introduced rather boldly the idea of a separate tax category for artists when he said, "I have always felt that the simplest way to do it would just be to say that the first $15,000 of an artist's income would not be taxable." Such a measure would of course put the artists in a special class, but it would recognize that, like farmers and fishermen, they have special problems in earning a living, and also make a special and essential contribution to the life of the community.

Another suggestion that emerged during the hearings was that all artists should have a basic $5,000 allowance for costs, within which they would not have to offer receipts; artists with heavy costs above $5,000 would have to justify them. This suggestion would save artists many problems with uncomprehending auditors, but it seems to me that if tax remission is to be given to artists, Gourd's proposal of a straightforward basic exemption — whether it is $5,000 or $10,000 or $15,000 — makes more sense than any more refined and complex arrangement.

It will have been evident that, like the Canada Council's present practice in making grants — except in the Explorations program — the proposals I have extended, both positive and negative, are based on the assumption that the artists have already established their professional qualifications and that their works are at least beginning to be published, exhibited or performed, and to earn them money. The proposals do not help untested or apprentice artists except by improving the economic situation of the profession they hope to enter. I do not think there is any way in which one can eliminate the arduous and often long struggle by which artists have traditionally established themselves, and which offers a rough and perhaps necessary process of natural selection, though there are indeed ways in which that struggle can be made less painful. I have often thought that nobody would benefit more from the guaranteed minimum income that has long been proposed and discussed than those who wish to develop themselves as artists and have the kind of dedication that would keep them working diligently provided they had just enough to keep body and soul together

187

and buy their basic materials. Short of that, more generous assistance to students in the various arts, and broad help for obviously talented amateur artists and groups through the Canada Council's Explorations program and through provincial programs seem the best ways of assisting the artists who have not yet established their professional status.

It is in this area that co-operation between federal and provincial agencies is most vital, since the provincial arts councils and similar agencies have been most active in encouraging amateurs, both individually and as performing groups. The need for such co-operation emphasizes the parallel need for all arts funding to be detached from the kind of political imperatives that already exist in Quebec and that Bill C-24, if it had not been amended at the last minute, would have imposed on all the federal agencies concerned with fostering the arts. When governments enter directly into aiding the arts, with all the possibilities of manipulation such direct intervention suggests, instead of funding them at arm's length through public trusts like the Canada Council, then cultural co-operation is transformed into political rivalry. Frank Milligan, the former associate director of the Canada Council, commented revealingly on the effects in this area of the council having received federal funds that were earmarked for quasi-political purposes. He begins, in his essay "The Ambiguities of the Canada Council" (in *Love and Money: The Politics of Culture,* edited by David Helwig), by telling how in its early days the Canada Council was accepted by Quebec and later by the other provinces that developed cultural agencies as an autonomous body and "was able, independently of any inter-governmental channels, to develop direct links with them on matters of common interest." He continues:

> As Council policies in these matters showed signs of becoming subsumed by and subordinate to a cultural policy of the federal government itself, the process of consultation and accommodation became an intergovernmental affair, to be conducted within the broader framework of federal-provincial negotiations. This had the effect of further intensifying the intrusion of governments, both federal and provincial, in cultural matters, and reinforcing the tendency toward the politicizing of the arts and their public patrons.

The federal-provincial rivalry has had the further effect of encouraging not only the politicians but the public as well (including the artists) to choose sides in an argument that may miss the crucial issue. For in the dispute over which level of government should determine the role of the arts in Canadian society, what is lost is the question whether *any* government should presume to do so — or whether the function should be left to other, more diffuse, social processes, in which artists, patrons, critics and the interested public all play their parts. We may be moving to a judgment of Solomon in a dispute in which neither of the contending parties has a valid claim to parentage. In such a judgment, the welfare of the ward may count for little.

Clearly the co-operation between federal, provincial and also municipal agencies that is necessary for the support of the arts and the artists can only be effective if it is detached from political considerations, and therefore it should not be a matter of direct contact between governments.

Up to now I have been considering primarily the situation of artists, without whom there could be no arts, and what might be done to improve their individual circumstances. But the measures I have suggested will be little more than palliative unless they are carried out within the context of broader support for the arts considered as essential social functions. And here Milligan's reference to "other, more diffuse, social processes, in which artists, patrons, critics and the interested public all play their parts" becomes significant, for it has long been evident to those who have observed the development of the arts in Canada that their sustenance cannot be left entirely to governments acting on behalf of the community, and that unless there is some broader base of support, the great creative impetus of the past decades may not be sustained. For art, despite the aestheticists, is not a wholly autonomous activity. It depends, if its vitality is to be sustained, on a society that is both morally and materially receptive and sustaining.

And here we come to the question of how private support for the arts can be stimulated. I have deliberately avoided raising this question in discussing the situation of individual artists, since I believe the age of direct patronage has long been over.

The personal relation between patron and patronized has never been easy, and my own experience has led me to assume that it has not improved since the days of Mozart. The only occasion on which I approached a rich man for help in a cherished project left me with angry feelings closely resembling those of Dr. Johnson, and a conviction that for all the bureaucratic ossification it has undergone, and for all the "insolence of office" that sometimes enters its operations, a public agency like the Canada Council enables artists to request, and still keep their dignity, even in disappointment.

But the collective and corporate activities that are necessary to support the arts are another matter, and here the participation of the general public and of patrons, individual and corporate, has become more desirable as the limits of spending for the private purse are approached. Apart from that, the more private support for the arts is developed, the less peril there will be of political domination and manipulation.

Until now, private patronage of the arts in Canada has been less than lavish. As Bernard Ostry said in 1978, "there is not enough private funding; not enough entrepreneurial capacity in seeking out private donors, and not enough incentive for the private sector to respond to." One can pick figures from a number of sources, and none of them is very encouraging. A Statistics Canada survey in 1977 showed that private sector grants to a range of performing arts companies averaged less than 12 per cent. In 1979 the Winnipeg Art Gallery received approximately $360,000 in private donations as against $1.32 million in grants from various public sources, or about 22 per cent of the total of $1.68 million. Most estimates would in fact place the contribution from the private sector at between 12 and 20 per cent of the necessary subsidies. In 1974 the Council on Business and the Arts estimated that about 10 per cent of charitable donations made by Canadian businesses went to the arts; this meant at the time about $6 million, a fraction even then of what was being given by various public agencies.

The Council on Business and the Arts, with its disappointing record, is a good example of the relative unreceptiveness of private donors in Canada to the idea of aiding the arts. It was founded in 1974 and financed partly by the Canada Council, which was even then impressed by the need to supplement

public with private funds in order to meet the growing demands of the arts community. It got off to a poor start with a mere eighty-three firms participating, and it did little to increase the support of the arts by Canadian businesses.

American private patrons have been considerably more generous, and here there is a divergence in traditions that acts to the disadvantage of the arts in Canada. While the Medician tradition of large-scale patronage of the arts by financiers and industrialists took hold in the United States well before the end of the nineteenth century and resulted in the creation of a number of admirable and well-funded private bodies like the Guggenheim Foundation, the Ford Foundation and the Rockefeller Foundation which assisted art enterprises, nothing of the kind happened at the same time in Canada. Indeed, up to the middle of the present century, as the Massey Commission noted in 1951 with a mixture of gratitude and chagrin, the American foundations were virtually the only places where a Canadian writer or artist in need of a subsidy could go for help.

The Canadian tradition, ever since the government intervened in the provision of essential communications networks — first the canals and then railways and telegraphs and finally broadcasting and airlines — has been for the state to intervene heavily in times when help was needed, and not only to establish railways, airlines, broadcasting services and so on parallel to the private ones but also to offer subsidies to private firms — of which the great public grants to the CPR were among the first — when they seemed unable to complete a work of national importance. The result has been the emergence of a pattern of dependence on the government, according to which the country's most important businesses have tended to hang on to profits when they make them and expect the state to bail them out when they do not. From this it is a short step to leaving the government to fulfil also those public obligations which large businesses have traditionally assumed in the United States. Even banks and trust companies and other businesses whose profits are never at risk show in Canada a remarkable reluctance when it comes to fostering the arts.

It is possible that such attitudes are too deeply ingrained in the minds of Canadian businessmen to be changed even by the most eloquent appeal to their patriotism. Indeed, it is doubtful if

many of them would see supporting the arts as a form of patri-
otic activity. But the idea of investments rewarded by tax incen-
tives might do a great deal to change their attitudes, as it has
done in the case of research-oriented enterprises and films. If
the film industry can generate round about $150 million a year in
investment through this kind of encouragement, it seems likely
that publishing and private art galleries, given similar encour-
agement, might have the means to considerably expand their
activities.

One of the ways in which publishing might grow from a
reorganization within the industry was suggested by Mel Hurtig
in a very interesting unpublished paper which he circulated
early in 1984. Hurtig pointed out that the crux of the situation
for Canadian publishing — and in the long run for Canadian
writers — lies in the fact that even if Canadian publishing flour-
ishes and Canadian writers produce ever more books, we are
part of the English-speaking world, which will always mean
that between fifty and seventy-five per cent of the books we buy
will "represent mostly American books plus some British
books and fewer French books and a tiny fraction of a per cent
from other countries." Almost all these books, according to the
old-established agency system, are sold here in American, Brit-
ish or other foreign editions. The time has come, Hurtig sug-
gests, for Canadian publishers to have the opportunity to com-
pete for the rights to international books "which, as far as we
can see into the future, will form the majority of books sold in
this country." This would actually benefit the foreign authors
and agents since they would receive domestic royalties which
are usually at least twice the rate of export royalties. As for the
Canadian publishing industry, the consequences of this sheer
increase in the quality of titles printed and published here are
obvious. "There would be more book printers and binders.
More competition would bring more competitive prices and
better delivery. More volume would do wonders for production
profitability and result in better equipment. Canadian book
publishers would benefit substantially."

It is obvious that such an opening of the Canadian publishing
industry from its present rather incestuous concentration on
books by Canadian authors mainly on Canadian subjects has
long been necessary. For if our publishing industry were mature

192

enough to publish books of all types flowing in from the outside world, then Canadian authors could look forward to publishing at home the kind of books for which in the past they have sought American or British publishers because they did not fit into the conventional Canadian subject range.

Hurtig sees such an innovation linked to a federal program not of grants but of loan guarantees and incentives (presumably tax incentives of the kind I have been discussing) for equity investment in Canadian book publishing companies.

> Canadian publishers, like other publishers around the world, would be able to build up their "stables" of not only their own national authors but authors from around the world as well. The big-name international bestsellers would help produce profits. The names and profits and investment incentive would help attract equity. The loan guarantees would provide capital to compete for rights. It would be a most successful circle. . . . Most of the Canadian book publishing would be in great shape, and the public cost would be much, much smaller than today.
>
> Most important of all, many more excellent Canadian books would be published.

As Hurtig suggests, the eventual costs of a scheme like this to the taxpayer would be less than any scheme based merely on subsidies, since a revitalized publishing complex would be the result, and Canadian writers would benefit as much as Canadian publishers. Once again, as in the case of PLR, it is a question of recognizing a right rather than making a concession: the right of Canadians to publish the books that are sold in this country.

In the case of the visual arts, tax incentives might encourage investment in the kind of private galleries that foster younger artists, and a further measure of benefit might come from a reorientation of the Canada Council's Art Bank. If this ceased to be a repository of works to be loaned to government offices and were reorganized as a source of extensive loan exhibitions to smaller centres throughout Canada, exhibition fees could be charged that would benefit the artists directly, and their work would be shown to a broader audience which would eventually result in enhanced reputations and larger sales.

At this point I have moved over from the private patron, or investor, to the general public. And here is perhaps the most hopeful factor in the equation. For, as we have seen, there has been a vast increase during the past two decades in the number of Canadians attending concerts, seeing live theatre and ballet, reading books, buying recordings. The fact that between 50 and 55 per cent of the receipts of performing companies come from the sales of tickets makes the millions of people who form audiences every year a more important element in sustaining the arts than all the levels of government combined. If their numbers can not only be sustained but also slowly increased, then — with the measures I have already suggested — many of the troubles of the arts and artists in Canada might be well on the way to solution.

Here again, financial incentive seems the most practical form of encouragement. The cost of tickets to performing art shows and of Canadian books and recordings should be regarded as tax deductible. A slip attached to each book, recording or admission ticket could serve as a tax receipt, and the current limit of 20 per cent exemption for charitable donations could be increased to 25 per cent to include such purchases.

To sum up what I have been saying in this chapter, we seem to have come near the limit to which actual grants to the arts from public funds can be extended without risk of political pressures and some measure of subordination of the artist to the state entering the situation. Some further help can be given to artists by restoring the original Canada Council ratio of grants to applications, by direct tax reliefs, and by measures intended to establish a just payment for their work, like the PLR for writers, the *droit de suite* for painters and better copyright arrangements for everyone. The maintenance of the major performing companies can perhaps by now be taken for granted as an accepted public obligation, a political as well as an artistic gesture.

But the engagement of the private sector on a broader scale than ever before is essential if the arts are to flourish and grow in freedom and Canadian artists are to cease to be, in general, the second most financially deprived group in Canada. And here the simplest means available — whether it is a case of investors in a revitalized publishing industry or in private art galleries or films or records, or of encouraging individual Canadians to read

more Canadian books or listen to more Canadian music or see more Canadian plays — is that of tax incentives. Whatever the cost in lost taxes, it would be only a tiny fraction, perhaps 1 or 2 per cent of what the Canadian government pumps in to the petroleum industry in grants and tax reliefs, and the gain in increased prosperity and sustained vitality in the worlds of art and literature would be well worth the price. For the first time in Canadian history, artists might not only be adequately recognized, as they often are today, but also adequately rewarded, which most of them are not.

It will never be a perfect situation, since artists automatically sacrifice security when they choose freedom. There will always be experimenters who go against the stream and find recognition and reward coming slowly. For all artists there will always be the dreaded blocks, the periods when inspiration flags and creation lapses. There will always be the slow developers and the fast faders with their special problems. There will always be those whose pride or principles make them reject all aid. But if the arts gain full recognition as professions equally important to medicine and somewhat more important than law and politics, and if average incomes within them rise to a reasonable level, then the exceptional cases can be cared for and Canada will at last deserve the gifts its artists have lavishly made in the past quarter of a century and are still making.

# SELECTED
# BIBLIOGRAPHY

Amiel, Barbara. "A simple path to cultural improvement." *Maclean's*, November 1979.

Andrews, Marke. "Artist vs. the taxman." Vancouver *Sun*, 31 December 1983.

Anon. "Turmoil in the Art World." *Saturday Night*, June 1978.

*Arts. Bulletin of the Canadian Conference of the Arts*. Special Edition on Taxation. September 1983.

Audley, Paul. *Canada's Cultural Industries: Broadcasting, Publishing, Records and Film*. Toronto, 1983.

Bain, George. "Why the CBC won't bite where it eats." *Maclean's*, 20 December 1982.

Boggs, Jean Sutherland. *The National Gallery of Canada*. Toronto, 1971.

Canada. Department of the Secretary of State. *The Arts in Canada*. Ottawa, 1967.

Canada. Department of the Secretary of State. *The Film Industry in Canada*. Ottawa, 1976.

Canada. Federal Policy Review Committee. *Summary of Briefs and Hearings*. Ottawa, 1982.

Canada. Federal Cultural Policy Review Committee. *Report*. Ottawa, 1982.

Canada. Federal Cultural Policy Review Committee. *Speaking of Our Culture*. Ottawa, 1981.

Canada. House of Commons. Special Committee on Reconstruction and Re-establishment. *Minutes of Proceedings and Evidence*. The Turgeon Report. Ottawa, 1951.

Canada. House of Commons. Sub-Committee of the Standing Committee on Communications and Culture on the Taxation of Visual and Performing Artists and Writers. *Minutes of Proceedings and Evidence.* Ottawa, 1984.

Canada. House of Commons. Sub-Committee on the Taxation of Visual and Performing Artists and Writers. *Report.* Ottawa, 1984.

Canada. Royal Commission on National Development in the Arts, Letters and Science. *Report.* Ottawa, 1951.

Canada. Royal Commission on Publications. *Report.* Ottawa, 1961.

Canada Council. *An Assessment of the Impact of Selected Large Performing Companies upon the Canadian Economy.* Study conducted by Urwick, Curry & Partners Ltd., Management Consultants. Ottawa, 1974.

Canada Council. *Annual Reports.* Ottawa, 1958–1984.

Canada Council. *Canada Council Brief on Bill C-24 to the Standing Committee on Miscellaneous Estimates, 7 June 1984.* Ottawa, 1984.

Canada Council. "Canada Council objects to Crown Corporation legislation." News release. Ottawa, 1984.

Canada Council. *The Canadian Artist and the Income Tax Act.* Ottawa, 1984.

Canadian Broadcasting Corporation. *Report of the CBC Radio Study Group on Programming of and about Arts, Music and Drama.* Toronto, 1976.

Condon, Jane. "Taxation: the situation to date." CARFAC *News,* Spring 1984.

Conlogue, Ray. "Regional theatre: a concept wanes." *Globe & Mail,* 3 March 1984.

Crean, Susan M. "So far no good." Review of Paul Audley's *Canada's Cultural Industries. Books in Canada,* June/July 1983.

———. *Who's Afraid of Canadian Culture?* Don Mills, 1976.

———. "Understanding Applebert." *Canadian Forum,* April 1983.

Czarnecki, Mark. "A new blueprint for culture." *Maclean's,* 29 November 1982.

———. "Open season on the CBC." *Maclean's,* 1 November 1982.

Davies, Ioan. "Ideology, Bureaucracy and Culture: Comments on Applebaum-Hébert." *Canadian Forum,* February 1983.

Disney, Russell. *Federal Tax Issues of Concern to the Arts Community in Canada: An Analysis.* The Disney Report. Ottawa, 1977.

Drache, Arthur. "Taxman puts artist's costs on test." *Financial Post,* 15 October 1983.

Eliot, T. S. *Christianity and Culture.* New York, 1949.

Ellis, David. *Evolution of the Canadian Broadcasting System: Objectives and Realities, 1928–68.* Ottawa, 1979.

Finlayson, Ann. "An era ends in Canadian film." *Maclean's,* 11 June 1984.

Frégault, Guy. *Chronique des années perdues.* Montreal, 1976.

Frith, Valerie. "An Interview with Francis Fox." *Quill & Quire,* November 1980.

Fulford, Robert. "Can Pierre Juneau save the CBC?" *Saturday Night,* January 1983.

————. "The Canada Council at Twenty-Five." *Saturday Night,* March 1982.

————. "The Crisis that faces Canadian broadcasting." *Saturday Night,* March 1978.

————. "Dialling for Dollars." *Saturday Night,* May 1983.

————. "The Edifice Complex." *Saturday Night,* June 1983.

————. "Paint by numbers." *Saturday Night,* January 1984.

————. "Pay in the Sky." *Saturday Night,* December 1983.

————. "Who should run the National Gallery?" *Saturday Night,* October 1976.

Gathercole, Sandra. "Refusing the Challenge: Comments on Applebaum-Hébert." *Canadian Forum,* February 1983.

Godfrey, Dave, and Stephen Clarkson, Tom Hendry, John B. Boyle, Sandra Gathercole, Gwenlyn Creech, Eli Mandel, Scott Symons and Ioan Davies. "Canadian Cultural Policy: A Symposium on National Pathology." *Canadian Forum,* September 1977.

Granatstein, J. L. "And the winner is: a juror takes us inside the G. G.s." *Quill and Quire,* May 1984.

Gwyn, Richard. "Flaws pointed out in Crown corporation bill." *Toronto Star,* 22 May 1984.

Gwyn, Sandra. "The Canada Council had the right people at the right time." *Saturday Night,* June 1977.

Hardin, Herschel. *A Nation Unaware.* Vancouver, 1974.

Harrison, Brian R. *Canadian Freelance Writers: Characteristics and Issues.* Ottawa, 1982.

Helwig, David, ed. *Love and Money: The Politics of Culture.* Ottawa, 1980.

Hindley, Patricia, with Gail M. Martin and Jean McNulty. *The Tangled Web: Basic Issues in Canadian Communications.* Vancouver, 1977.

Hluchy, Patricia. "A sharp knock at Hollywood's door." *Maclean's,* 11 June 1984.

Hurtig, Mel. "Some thoughts on the Canadian Book Publishing Industry." Unpublished paper. January, 1984.

Janus [pseud.]. "Resurrecting the ghosts of the cultural past." *Quill & Quire,* January 1983.

Johnson, Bryan. "Arts and the taxman." *Globe & Mail,* 12 November 1983.

Knelman, Martin. *This Is Where We Came In: The Career and Character of Canadian Films.* Toronto, 1977.

Lorimer, James. "Cultural Politics." *Quill & Quire,* February 1980.

———. "Needed: a public enquiry into book distribution." *Quill & Quire,* July 1979.

MacKay, Gillian. "Angry artists against the tax man." *Maclean's,* 19 December 1983.

Mackenzie, Hilary. "Director of NAC charges intimidation over arts bill." *Globe & Mail,* 16 June 1984.

———. "Bill C-24 would destroy Canada Council." *Globe & Mail,* 8 June 1984.

McPherson, Hugo. "Guiding the Muses: The Canada Council." In *The Prospect of Change,* edited by Abraham Rotstein. Toronto, 1965.

Martin, Susan. "What is ACTRA and why is it doing these terrible/ wonderful things?" *Maclean's,* 17 October 1977.

Michaels, David. "Enter the tax man: artists oppose Revenue's unwelcome visitations." *Quill & Quire,* April 1984.

Minihan, Janet. *The Nationalization of Culture.* New York, 1977.

Moore, Mavor. "Canada Council caught in the net of politics." *Globe & Mail,* 7 June 1984.

———. "Where do the politicians stand on cultural policy?" *Globe & Mail,* 7 April 1984.

Ontario. Royal Commission on Book Publishing. *Canadian Publishers and Canadian Publishing.* Toronto, 1973.

Ostry, Bernard. *The Cultural Connection.* Toronto, 1978.

Pape, Gordon. "Painted into a corner." *Financial Post Magazine,* 1 June 1984.

Panusak, Christine. *An Analysis of Selected Performing Arts Occupations.* Ottawa, 1974.

Peers, F. W. *The Politics of Canadian Broadcasting, 1920–1951.* Toronto, 1969.

———. *The Public Eye: Television and the Politics of Canadian Broadcasting, 1952–1968.* Toronto, 1979.

Pickersgill, J. W. *My Years with Louis St. Laurent.* Toronto, 1975.

Porteous, Timothy. *The Canada Council and Bill C-24: A Background Paper.* Ottawa, 1984.

Quebec. Le ministre d'Etat au Dévellopement Cultural. *La Politique québecoise du dévellopement culturel.* 2 vols. Quebec, 1978.

Shuh, John Hennigar, with Paul Hornbeck, Joyce Wayne, Christina Hartling, Alan Twigg and James Lorimer. "From Atlantic aspira-

tions to Pacific perseverence." Symposium on the publishing situation coast to coast. *Quill & Quire,* November 1980.

Statistics Canada. *Culture Statistics. Book Publishing: A Financial Analysis, 1975–77.* Ottawa, 1980.

————. *Preliminary Statistics on Writers in Canada.* Ottawa, 1980.

Symons, T. H. B. *To Know Ourselves: The Report of the Commission on Canadian Studies.* 2 vols. Ottawa, 1975.

Wachtel, Eleanor. "Prize and Prejudice: Do the Governor General's Awards celebrate literary excellence?" *Books in Canada,* March 1982.

Walker, Susan. "Applebert's Verdict on the Book Trade." *Quill & Quire,* January 1983.

Walker, Susan, with Dian Pullan Wilson, Paul Hornbeck and James Lorimer. "Ten years that shook the Trade." Symposium on Canadian publishing in the 1970s. *Quill & Quire,* December 1979.

Walmsley, Ann. "A Patron's heavy hand." *Maclean's,* 2 July 1984.

Woodcock, George. "Art and Taxes." *Saturday Night,* March 1984.

————. "Art versus Culture." *Queen's Quarterly,* Winter 1981.

————. "Thoughts on the laws of libel." *Amphora,* June 1981.

————. "The state and the arts: the need to bite the hand that feeds." *Books in Canada,* January 1984.

Young, Walter. "Why does the CBC stress the wrong C?" *Vancouver,* August 1982.

# INDEX